ROPOLITAN MUSEUM OF ART NEW YORK · THE METROPOL

SEUM OF ART NEW YORK · THE METROPOLITAN MUSEUM O

W YORK · THE METROPOLITAN MUSEUM OF ART NEW YOR

ETROPOLITAN MUSEUM OF ART NEW YORK · THE METROP

MUSEUM OF ART NEW YORK · THE METROPOLITAN MUSEU

NEW YORK · THE METROPOLITAN MUSEUM OF ART NEW Y

E METROPOLITAN MUSEUM OF ART NEW YORK · THE METR

N MUSEUM OF ART NEW YORK · THE METROPOLITAN MUSE

ORK · THE METROPOLITAN MUSEUM OF ART NEW YORK · T

OPOLITAN MUSEUM OF ART NEW YORK · THE METROPOLI

EUM OF ART NEW YORK · THE METROPOLITAN MUSEUM O

W YORK · THE METROPOLITAN MUSEUM OF ART NEW YOR

ETROPOLITAN MUSEUM OF ART NEW YORK · THE METROP

USEUM OF ART NEW YORK · THE METROPOLITAN MUSEU

NEW YORK · THE METROPOLITAN MUSEUM OF ART NEW Y

E METROPOLITAN MUSEUM OF ART NEW YORK · THE METR

N MUSEUM OF ART NEW YORK · THE METROPOLITAN MUSE

THE METROPOLITAN MUSEUM OF ART

Europe in the Age of Monarchy

THE METROPOLITAN

INTRODUCTION

BY

John T. Spike

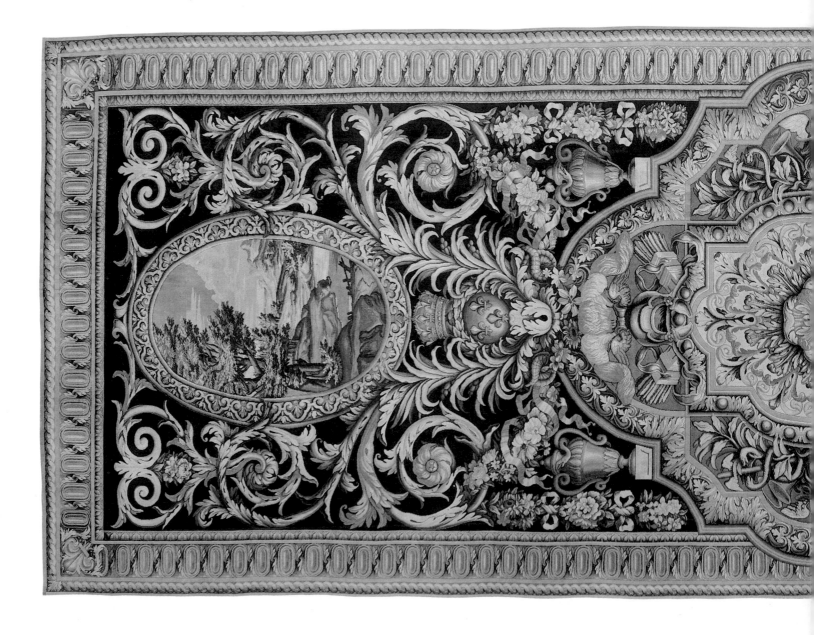

MUSEUM OF ART
Europe in the Age of Monarchy

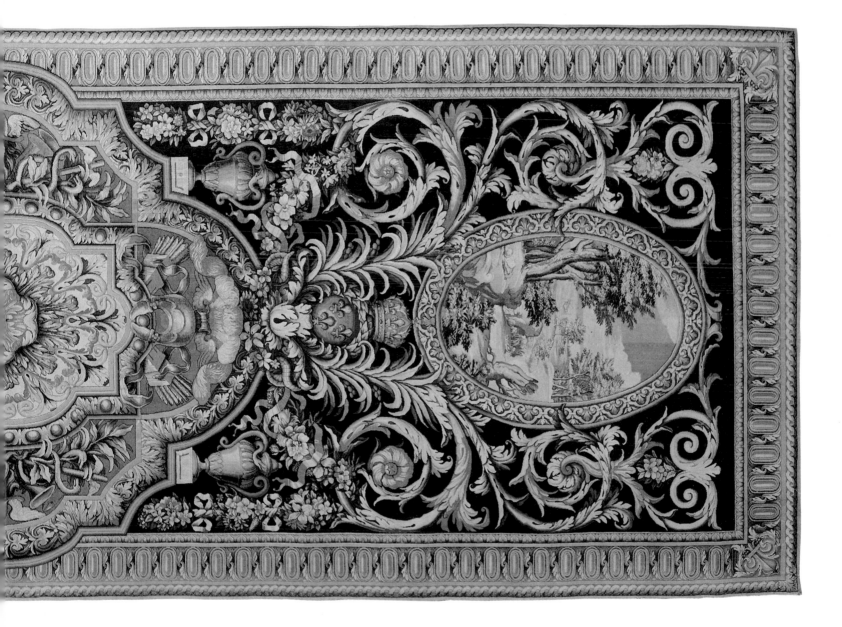

THE METROPOLITAN MUSEUM OF ART, NEW YORK

PUBLISHED BY

THE METROPOLITAN MUSEUM OF ART
New York

PUBLISHER

Bradford D. Kelleher

EDITOR IN CHIEF

John P. O'Neill

EXECUTIVE EDITOR

Mark D. Greenberg

EDITORIAL STAFF

Sarah C. McPhee

Josephine Novak

Lucy A. O'Brien

Robert McD. Parker

Michael A. Wolohojian

DESIGNER

Mary Ann Joulwan

————

Commentaries: Matthew Armstrong (paintings and prints); James D. Draper, curator, Department of European Sculpture and Decorative Arts [ESDA] (Plates 6, 7, 86, 112, 120); Jessie McNab, associate curator, ESDA (Plates 84, 87); Clare Vincent, associate curator, ESDA (Plates 93, 94); Johanna Hecht, associate curator, ESDA (Plates 11, 12, 23, 41, 42, 92, 104, 108, 110, 123); Daniella O. Kisluk-Grosheide, curatorial assistant, ESDA (Plates 22, 31, 90, 91, 111, 118, 122); Maureen Cassidy-Geiger, research assistant, ESDA (Plates 32, 33, 85, 95–97); Alice Zrebiec, associate curator, Textile Study Room (Plates 109, 113); Helen Mules, assistant curator, Department of Drawings (Plates 27, 30, 35, 36, 47, 49, 58, 59); Lawrence Turčić, research associate, Department of Drawings (Plates 2, 8, 9, 13, 15, 20, 107, 114, 115).

Photography commissioned from Schecter Lee, assisted by Lesley Heathcote: Plates 2, 4, 7–9, 12, 13, 15, 20, 25–27, 28, 31–33, 35, 41, 42, 49, 54, 61, 66, 68, 69, 72, 77, 84, 86, 92, 95–97, 104, 107, 108, 110, 112, 114, 115, 120, 121, 123. All other photographs by The Photograph Studio, The Metropolitan Museum of Art.

Maps and time chart designed by Wilhelmina Reyinga-Amrhein.

THIS PAGE

Vase
French (Vincennes), ca. 1745–50
Soft-paste porcelain; H. 6⅜ in. (16.2 cm.)
The Charles E. Sampson Memorial Fund, 1972, (1972.132.1)

TITLE PAGE

Carpet
Number 73 of a series of 92 carpets woven for the Long Gallery of the Louvre; French (Paris, Savonnerie manufactory), 1680
Knotted and cut wool pile; ca. 90 knots per sq. in.
29 ft. 9¾ in. x 10 ft. 4 in (9.09 x 3.15 m.) Gift of Mr. and Mrs. Charles Wrightsman, 1976 (1976.155.114) *Page 140*: text

Library of Congress Cataloging-in-Publication Data

Metropolitan Museum of Art (New York, N.Y.)
 Europe in the Age of Monarchy.
 Includes index.
 1. Art, European—Catalogs. 2. Mannerism (Art)—Europe—Catalogs.
3. Art, Modern—17th–18th centuries—Europe—Catalogs. 4. Art—
New York (N.Y.)—Catalogs. 5. Metropolitan Museum of Art (New York, N.Y.)--Catalogs. I. Title
N6754.M47 1987 709'.4'07401471 86-23649
ISBN 0-87099-449-2 ISBN 0-87099-450-6 (pbk.)

Printed in Japan by Dai Nippon Printing Co., Ltd. Composition by U.S. Lithograph, typographers, New York.

This series was conceived and originated jointly by The Metropolitan Museum of Art and Fukutake Publishing Co., Ltd. DNP (America) assisted in coordinating this project.

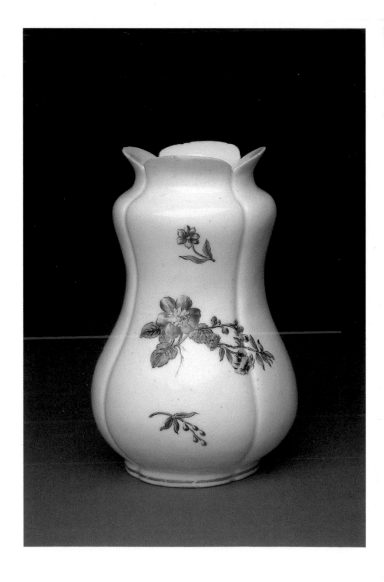

This volume, devoted to the arts of Europe during the period roughly 1600 to 1750, is the sixth publication in a series of twelve volumes that, collectively, represent the scope of the Metropolitan Museum's holdings while selectively presenting the very finest objects from each of its curatorial departments.

This ambitious publication program was conceived as a way of presenting the collections of The Metropolitan Museum of Art to the widest possible audience. More detailed than a museum guide, broader in scope than the Museum's scholarly publications, this series presents paintings, drawings, prints, and photographs; sculpture, furniture, and the decorative arts; costumes, arms, and armor— all integrated in such a way as to offer a unified and coherent view of the periods and cultures represented by the Museum's collections. The objects that have been selected for inclusion in the series constitute a small portion of the Metropolitan's holdings, but they admirably represent the range and excellence of the various curatorial departments. The texts relate each of the objects to the cultural milieu and period from which it derives and incorporate the fruits of recent scholarship. The accompanying photographs, in many instances specially commissioned for this series, offer a splendid and detailed tour of the Museum.

We are particularly grateful to the late Mr. Tetsuhiko Fukutake, who, while president of Fukutake Publishing Company, Ltd., Japan, encouraged and supported this project. His dedication to the publication of this series has contributed greatly to its success.

The collections of the Metropolitan Museum are particularly rich in Baroque and later European art, collections that have grown both through gifts of many generous donors and judicious purchases made possible by the Museum's acquisition funds.

Among the many donors of paintings, we must mention Benjamin Altman, Jules Bache, Michael Friedsam, Mrs. H.O. Havemeyer, Mr. and Mrs. Harold Morton Landon, Robert Lehman, Jack and Belle Linsky, Henry G. Marquand, the Wildenstein Foundation, and Mr. and Mrs. Charles Wrightsman.

The collections of European sculpture and decorative arts owe special gratitude to Jules Bache, Douglas Dillon, Mrs. Jean Mauzé, J. Pierpont Morgan, Josephine Bay Paul and C. Michael Paul, John M. Schiff, Emma A. Sheafer, Lilliana Teruzzi, Irwin Untermyer, R. Thornton Wilson, and Mr. and Mrs. Charles Wrightsman. Crosby Brown and George Gould both contributed significantly to the Museum's magnificent collection of musical instruments.

Important prints of the period have been donated to the Museum by Sarah Lazarus, Robert L. Manning and Bertina Suida Manning, and Felix M. Warburg. Equally important drawings have been given by Walter C. Baker, Ann Payne Blumenthal, Harold K. Hochschild, and Robert Lehman.

Purchases in all these areas have been made possible by funds established by Gwynne M. Andrews, Edith Perry Chapman, Harris Brisbane Dick, Isaac D. Fletcher, Adelaide Milton de Groot, Frederick C. Hewitt, Samuel D. Lee, Joseph Pulitzer, Jacob S. Rogers, and Henry G. Sperling.

In preparing this volume, the editors drew on the expertise of curators in several departments. We are especially grateful to James David Draper for his invaluable assistance in organizing the book, selecting objects from his department, and in writing many commentaries and reviewing many more. His colleagues in the Department of European Sculpture and Decorative Arts—Maureen A. Cassidy-Geiger, Johanna Hecht, Daniella O. Kisluk-Grosheide, Jessie McNab, Clare Vincent, and Alice Zrebiec—all wrote on objects within their special fields of interest. Matthew Armstrong prepared commentaries on paintings and prints. Helen B. Mules and Lawrence Turčić, in the Department of Drawings, were responsible for the commentaries on works from their department. Katharine Baetjer, in the Department of European Paintings, reviewed the layout, and John T. Spike, the author of the introduction, helped immeasurably in researching and ensuring the quality of the text throughout.

Philippe de Montebello
Director

EUROPE IN THE AGE OF MONARCHY

The violent, impassioned, absolutist, and triumphant seventeenth century in Europe was an age of superlatives—and extremes. Above all, it was a time of sustained accomplishment. In most of Europe the seventeenth century is traditionally viewed as a golden age of art: in Spain, France, Holland, and Flanders. Recently, Italian Baroque art has enjoyed renewed appreciation after more than a century of neglect.

As is so often the case, the art-historical designation for this period, the "Age of the Baroque," is a misnomer. The Baroque was but one of the stimulating, if at times perplexing, multiplicity of styles that vied for preeminence during the seventeenth and early eighteenth centuries. The term "Baroque" was itself coined only at a later date by unsympathetic critics who wished to condemn an artistic (and literary) style that they judged eccentric and irreconcilable with the precepts of classicism, the principal rival to Baroque style during the seventeenth century. It is important to bear in mind, however, that while classicism never wanted for apologists or explanatory tracts, there were no contemporary theoreticians of the Baroque—this style was forged in the studios of Peter Paul Rubens, the painter, and Gian Lorenzo Bernini, the sculptor and architect, to name two particularly influential exemplars.

Baroque style occurred in as many brands as there were schools of painting in different countries and cities, and even individual artists painting or sculpting. By its intrinsic nature, Classical style tended to be more codified. Although definitions are especially elusive for seventeenth century art, it is nonetheless reasonable to conclude that Baroque artists were captivated by the ceaseless flux of nature and human existence, while classicizing artists—such as Annibale Carracci, his pupils, and spiritual heirs, especially the Frenchman Nicolas Poussin—sought to express timeless quintessences of beauty and harmony. Classicists invoked ancient Greek and Roman statuary as the matchless paradigms for their forms and poses—they sought, moreover, to represent the emotional equilibrium professed by the Stoic philosophers. In contrast, the Baroque was the largest cannon in the arsenal of Counter-Reformation art, and it was called upon to thunder the transcendental ecstasies and horrendous martyrdoms of Roman Catholic mystics and visionaries. How should one describe spiritual rapture in Stoic terms? As strange as it seems to us today, Classical painters did not shrink from this challenge, but the unfettered emotionalism of the Baroque—Bernini as opposed to Domenichino—seems in retrospect to have been more suited to the religiosity of the time.

The conflict of Baroque versus Classical should not be overstressed; it is unlikely that the protagonists of this adventure would have construed themselves so narrowly. The available evidence suggests that the majority of artists considered themselves the faithful defenders of antique values. The Neapolitan painter Salvator Rosa pored through the Classical texts in search of new themes, seemingly unconcerned as to their pictorial potentialities (see Plate 16). It is a measure of his genius that Rosa was able to translate literary allusions into compelling images as often as he did, yet the root of his success lay in his interpretations of primordial nature, necromancy, and other proto-Romantic conceptions that were typically Baroque, not Classical (see Plate 15). By the same token, Peter Paul Rubens, the earliest full-fledged painter of the Baroque, was profoundly immersed in antiquarianism. In the first rank in every category of seventeenth-century erudition, Rubens was one of the most educated men who ever lived. He consciously set out to revive and to breathe life into the ancient sculptures of the Greeks and Romans; yet, he cautioned in *De Imitatione Statuarum* that the painter must take care not to make "stony" paintings that have the appearance of "marble tinted with different colors." Rubens would doubtless have rejected any label that, like "Baroque," had connotations of the bizarre or extravagant; nevertheless, his dynamic compositions of vital, sensuous, and emotive figures eschew the measured calm of orthodox classicism.

The Baroque was a turning point in art that was reached precisely at the end of the seventeenth century. Its cradle was Rome. During the previous half-century, following the death of Michelangelo in 1564, Rome had been conspicuously bereft of artistic genius, with no resident painters or sculptors comparable to Bronzino and Giambologna in Florence, not to mention the brilliant generations of Titian, Tintoretto, Veronese, Jacopo Bassano, and Alessandro Vittoria in Venice.

By 1600, however, the darkest phase of this eclipse was past, and Rome gave every indication of its readiness to reemerge as the capital of European art. Throughout the period examined in this volume, from roughly 1595 to 1760, Rome was indeed the crossroads of Europe, an academy-without-walls to which artists from every nation came in order to improve and test themselves against the time-honored standards of ancient art as well as the best art of their contemporaries. As such, the Eternal City is the most appropriate venue with which to begin this survey of some of the salient aspects of this period.

Rome was the capital of two realms: the worldwide body of

the Catholic Church and the territories of the Papal States, which encompassed large tracts of central Italy. The Roman popes played pivotal roles in European politics and, especially during the papacy of Urban VIII (1623–44), had no scruples against crossing swords with anyone, regardless of their faith, who ventured to disappoint them in the secular sphere.

Everyone recognized that these were historic times: Pope Clement VIII had decreed that 1600 would be a Holy Year, and more than half a million of the faithful (some sources estimate the number of pilgrims as upwards of a million) made their way to Rome from all over Europe. During that auspicious year, there was evidence all about that Rome was undergoing a complete transformation.

Beginning with the election to the papacy of Sixtus V in 1585, a spirit of renovation had motivated extensive measures to impose some order onto the medieval plan of the Eternal City. Encouraged moreover by the approach of the Jubilee, Clement VIII (1592–1605) inaugurated a campaign of decorations in the most venerable churches, including extensive cycles of frescoes in the nave of S. Maria Maggiore and in the transept of St. John in the Lateran.

The mood of austerity that had followed the self-examinations of the Council of Trent (1545–63) was by now completely dissipated. Throughout the seventeenth century a consistent pattern of patronage emerged: As soon as a new pope was elected, the princes and cardinals of his family (and his allies) promptly set to recreating Rome in their own image, both through the elevation of public monuments (churches, family tombs, fountains, other urban improvements) and in the adornment of their residences. Portraiture played an integral role in both the public and private domains of the great families, and sculpture was the preferred medium. The papal portrait bust as developed by Urban VIII and his court artist Bernini represented a deliberate revival of the Roman emperors' practice of keeping their sculptural presences on prominent display. Rome led the way in an international surge of art collecting.

To an unprecedented degree, every possessor of wealth or social status felt that patronage of the fine arts was his distinctive perogative—almost, in fact, an obligation of his rank. The prototypical cardinal-nephew, Scipione Borghese (Plate 12), sponsored favorite artists such as Bernini and went so far as to bend papal justice to force other collectors to surrender treasures for his private collection (now in the Villa Borghese). By the end of the seventeenth century, the noble palaces of Rome, which were accessible to well-born tourists and to artists and other interested parties, had acquired the furnishings (Plate 22) and something like the ambience of stupendous museums. The contemporary inventories of the great private collections—Barberini, Chigi, Colonna, Doria-Pamphily, Rospigliosi, and others —require hundreds of pages in order to list the thickets of paintings and sculptures that crowded the corridors and chambers of their city palaces.

The Church was the other abiding source of patronage. The new orders and congregations of Roman Catholicism, which had been organized in the course of the Counter-Reformation, naturally required suitable temples of worship. These new edifices were financed through the gifts of individual benefactors and through the sale of private chapels. The Society of Jesus (the Jesuits), the Theatines, and the Oratorians, for example, engaged Bernini, Borromini, Pietro da Cortona, and other leading architects to erect towering churches as memorials to their patron saints. Between 1523 and 1582 no saints were canonized. Between 1610 and 1746, by contrast, fifty-three saints were canonized by the Catholic Church, and these additions to the liturgical calendar more often than not were consecrated in mortar and stone. Concomitantly, the skyline of Rome began to bear permanent witness to the architectural genius of the Baroque.

This outpouring of patronage attracted artists from every corner of Europe with the promise of steady employment and the opportunity to pass some part of their careers in Rome. Thus, by the year 1600, both Caravaggio and Annibale Carracci had been active in Rome for several years and were now constantly occupied with prestigious commissions for altarpieces in churches and for paintings for their private, noble sponsors. In the early 1590s, Michelangelo Merisi da Caravaggio, an unproven beginner, had left his native Lombardy and made his own way to Rome, joining the workshop of Cavaliere d'Arpino in a minor capacity. In contrast, Carracci had been invited in 1594 by Cardinal Odoardo Farnese to come from Bologna in order to undertake major fresco decorations in the Farnese Palace. Annibale arrived and, aided by his brother Agostino, painted one of the most celebrated works of the century on the vault of the grand salon between 1597 and 1599. Annibale finished the Farnese Gallery just in time, so to speak, for the purposes of Peter Paul Rubens, a young painter trained in Antwerp, who immigrated to Italy in 1600 and accepted a post as painter to the court of Vincenzo Gonzaga, duke of Mantua. Rubens made his first visit to Rome in 1601 and returned there frequently during the next seven years. Three artists, none of them native to Rome—Caravaggio, Carracci, and Rubens—formed at the turn of the seventeenth century individual styles of painting that collectively established the parameters of every consequential stylistic development during the following century.

Under the spell of Rome, Annibale Carracci soon discarded his Bolognese sensibility for naturalism and for vibrant sensuousness in favor of his studies of Raphael and the High Renaissance cult of the antique. Annibale's efforts to bring Raphael's style up to date are evident as early as his Camerino in the Farnese Palace and in his *Coronation of the Virgin* (Plate 3) both from around 1595. A whole squadron of major artists were his students or moved in his close circle: Guido Reni (see Plate 14), Domenichino (see Plate 5), Francesco Albani, Giovanni Lanfranco. With the exception of Lanfranco, whose origins in Parma left him exceptionally attuned to the proto-Baroque vitality of Antonio Correggio, the pupils of Annibale Carracci came to be regarded as the keepers of the Classical flame in seventeenth-century painting. The workshop of Francesco Albani proved to be the most influential in this respect: In Rome, Albani trained Andrea Sacchi (see Plate 10), who in his turn passed on the mantle of Carraccesque painting to Carlo Maratti (see Plate 20); in Bologna, Albani trained Carlo Cignani, whose most famous pupil was Marcantonio Franceschini. At the turn of the eighteenth century, through the activity of Maratti, Cignani, and Franceschini, the flame of classicism that Annibale had lit fully one hundred years before was still burning brightly.

The legacy of Caravaggio met rather a different fate. It is only relatively recently that Caravaggio's reputation has been rehabilitated to the point that he is now far more admired than Carracci, a dramatic turnaround from the attitudes of the past three centuries. At the close of the sixteenth century, both Caravaggio and Carracci undertook to reform Italian painting, and their styles had profound consequences for painting throughout Europe. Annibale proposed to recreate the High Renaissance in the seventeenth century, and he succeeded in this remarkably. Caravaggio's approach was undoubtedly more novel: He claimed to despise the past and to have no other method than nature and his eyes. His intentions were unequivo-

cably realistic, and he was condemned for being so. As one instance, the Spanish painter, Vincencio Carducho (actually a transplanted Florentine), published a theoretical tract in 1633 in which he stated that Caravaggio represented "the ruin and the demise of painting." Carducho's rancor was undoubtedly fueled by his resentment over the ascendence in the court of Philip IV of a painter from Seville—Diego Velázquez—whose early works evinced unmistakable affinities with Caravaggesque style. Caravaggio's realism derived from Lombard and Venetian sources, as Roberto Longhi was the first to point out, but no artist before him had refused so resolutely to differentiate between the physiognomies of saints and sinners. Caravaggio's compositions, whether sacred or secular, often seem to be thinly disguised portraits of the artist's friends and models dutifully posing with various props. During the 1590s Caravaggio established his reputation mostly with genre subjects painted for a small circle of patrons, such as his *Musicians* (Plate 1) for Cardinal del Monte. He also gave a crucial impetus to the nascent art of still-life painting, although only one undoubted example from his hand is known, the *Basket of Fruit* in the Ambrosiana, Milan.

In July of 1599 Caravaggio received the commission to paint two lateral paintings, *The Calling of St. Matthew* and *The Martyrdom of St. Matthew*, in the Contarelli Chapel in the church of S. Luigi dei Francesi. Both paintings were in place by September 1600 and revealed the style for which he became best known: interior or nocturnal scenes in which the actors are dramatically lit by a single focused beam of light that descends along a diagonal. The next six years of Caravaggio's life bore the impress of a fatal pattern of intense activity, accomplishment, controversy, and increasingly frequent encounters with the law. Finally in 1606, Caravaggio was compelled to flee Rome when he murdered his opponent in a dispute over a ball game in the Campo Marzio. For the remainder of his life, until his premature death of a fever in 1610 in Port' Ercole, he was a fugitive, traveling from Naples, to Malta, Sicily, and again to Naples.

During the first two decades of the seventeenth century, the influence of Caravaggio's realism was pervasive in the two centers where he had left almost all of his works, Rome and Naples; but it is clear that his innovative style was quickly known throughout Europe. In Rome, the ranks of his followers comprised many foreigners, including the Frenchmen Valentin de Boulogne and Simon Vouet; the Dutchmen Gerard Honthorst, Dirck van Baburen, and Hendrik Ter Brugghen; and the Spaniard Jusepe de Ribera. Caravaggio's Italian followers included his acquaintances Carlo Saraceni, Orazio Gentileschi, and Bartolomeo Manfredi. Among the last artists to take up this style was the much younger Mattia Preti, an autodidact who steeped himself in Caravaggesque style during the 1630s and stood out in later decades for the intensity of his psychological interpretations, as in his *Pilate Washing His Hands* of 1663 (Plate 18).

In contrast to Annibale Carracci, whose influence and reputation were disseminated through the workshops of his students, Caravaggio's distinctive style impressed the first generation of artists working after his death, then rapidly fell out of favor. Caravaggio had never taken pupils; indeed, he had vociferously discouraged imitators while he was alive. For the most part, Caravaggio's followers diluted his realism with other, often decorative, impulses, but he was ultimately responsible for the current of naturalism that lies at the heart of Baroque style and that surfaces, in modified form to be sure, in the works of such different artists as Rubens, Ribera, Velázquez, and Rembrandt.

The first paintings executed in an unequivocally Baroque style came from the precocious brush of the Flemish artist Peter Paul Rubens, who moved between Mantua, Rome, and Genoa during his Italian period (1600–08). Like Annibale Carracci, Rubens wanted nothing so much as to revive Renaissance painting, and he drew upon the same sources that had inspired the Bolognese master twenty years before: Correggio, Barocci, Veronese, Titian, and Raphael. Rubens, however, did not put all of the former aside except for Raphael, as Annibale eventually did. Rubens had, in addition, the extraordinary advantage of knowing the individual solutions at which Carracci and his competitor, Caravaggio, had arrived. He essentially formed his own style by adopting from both of these masters the physical immediacy and emphatic three-dimensionality of their figure styles, and through his accommodation—and this was typically Baroque—of Caravaggio's observations of naturalistic detail with Carracci's unfailing sense of decorum (a term that refers to the conventional distinctions between sacred and secular imagery). To this equation Rubens contributed two variables of crucial importance: namely, his understanding that space expands into infinity, and his genius for expressing these limitless reaches on the two-dimensional surface of a canvas.

For the Oratorian church of St. Philip Neri in Fermo, Rubens painted a nocturnal *Nativity* in 1606–08 that was based on Correggio, yet surpassed even that master for the sweep and fluency with which the diverse figures are arranged in space. During the same period, Rubens also executed for the Oratorians one of the most prestigious commissions then to be had in Rome: He was selected to paint the high altarpiece for the principal church of the order, S. Maria in Vallicella, known as the Chiesa Nuova (see Plate 47). The assignment was a remarkable honor for a foreign painter and further proof, if such is needed, of the degree to which Rubens had assimilated Italian style. Rubens thus left ample evidence of his stylistic breakthrough on public view in Rome when he returned to Antwerp in 1608. It is notable, however, that Rubens's works were isolated within the Roman school for more than ten years, while most of his contemporaries endeavored to understand the rival styles of Caravaggio and Carracci individually.

Baroque style came into its own in Rome during the 1620s under the guidance of two prolific and versatile artists: Giovanni Lanfranco, whom we have mentioned as a pupil of Annibale Carracci, and Pietro da Cortona (see Plate 9), who was influenced by Rubens and by his own studies of Venetian painting. During the brief pontificate of Gregory XV (1621–23), Guercino (see Plate 13), another Baroque painter in the Carraccesque tradition, came to Rome and left influential works. Pietro da Cortona, a Florentine by origin, profited from the Tuscan bias of the Barberini papacy. His fresco ceiling in the Palazzo Barberini (1633–39), *Triumph of Divine Providence*, offers an Italian Baroque analogue to Rubens's grandiose Marie de Medici cycle painted in France a decade before. Both works were never to be surpassed for the volume of their trumpeting rhetoric, and both are similarly redeemed by sheer virtuosity. Pietro da Cortona trained many pupils so that his style was carried forth into the eighteenth century, although toward the end of this period, the works by his followers become hardly distinguishable from those of ostensibly more Classical style by Carlo Maratti's pupils.

As regards seventeenth-century Roman architecture and sculpture, the personality of Bernini towered over each like a colossus. Born in Naples in 1598, the son of a Florentine sculptor, Gian Lorenzo Bernini moved with his father to Rome during the pontificate of Paul V (1605–21). Within a few years, this prodigy had established himself as the most brilliant

presence in contemporary Roman sculpture: In time he was recognized as the most inspired sculptor since Michelangelo. Throughout his long life (excepting only a few years following the controversial Barberini papacy), Bernini held unchallenged sway over Roman art and its patronage by the Vatican. He was also a painter, although few of his canvases—most of which were portraits—have been identified as yet. For large-scale projects in fresco or for altarpieces under his purview, Bernini usually entrusted his designs to the execution of a protégé, G.B. Gaulli, called Baciccio, a painter from Genoa. Bernini organized a workshop on a scale that even Rubens in Antwerp—that other master organizer—would have had to envy. With the aid of his army of pupils and associated sculptors and casters in bronze, Bernini orchestrated the transformation of St. Peter's into the flagship vessel of the Baroque.

Rome, Bologna, and Naples boasted the three most accomplished schools of painting in Italy. The links between Roman and Neapolitan painting were close and numerous; a few have already been noted above. Caravaggio's two sojourns in Naples, however brief, ensured that by 1610 several local painters, most notably Caracciolo, were already working in the most modern style in Italy. About 1616, Ribera arrived from Rome, bringing with him another infusion of Caravaggism. In the mid-1630s, Neapolitan painting was dislodged from its Caravaggesque course when the persuasive influence of such pupils of Carracci as Guido Reni and Lanfranco unexpectedly made itself felt upon the styles of Ribera, Massimo Stanzione, and their pupils. Ribera's *Holy Family* of 1648 (Plate 44) represents the final phase of his development: The figures are arranged with Classical balance yet rendered with every realistic detail imaginable.

The population of Naples was decimated by the plague of 1656, and artists were not immune. Two painters came forth to establish the outline of Neapolitan painting for the next half-century and more. One was a recent arrival on the scene: Mattia Preti, a mature artist who had formed a dramatic and highly original Baroque style, combining elements of Caravaggism and neo-Venetian colorism and composition (see Plate 18). The second was a prodigy and a chameleon talent: Luca Giordano (see Plate 19), who could imitate to perfection the style of his master, Ribera, or of any other painter he chose (he painted more than one forgery). Giordano's chief influence, however, was Pietro da Cortona whose appealing expressions and bright colors Giordano developed into a late Baroque style that made him the fresco decorator of choice at the end of the seventeenth century. Nicknamed *fa presto* ("do it fast"), Luca Giordano was the most prolific artist who ever lived until Pablo Picasso. Giordano's renown led Charles II to summon him in 1692 to Spain, where his frescoes in the Escorial may well be the masterpiece of his career. He worked contentedly for the Spanish crown until 1702.

Giordano's service abroad provides a convenient occasion to transfer the focus of this survey to Spain. The seventeenth century has always been considered the Golden Age of Spanish art, not only for its abundance of first-rank masters, but also out of a sense that the dual character of the Spanish Baroque—its accommodation of ardent mysticism on one hand and iron realism on the other—was peculiarly demonstrative of the Spanish national genius. An unexpected corollary of this understandable pride has been the tendency in art-historical writings to treat the Spanish Baroque in isolation and to underestimate or ignore the crucial importance of non-Spanish influences—especially Flemish and Italian—for the maturation and development of artists so quintessentially Spanish as Ribera, Velázquez, and Murillo.

Indeed, the Spanish Golden Age was ushered in by the arrival of an artistic hybrid, a pupil of Titian who had been born in the Greek colony on Crete. In the late 1570s, Domenicos Theotocopoulos, better known as El Greco, decided to forsake the artistic doldrums of Rome and relocate in Spain. He doubtless hoped to attract the patronage of Philip II, who, he knew, had been Titian's best client. In the event, El Greco never became court painter in Madrid, but he found a receptive and stimulating climate in nearby Toledo, the spiritual capital of Spain. He painted a brooding portrait of Toledo on top of its mountain, which was one of the first pure landscapes in European art (Plate 38). His numerous portraits of the clerics (Plates 39, 40) and intellectuals of Toledo constitute the most sustained achievement in European portraiture at the turn of the seventeenth century. El Greco's portraits are less admirable for the accuracy of their likenesses—which we would not ask anyway from a Byzantine—than for the sense that the artist's gaze has penetrated to the hidden qualities of the man.

El Greco had two pupils of note: his son, Jorge Manuel, and Luis Tristán. The latter was a competent master, who most concerns us in the present context in his capacity as an early, albeit minor, influence on Diego Velázquez, the greatest painter in the history of Spain. A native of Seville, Velázquez was the pupil of a local painter (his future father-in-law), Francisco Pacheco. From the start, however, Velázquez's ambitions were anything but provincial. Pacheco wrote a biography of his son-in-law, which confirms the signs in his early paintings, e.g. the *Water Carrier* (Wellington Museum, London), of Velázquez's intensive study of Caravaggesque paintings. There is plentiful documentation for the existence in Spain of copies after Caravaggio and at least one original canvas. The prime minister Olivares introduced Velázquez and his novel style to the new king, Philip IV, and Velázquez moved to Madrid where he worked in the court for the duration of his career.

In retrospect, it seems incongruous that any Baroque sovereign would have selected the unflattering vision of a Caravaggesque painter for his official portraitist. Throughout the 1620s Velázquez honed his powers at naturalistic description: The turning point in his development as an artist was his encounter with Rubens during the elder master's visit to Spain in 1628. Rubens convinced Velázquez to go to Italy and to keep himself abreast of current artistic developments. Rubens probably deserves the credit for opening Velázquez's eyes to the Spanish royal collections of Venetian Renaissance paintings. After his return from Italy, the colorful palettes of Titian and Veronese appear in Velázquez's art for the first time; his famous *Surrender of Breda* (Madrid, Prado) of 1634 is a case in point.

In the decades remaining to him, Velázquez duly kept himself up to date through two visits to Italy (1629–31 and 1648–51) and through the collecting efforts of the Spanish crown. When Velázquez came to Italy in 1650 for his second visit, he was a master in full command of his art. He decided to put his talents on display, so he made a picture and sent it to a public exhibition at the Pantheon in Rome. It was the portrait of his slave, Juan de Pareja (Plate 43), who strikes a Titianesque pose with all the self-assurance of a Venetian procurator.

Early in the 1630s, Velázquez had achieved his mature portrait style, replacing the severity of his early manner with a warmth, atmosphere, and optical vibrance that still seemed modern to Manet and the Impressionists three centuries later. It is clear that Velázquez was fully aware of the portraits of Anthony van Dyck, Rubens's principal pupil. Although van

Dyck never went to Spain, the constant passage of governors and generals between Flanders and Spain sufficed to ensure that van Dyck's influence was felt as strongly as if he had actually worked there. Velázquez must have admired the fluent brushwork of Titian and van Dyck, and certainly the latter's portraits were instructive to him as he abandoned his adherence to Caravaggio's somber manner; however, a crucial distinction sets Velázquez's portraiture apart and above his Flemish colleague's. As orthodox and as reverent as his regal imagery was (how different he was from Goya in this respect!), Velázquez was never merely a painter of social station; he painted the direct evidence of his eyes and captured images of the utmost psychological intimacy: the inexorable decline of his monarch, overmatched by Louis XIV; or the fragile features of a child-prince who would not survive his infancy.

After the death of Velázquez in 1660, the momentum in Spanish art shifted from Madrid back to Seville and the person of Bartolomé Murillo. This painter's career encompassed an extraordinary succession of styles. His earliest works are intelligent variations on Ribera's naturalism; eventually, however, Murillo fell under the spell of van Dyck's Madonnas, and he became practically a specialist in the subject. Murillo's *Virgin and Child* (Plate 45) is a brilliant translation into Spanish idiom of van Dyck's fluid technique superimposed on a Raphaelesque composition. The late style of Murillo achieves a grace and "vaporous" lightness that signals the advent of the Rococo.

One of the most versatile talents of the Spanish Baroque was Alonso Cano, painter, sculptor, and architect, whose fame is less than it might be since few of his works can be seen outside of Spain. The same holds true for the distinguished sculptures in seventeenth-century Spain, among them, Juan Martinéz Montañés (see Plate 42) and Pedro de Mena. Working mostly in polychromed wood, and mostly on figures of beleaguered Christs or penitential saints, these sculptors advanced both realism and mystic religiosity seemingly to their extremes.

Francisco de Zurbarán had issued from essentially the same Sevillan training as Velázquez. Zurbarán's career began brilliantly with a grave naturalism akin to Velázquez's, but his work declined sadly during the 1640s. He attempted to emulate Murillo and Murillo's assimilation of van Dyck's Flemish grace, but he proved to be temperamentally unsuited to it.

We have already referred several times to Rubens and to van Dyck, the leading Flemish painters of this century. When Europe was divided by the Reformation into Catholic and Protestant regions, the southern Netherlands (modern-day Belgium) remained under Spanish dominion and faithful to the Roman Church. Rubens had returned to Antwerp with all the requisite tools to extol both God and the Spanish monarchy, and it is not surprising that his personality was impressed upon every aspect of art in Flanders. He organized a workshop of unprecedented size, which he used to replicate or execute his designs in every medium, from engravings to tapestries. Rubens and his followers frequently painted figures in the landscape compositions of other artists: The Flemish dynasty of painters that descended from Pieter Breughel the Elder was worthily represented in this generation by Jan "Velvet" Breughel, who specialized in landscapes and still lifes. Breughel had made a successful trip to Italy even before Rubens, and the two masters collaborated more than once on works in Antwerp.

Rubens's extraordinary intelligence and innate tact earned him several diplomatic assignments on behalf of the Spanish crown. Thus, as if he were the self-appointed emissary of the Baroque, Rubens was able to pursue his peripatetic career across the face of Europe. In 1622 King Louis XIII of France commissioned cartoons for a series of Constantine tapestries: Rubens thereupon went to France and soon began work on a cycle of immense canvases (1622–25, Paris, Louvre) devoted to the largely ineffectual life and regency of Marie de Medici. These lavish works, replete with over-life-size tritons and mermaids, represent the pinnacle of Baroque pomp and panoply, not to mention regal ego, and their impact on French painting over the next two hundred years can hardly be overstated.

On a diplomatic mission to Spain in 1628, Rubens recognized the talents of the king's young painter, Velázquez, and established a warm friendship with important consequences. In England in 1629, Rubens painted portraits and was knighted by Charles I: Everywhere he went, no one had ever seen paintings of such vivacity nor such facility in their execution. Rubens returned to England in 1635 to paint the ceiling of the king's Banqueting House. He refused invitations to reside in England but was able to oblige his hosts in a sense with the person of his foremost pupil, Anthony van Dyck. Above all, the English wished their portraits to be painted with suitable elegance, and van Dyck passed the last nine years of his life perfecting a style of official portraiture that has always been emulated but never surpassed (see Plate 52).

Rubens's travels as well as van Dyck's service in foreign lands are but two instances of the unprecedented internationalism of European art in the seventeenth and eighteenth centuries. Italy, and Rome in particular, was a crossroads for artists and collectors. That northern artists made study voyages to Italy was hardly new, of course. Dürer had gone in 1494 to Venice and again ten years later. And Rome had always been a beacon to artists for its monuments and sculptures from antiquity—we can cite the single example of Hendrik Goltzius, the most influential Dutch artist at the turn of the seventeenth century, who made a formative visit to Rome in 1590–91. But the seventeenth century stands apart from any age before or since for the number and distinction of foreign-born painters who elected to reside permanently in Italy and to enter the mainstream of Italian painting.

Of all the expatriates who could be mentioned, two French painters, Nicolas Poussin and Claude Lorrain, rise to the top of the list. Both Poussin (see Plates 101–103) and Claude (see Plates 105, 106) were obligated to remain in Rome, it would seem, by the passion with which they researched their evocations of Classical Arcady. Poussin was a learned painter, and his style became progressively more severe and friezelike. Claude was exclusively a painter of landscapes. His nostalgia for the antique was more sentimental than Poussin's, his memories wrapped in golden haze. He was not overly concerned, either, that his drawing should be academically correct (see Plate 106).

Through the odd circumstance that the two principal painters resisted all entreaties to return home (Poussin finally acquiesced to Cardinal Richelieu's pressure in 1640 but found an excuse to go back to Rome after only eighteen months), a considerable part of seventeenth-century French painting took place out of the country. External influences were critical for French art in this period. Italy was the source for most artists, such as Simon Vouet who brought back to Paris a luxuriant Baroque style, and including even artists like Georges de La Tour (see Plates 98, 99), a brilliant provincial who may never have left home. La Tour evidently knew Caravaggesque paintings by Netherlandish artists. Philippe de Champaigne (see Plate 100) was the most important of the French artists who preferred to look eastward to Flanders for inspiration rather than to the south and Italy.

The seventeenth-century is known in France as the Age of Louis XIV, and indeed a political definition is more appropriate than a cultural one. The Sun King cast the longest shadow in Europe and constantly threatened the stability of his neighboring states. He succeeded, in fact, in humbling Spain, which never again was the power it had been under Philip II, and in promoting disunity in Italy. He hoped that Vienna would fall to the Turks!

As a rule, Louis XIV was more interested in armies than in art, but he recognized the impressiveness of architecture and the regal advantages of conspicuous consumption. He founded the Académie Royale in 1648, the tapestry factory at Gobelins and, among many monuments to himself, raised Versailles, formerly a hunting lodge, into the most magnificent palace in Europe. This king determined that the native style of his regime, and therefore France, would be Classical, and this idea has never left the French consciousness since. Louis XIV was satisfied to entrust the state production of art (for such it was) to J.B. Colbert (see Plate 100), a brilliant administrator, and to Charles Le Brun (see Plate 107), a competent artist likewise talented in organization. For tapestries, carpets, stage designs, and ceiling decorations, Le Brun and his équipe could be called upon for prompt, efficient service. Paintings suitable for connoisseurs were not forthcoming, of course. With the notable exceptions of the portraitists, Largillière and Rigaud (see Plate 119), French painting entered a period of dormancy in the latter half of the French seventeenth century from which it would emerge spectacularly under the encouragement of Louis XV.

In political terms, Protestant Holland was the odd man out in this century of absolutist monarchy. In 1609 the northern Netherlands, under the courageous leadership of the House of Orange, signed a truce with their former Spanish overlords that effectively recognized their independence. The seven Dutch provinces were loosely bound together as the Republic of the United Netherlands. Holland was the largest and most influential province of the new nation: Amsterdam was its commercial center, and The Hague was the residence of the ruling stadholder, but there was little, if any, courtly ostentation.

In Catholic, aristocratic Flanders, all artistic expression had emanated from the capital, Antwerp, where Rubens orchestrated the plastic arts to the greater glory of Church and Crown. In contrast, an exciting profusion of local schools arose in the northern Netherlands, not only in Amsterdam, but in Haarlem, Leyden, Delft, and Utrecht. An extraordinary percentage of the work force consisted of artists, and paintings were traded as avidly as tulips. Dutch paintings satisfied the essential market requisites of being numerous, easily identified (more Dutch paintings are signed than from any other nation), and of consistently fine craftsmanship. And the impetus for all this production came from the upright citizens, the famous burghers of Holland. It is curious that picture making flourished in the context of Calvinist iconoclasm: As the churches were being stripped of their sacred images, the homes, inns, and public edifices of Holland were being filled to bursting with portraits, landscapes, still lifes, scenes of everyday life, and ironically, pictures of church interiors.

Dutch art during the first two-thirds of this century was characterized by a formulation of Baroque style that had no counterpart in Europe: The differences have traditionally and justifiably been credited to the circumstance that the United Netherlands was the only country in which patronage stemmed predominantly from the Protestant middle class. Since the Dutch did not care for their art to be religious or aristocratic,

the result was a Baroque without rhetoric, without euphoria. The basis of Netherlandish art had always been an insistent naturalism—van Eyck, van der Weyden, Pieter Breughel are compelling proof of this—so that Dutch audiences had no difficulty in accepting the Baroque rediscovery of nature and direct observation as a replacement for the contorted extravagances of Goltzius and the northern Mannerists.

Actually Goltzius lived long enough (until 1614) to respond to the first breezes of the new art that drifted northward from Italy. He made portraits that are sober and unflattering, and perhaps more remarkably, a series of woodcut landscapes that are free of Mannerist shorthand devices. It was in large part due to Goltzius's change of heart that his native Haarlem became the leading school of Dutch painting during the early decades of this century.

In fact, it was in Haarlem, not mighty Amsterdam to the east, that the parameters of Dutch Baroque painting were established. Here worked Esaias van de Velde, the pivotal personality in Dutch landscape painting, who was the master of Jan van Goyen, archetypical landscape specialist. Esaias van de Velde also left his mark on the other leading tonalist landscape painter in Haarlem, Salomon van Ruysdael (see Plate 68), whose nephew, Jacob van Ruisdael, was the greatest Dutch landscape painter. Born in Haarlem, Jacob van Ruisdael is usually associated with painting in Amsterdam, where he settled in about 1655. This Ruisdael tapped a proto-Romantic current in Baroque art, and his anthropomorphic trees set in somber copses and bird's-eye views of wheatfields (see Plate 81) seem to be personal emblems of human fragility and transience. When at his best (see Plate 82), Meindert Hobbema, Ruisdael's best follower, is nearly his master's equal in technical facility, although he seems not to have grasped the thematic import of Ruisdael's art.

Frans Hals was born in Antwerp but passed most of his life in Haarlem: He translated Breughelian banquets and parables into the Baroque idiom and invented a portrait style of breathtaking immediacy and flamboyance (see Plates 55, 56). Hals maintained a large workshop, and his pupils included most of the pioneers of the Dutch tradition of low-life and merry company genre subjects: Adriaen Brouwer, Jan Molenaer, Judith Leyster, Adriaen van Ostade, and Phillip Wouwermans.

Pieter Saenredam, the greatest painter of church interiors, a category of painting that for all intents and purposes can be considered uniquely Dutch, was also native to Haarlem. To judge from the popularity of these subjects, it would seem that the Dutch manifested their pride in their churches (which they did not permit themselves to decorate) through collecting paintings of their unadorned architecture. At mid-century Delft took the lead in church interiors with several outstanding practitioners including Hendrick Cornelisz. van Vliet (see Plate 80) and Emanuel de Witte, who was the best of the group.

Utrecht was a stronghold of Catholicism in the northern Netherlands and seems to have sent its sons for final studies to Italy as a matter of course. Only a Dutchman from Utrecht, such as Ter Brugghen, could have painted his *Crucifixion* (Plate 53). Ter Brugghen was one among many Utrecht painters who returned to the north completely taken with Caravaggism. They thus imported a strain of naturalistic painting that was essentially sympathetic to the Dutch. Ter Brugghen's Caravaggesque chiaroscuro is widely held to have influenced Rembrandt, while his strong, clear colors have been seen to have struck a chord in Vermeer. He was therefore a critical and particularly revealing example for a recurrent theme in our survey, the internationalism of the Baroque.

The greatest Dutch painter of the century was Rembrandt, and most critics would feel comfortable in assigning him that distinction, with or without the qualification of "Dutch." Born in Leyden and initially influenced by Pieter Lastman and other minor Italianizing history painters now known as the pre-Rembrandtists, Rembrandt moved to the larger pond of Amsterdam in 1631 when only twenty-five years of age. He had already been sufficiently advanced in Leyden to have trained Gerrit Dou, who won subsequent fame for his exquisitely detailed genre paintings. Rembrandt set himself up in Amsterdam as a specialist in portraits and enjoyed considerable success over the course of the next decade. He was evidently a man of deep religious conviction and undertook the lonely task of forming a Protestant iconography. His accomplishments are too many and too often told to be summed up in this short space. It must be mentioned at least that Rembrandt drew incessantly and with unfailing expressiveness; he takes his place, moreover, with Dürer as one of the most influential printmakers in European history.

The widespread dissemination of prints was critical in establishing Rembrandt's European reputation during his own lifetime. Toward the end of the 1650s, a leading collector in Sicily, Don Antonio Ruffo, acquired several paintings from Rembrandt, for one of which, the Metropolitan Museum's *Aristotle with a Bust of Homer* (Plate 60), he commissioned companion pieces from Mattia Preti and Guercino. The latter master (see Plate 13) responded in a letter to Ruffo that he was pleased to cooperate, since he greatly admired Rembrandt on the basis of his etchings (see Plate 61). Indeed, references to Rembrandt's prints are plentiful in seventeenth- and eighteenth-century Italian art texts: It is evident moreover that Rembrandt and Giovanni Benedetto Castiglione, a Baroque artist in Genoa, were aware of each another's prints and exchanged influences via this medium (see Plate 17).

Rembrandt always had pupils, including many good painters: Philips Koninck was his most gifted follower in landscapes (see Plate 67). Rembrandt himself had been strongly attracted to the visionary landscape style of the idiosyncratic Hercules Segers (see Plate 66). At mid-century, Nicholas Maes came from Dordrecht and began to paint interior genre scenes in Rembrandt's style (see Plate 71). Unfortunately, Maes's career epitomizes the decline of Dutch painting in the latter half of the century: Following a visit to Antwerp in the 1660s, he decided to emulate the decorative grace and showiness of contemporary Flemish portraiture in the French taste.

With Hals and Rembrandt, Johannes Vermeer of Delft completes the great triumvirate of Dutch painting. Vermeer was certainly the brightest light of the third quarter of the century, as much of Dutch painting was dimmed by a veneer of classicism or superficial decorativeness. Fewer than forty paintings by Vermeer are known, and five of these are in The Metropolitan Museum of Art. Most of them subscribe to the simple formula in the Metropolitan's *Young Woman with a Water Jug* (Plate 77): a pretty girl pausing at a window, the corner of a map, an oriental rug on the table. The same motifs can be found in any of a dozen other paintings in seventeenth-century Holland, especially de Hooch and ter Borch (see Plate 72). The difference between Vermeer's interiors and everyone else's is that Vermeer never encumbers his pictures with useless facts. What does this girl contemplate so attentively? Vermeer was a poet in the midst of storytellers and chroniclers.

Before leaving Holland, two major, if diverse, personalities of the latter half of the century should be cited. Aelbert Cuyp (see Plates 73, 74) was a Dordrecht painter who was influenced in his landscapes and harbor scenes by Salomon van Ruysdael before developing his definitive seascapes and pastorals, which have the yellow tint and even the romanticism of Claude Lorrain. The restless and amiable Jan Steen was a specialist in uproarious taverns and bedroom larks (see Plates 75, 76). In Steen's case, it is undoubtedly relevant that he was employed as an innkeeper. He found plenty of fresh material for his good-natured social comedies, which were worthy successors to the Flemish tradition associated with Pieter Bruegel the Elder.

The advent of the eighteenth century did not portend stylistic innovation so much as it witnessed unexpected reversals in the creative and critical fortunes of the major schools of European painting. The Golden Age of Dutch painting hardly lasted through the end of the seventeenth century, as more and more painters devoted themselves to glossy imitations of the *feinmalerei* genre subjects of Gerrit Dou and Frans van Mieris, or they turned to Classical mythologies rendered in slick French taste. Spain never found among its native ranks a worthy successor to Velázquez until Goya appeared in the last quarter of the eighteenth century.

Accompanied by his sons Domenico and Lorenzo, the Venetian Giovanni Battista Tiepolo came to Spain towards the end of his long, distinguished career as the leading exponent of history and mythological painting in the Italian counterpart to Rococo style. Tiepolo had also presided over the triumphant emergence of Venice as the most admired and productive school of painting in Italy. Tiepolo had burst upon the scene about 1720, a prodigy who forged a new style that harked back to the early Baroque (remarkably, Venice in the seventeenth century had suffered from the very lack of a vigorous Baroque movement). Tiepolo garbed his compositions in splendid raiments of Venetian Renaissance color and very quickly won commissions all over Europe for his gorgeous frescoes. Typical of the age, and in contradistinction to the previous century, the ceiling decorations in demand were for secular subjects in private residences, no longer for churches. Tiepolo executed major cycles on canvas or in fresco in palaces in Venice of course (Plate 26), but also abroad: in Udine, Milan (Plate 27), Würzburg (Plate 28), and ultimately, Spain.

Giovanni Battista's son, Giovanni Domenico Tiepolo, returned to Venice in 1772. He was a fine painter in the style that his father had made famous, and for a time he served as director of the Venetian academy. After 1785 Domenico never accepted another major commission. He passed his final years in retirement; paradoxically, the capstone of his career dates from this epoch of the 1790s. Domenico Tiepolo had earlier revealed a streak of personality that was independent from his father's, his joy in Venetian popular culture and in carnival escapades, such as can be seen in his *Dance in the Country* of about 1756 (Plate 37). At the end of his days, Domenico gave free rein to his satirical bent, but exclusively in the medium of drawings. Adopting a theme of his father's (see Plate 29), Domenico drew in pen and brown wash a picaresque life of Punchinello, a buffoon character from the theater of the commedia dell'arte (Plate 36). These drawings are rightly admired as a final flickering of eighteenth-century Rococo culture on the eve of its extinction by the Napoleonic revolution.

Italy in the eighteenth century continued to be the crossroads of Europe; indeed, this was the century of the Grand Tour, when it was recognized that no gentleman's education was complete until he had seen Rome and Venice. Italian painters could not afford to ignore the patronage of the English "milords" who came to furnish their country houses with paint-

ings and sculptures. The princes of central Europe also formed massive collections of Italian art, the remnants of which can still be seen in the galleries of Vienna, Munich, Dresden, and Liechtenstein. Foreign collectors were urgently needed to fill the void left by the precipitous decline of ecclesiastic commissions: By the eighteenth century, the Roman Church had effectively vanished as a primary employer of painters. A whole industry of works made for foreigners came into being, the Venetian *vedute*, or view paintings, by Francesco Guardi (see Plate 35) and Canaletto in Venice being the most famous, but Pompeo Batoni's continuous trade in portraits of British aristocracy amounted to the same thing.

Venetian painting of the eighteenth century kept the Italian school in the forefront of critical opinion; ultimately, however, the momentum of artistic creativity passed to France, although no one except the French was aware of this at the time. The highest honor that a budding French painter could achieve was still the *Grand Prix*, which entitled him to several years' residence and study at the Académie de France in Rome. The number of major French painters of the eighteenth century who did not pursue this course is small, indeed. Two of the exceptions are perhaps instructive: Watteau and Chardin.

Antoine Watteau, the first great painter of the French eighteenth century and arguably its greatest, was born in Valenciennes, a Flemish town that Louis XIV had annexed to France. His background explains his profound admiration for the works of Rubens. When Watteau arrived in Paris about 1702, he found that the Académie was divided into two parties, *Rubénisme* vs. *Poussinisme*, and he found ready sympathy for his rapt studies of Rubens's Marie de Medici cycle in the Palais Luxembourg. From the start, Watteau was recognized as an extraordinarily energetic and incisive draftsman (see Plates 114, 115). A determinative influence on his career was a period of training with Claude Gillot, a gifted painter of subjects derived from the theater. Watteau thereafter dedicated his own art to painting intimate subjects portraying contemporary society and theater and in his shortened life did more than any other artist to inaugurate the light-hearted style of French Rococo painting. In 1717 Watteau submitted his *Embarkation to the Isle of Cythera* (Paris, Louvre) and was admitted into the Académie as a master in a category invented for him, the *fête galante*, which described his special subjects of garden festivities, theatrical companies in the open air, not to mention escapades in the boudoir. Watteau's pupils, Lancret and Pater (see Plate 117), admirably seized upon every bit of *joie de vivre* in his art; they seem not to have understood, however, that his genius lay in the indefinable sense of melancholy that seems to lie in wait beneath the first impressions of his works. Watteau's *Mezzetin* (Plate 116) portrays a commedia dell'arte buffoon who was unlucky in love, yet the effect is not truly comic. For Watteau, this stock character is an Everyman who acts out universal sorrows.

The eighteenth century is often labeled the Age of the Rococo in respect of the brilliance of French art during this period. The term—which comes from the French word *rocaille*, meaning a rock motif of crescent shape—was coined to describe the style of interior decoration that flowered during the reign of Louis XV (1715–74). Following the death of Louis XIV in 1714, the focus of French life returned to Paris from Versailles. The interiors of Parisian townhouses were transformed into undulating grottoes of gilt woodwork, *chinoiseries*, and paintings set into the rounded corners of the rooms (see Plate 118). Paris itself bloomed during these days of laissez-faire government and laissez-faire morality; the blurring of distinctions between walls and ceilings in Rococo style was like a metaphor for the contemporaneous dissolving of traditional standards of behavior. Historians have commented that the personal life of the king might not have been to any degree more libertine than that of his fearsome grandfather, Louis XIV, but that attitudes had become altogether different. The age, the art, and the manners were wholly secular in outlook. Although Louis XV was personally devout, Madame de Pompadour was committedly anticlerical, and this was an age in which royal mistresses dictated state policy.

And artistic policy as well—François Boucher, first painter to the king, profited from his close relationship to Madame de Pompadour. Boucher was the most typical and indeed the most gifted painter and designer of the French Rococo. He eventually rose to be director of the Royal Academy in 1765. No painter had had such far-reaching influence over the creation of a royal iconography and the decorative tastes of an epoch since Charles Le Brun—the difference between them being that Boucher was a creative, vivacious, and charming painter, and a superb draftsman.

In 1724 Boucher won the *Grand Prix* and duly left for Italy in 1727. He returned to France in 1731, and his early works reveal his admiration for contemporary painting in Venice, Ricci and Tiepolo in particular. Within a very few years, however, Boucher developed his definitive style that displays a quintessentially French sensibility for elegant expression, graceful form, and unabashed sensuality.

Toward the end of his lifetime, Boucher's Rococo fantasies fell out of favor with Diderot and other critics as a general preference arose for art that was perceived to be morally uplifting. Tiepolo was being faulted on the same grounds in Spain, and an epoch can truly be said to have come to its end in 1770, the year in which both Boucher and Tiepolo died.

Among the artists championed by the influential Diderot was Jean Baptiste Siméon Chardin, a simple specialist in still lifes. Chardin was a devoted academician, but he passed his entire career without obtaining the traditional recognitions of *prix* or prestigious commissions from the Crown. Chardin's still lifes were undisguisedly derived from the Dutch masters of the previous century, but his results surpassed even these daunting prototypes: His style was less detailed, yet ultimately more natural in effect than that of the Dutch. Chardin's brushstrokes apply the pigment in crumbling layers that evoke palpable atmosphere and vibrations of reflected light. Above all, a composition by Chardin has an aura of suspension and watchfulness, as though his simple arrangements of rabbits, pots, and so on constitute the most important subject matter in the world. And because they may well be his poetic interpretations of the poignant themes of worldly transience and ephemeral pleasure, perhaps they are.

The Venetian and the French schools of painting were the most compelling manifestations of the sensual, pleasure-loving aspect of eighteenth-century culture. This age was split, however, as the seventeenth century had been, between the deep impulse of emotion on one hand—the Rococo—and an admiration for the intellectual attainments of Classical antiquity as well as a widespread respect for the empirical methodology of modern science. The arts in the latter half of the eighteenth century adopted a Neoclassical style, meaning that painters now attempted to revive the pictorial language of antiquity with the accuracy of the new discipline of archaeology. This spirit of open-minded inquiry into all realms of human endeavor has been named the Enlightenment.

John T. Spike

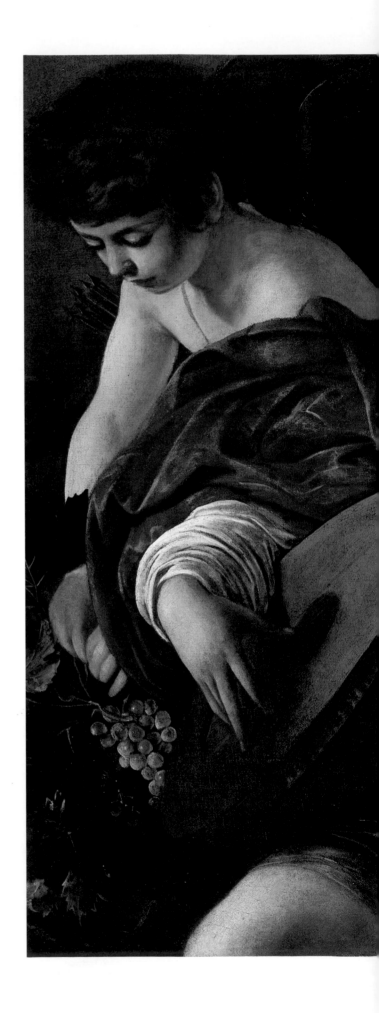

CARAVAGGIO
The Musicians

Born in Lombardy, Caravaggio received his early training in Milan and later in Rome. By 1660, he had attracted the attention of several important patrons and connoisseurs, most notably Cardinal Del Monte for whom this work was painted. Despite the fact that it has suffered from losses of pigment, *The Musicians* is universally accepted as a valuable example of Caravaggio's early style of genre painting.

A casually arranged group of cherubic, rather feminine-looking young men are readying themselves to make music. One holds a lute, another studies a sheet of music. In the foreground lies a violin. Although this painting was described by contemporaries as simply *una musica* (music piece), it is in fact an allegory of music. The figure in the background at left has been identified as Cupid, the god of Love, "who is always in the company of music" (Vasari). The grapes he holds are a bacchic allusion, befitting an allegory of music since "music, like wine, was invented to keep the spirit happy" (Ripa). However one chooses to read the image, the confrontational gaze of the informally grouped, classically dressed boys, the enticing display of food and costume, the sheet music, and the musical instruments all suggest an impromptu invitation to the viewer to partake in the ensuing festivities.

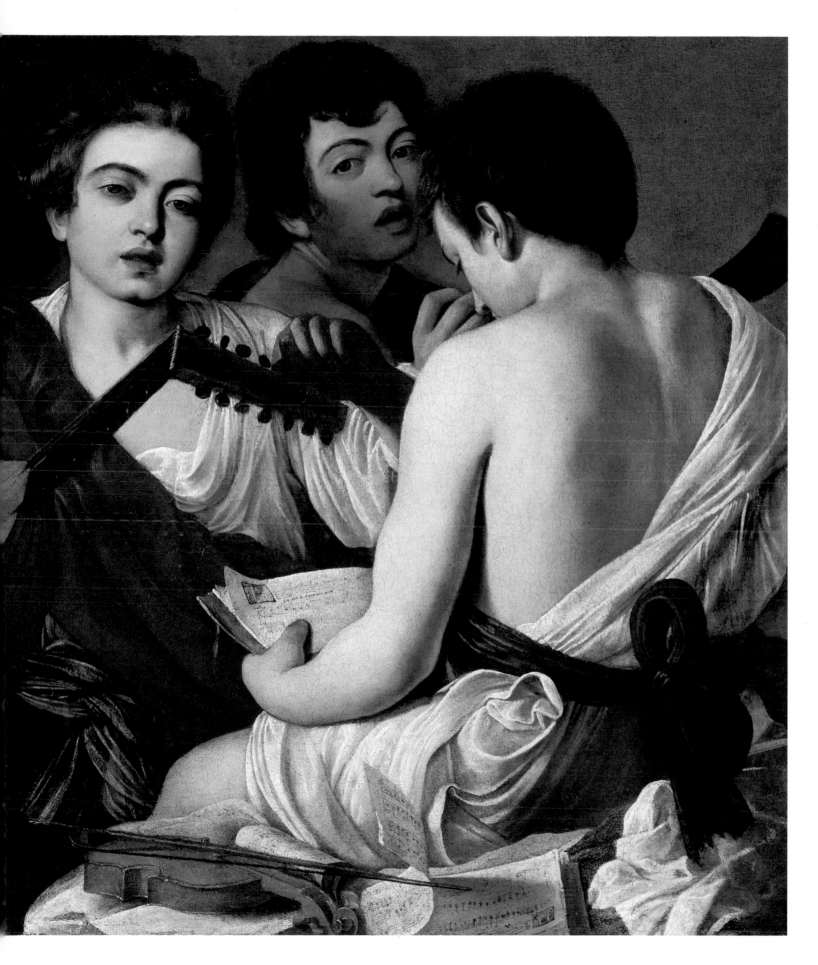

3 *The Coronation of the Virgin*
Annibale Carracci
Italian (Bologna), 1560–1609
Oil on canvas; 46⅜ x 55⅝ in. (117.8 x 141.3 cm.)
Purchase, Bequest of Miss Adelaide Milton de Groot
(1876–1967), by exchange, and Dr. and Mrs. Manuel Porter
and sons Gift, in honor of Mrs. Sarah Porter, 1971 (1971.155)

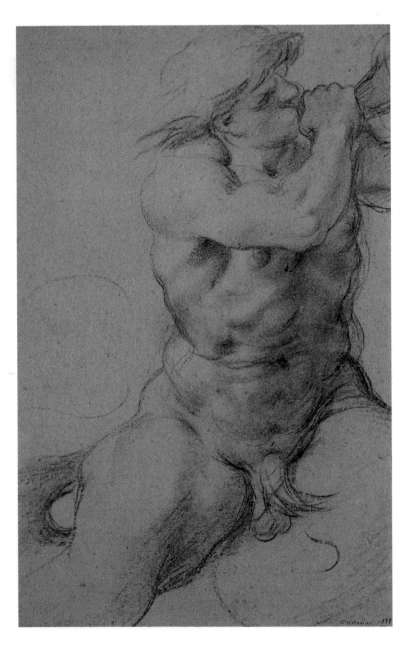

ANNIBALE CARRACCI
Triton Sounding a Conch Shell

The most gifted member of a family of artists from Bologna, Annibale Carracci had a profound impact on the history of seventeenth-century painting. Turning away from the artificiality of the later art of the previous century, Annibale sought to recapture the Classical ideals of the Renaissance and introduced a new naturalism into his work. The revolutionary directness and simplicity of his images flowed in large measure from the practice of drawing from life, an exercise to which great importance was attached at the Carracci academy in Bologna.

The vigorous black-chalk study of a triton blowing a conch shell is related to Annibale's most important commission —the fresco decoration of the gallery in the Palazzo Farnese, Rome, begun in 1597. Although the scene in which the figure appears was actually painted by Agostino Carracci, the drawing provides evidence that Annibale suggested alternate poses for figures in his older brother's composition.

2 *Triton Sounding a Conch Shell*
Annibale Carracci
Italian (Bologna), 1560–1609
Black chalk on blue paper;
15¼ x 9⁹⁄₁₆ in. (38.6 x 24.3 cm.)
Rogers Fund, 1970 (1970.15)

16

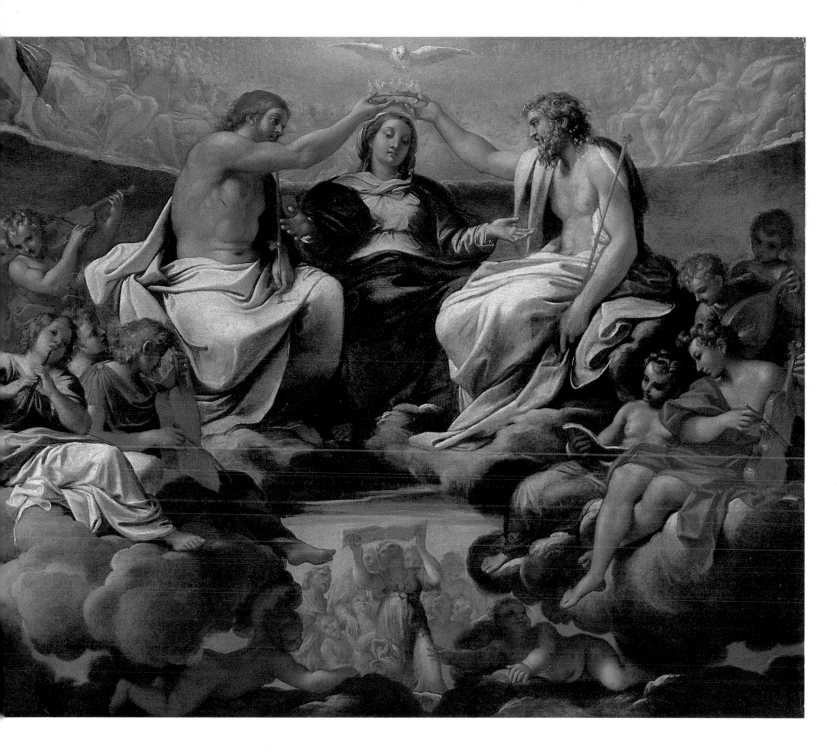

ANNIBALE CARRACCI
The Coronation of the Virgin

Surrounded by a host of angels and supported by heavenly clouds, God the Father and Jesus Christ crown the Virgin Mary as the Queen of Heaven. Above her head is the white dove, symbol of the Holy Spirit. The Virgin's noble expression and outstretched arms convey an elevated spirit of reverence and dignity.

Carracci began this work while still in Bologna, and preparatory drawings for this painting show that it was originally conceived in northern Italian terms, reflecting the style of Correggio and Tintoretto, among others. Upon his arrival in Rome, however, Carracci was immediately impressed by the grandeur of Classical art and the work of Raphael and Michelangelo. This picture was painted for Cardinal

Pietro Aldobrandini, a nephew of Pope Clement VIII, immediately after Carracci's arrival in Rome in 1595. It shows his assimilation of the principles of Roman composition; it is far more compact, more monumental, and more insistently Classical than anything he had previously attempted. Singled out by early sources as one of the most distinguished works in the cardinal's collection, this painting has also been called the most important Italian Baroque painting in America.

Carracci's powerful and idealized figures, his rich use of color and soft modeling, and his new-found sense of Classical monumentality are the antitheses of the naturalism found in Caravaggio's work of the same period.

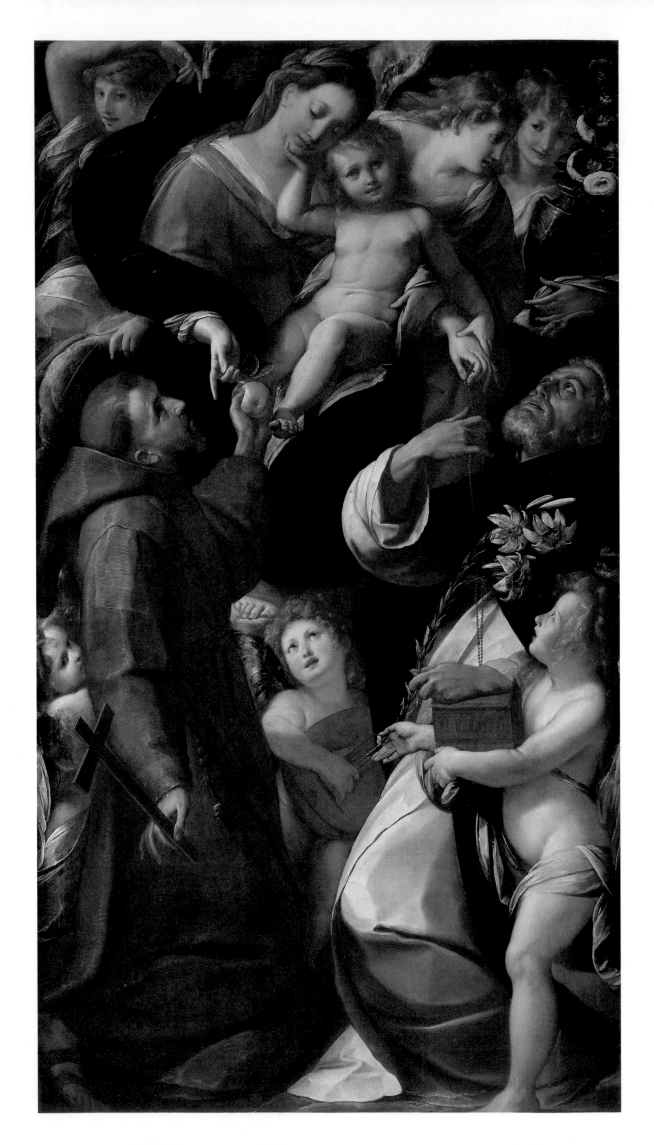

GIULIO CESARE PROCACCINI
Madonna and Child with Saints and Angels

The subject of this painting is the Institution of the Rosary, which was established by Saint Dominic in the thirteenth century. The devotion of the rosary had increased in importance into the sixteenth century and had long historical associations with the victories over the heresies of the Albigensians in the thirteenth century and the victory of Christian forces over the Turks at Lepanto in 1571.

In his left hand, Saint Francis holds an apple, symbolic both of the Fall of Man and the redemption promised through faith in Christ. In his right hand is a crucifix, an allusion to Christ's Passion. St. Dominic receives a rosary from the Virgin and rests his left hand on a model of a church, which is held by a putto. In the background are three angels, one of whom holds a vase, symbolic of the Virgin's purity. The gentle, almost melancholic Virgin is the epitome of feminine gracefulness, just as the Holy Infant embodies innocence. The figures are unexpectedly energetic for such a constrained spatial setting, but equally striking is Procaccini's dynamic use of color: the ruby red of the Virgin's garment, the crystal blue of the putti's wraps, and the vivid contrasts of black and white.

This altarpiece was commissioned in 1612 by Gaspare Spanzotta for the Chapel of Saints Francis and Dominic in the church of the Madonna dei Miracoli in Corbetta. It is one of Procaccini's most important works as well as a masterpiece of Lombard Baroque painting.

4 Madonna and Child with Saints Francis and Dominic, and Angels
Giulio Cesare Procaccini
Italian (Milan), 1574–1625
Oil on canvas; 101⅛ x 56⅜ in. (256.9 x 143.2 cm.)
Purchase, Enid A. Haupt Gift, 1979 (1979.209)

DOMENICHINO
Landscape with Moses and the Burning Bush

Domenichino left Bologna in 1602 to join the Roman workshop of Annibale Carracci, who profoundly influenced his development as a figure and a landscape painter in the Classical style. Domenichino transformed the Roman countryside into an Arcadian backdrop for his biblical narratives. These idealized landscapes exercised a deep influence on the Roman paintings of Claude and Poussin.

This picture, painted about 1616, illustrates a passage from Exodus, wherein God shows Moses three miracles in order that he should lead his people out of Egypt and into the Promised Land. Moses was keeping the flock of his father-in-law when an angel of the Lord appeared to him "in a flame of fire out of the midst of a bush; and he looked, and behold, the bush burned with fire, and the bush was not consumed. Moses stared at the bush and God called out to him, 'Draw not nigh hither; put off thy shoes from thy feet, for the place where thou standest is holy.'"

5 Landscape with Moses and the Burning Bush
Domenico Zampieri (called Domenichino)
Italian (Bologna), 1581–1641
Oil on canvas; 17¾ x 13⅜ in. (45.1 x 34 cm.)
Gift of Mr. and Mrs. Charles Wrightsman,
1976 (1976.155.2)

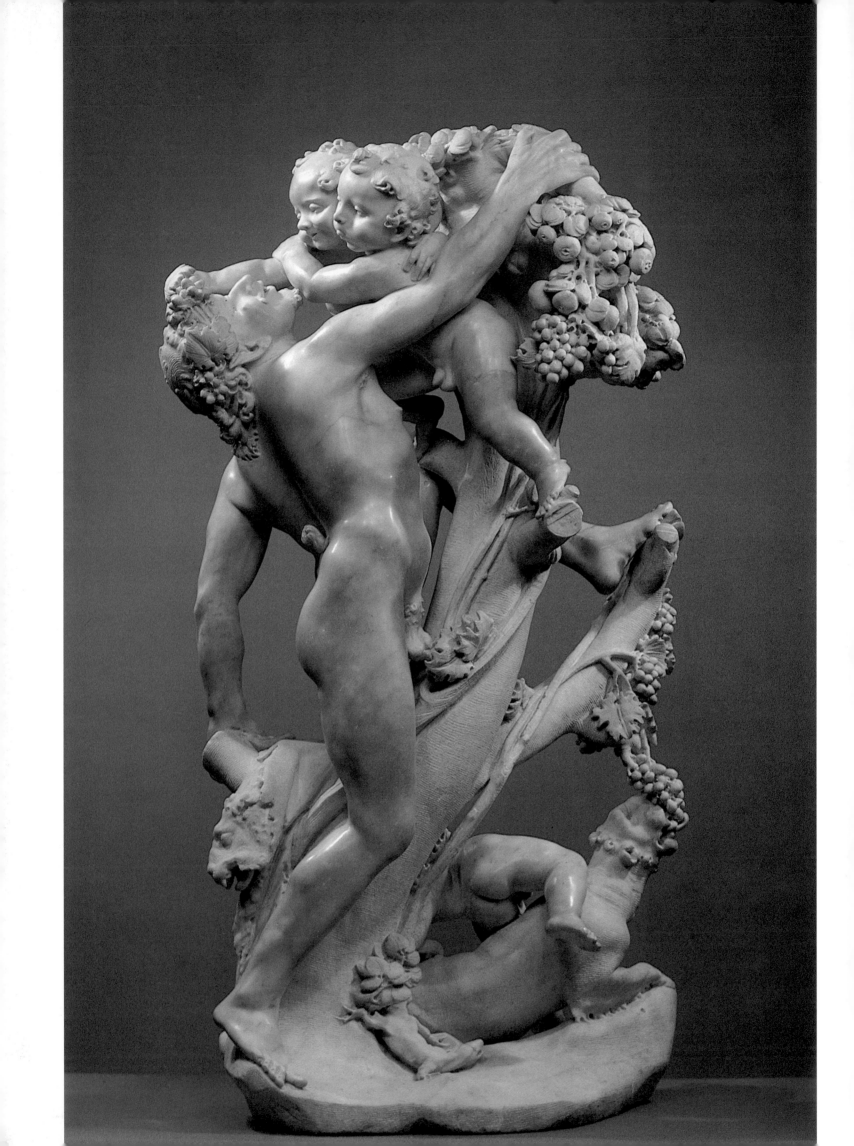

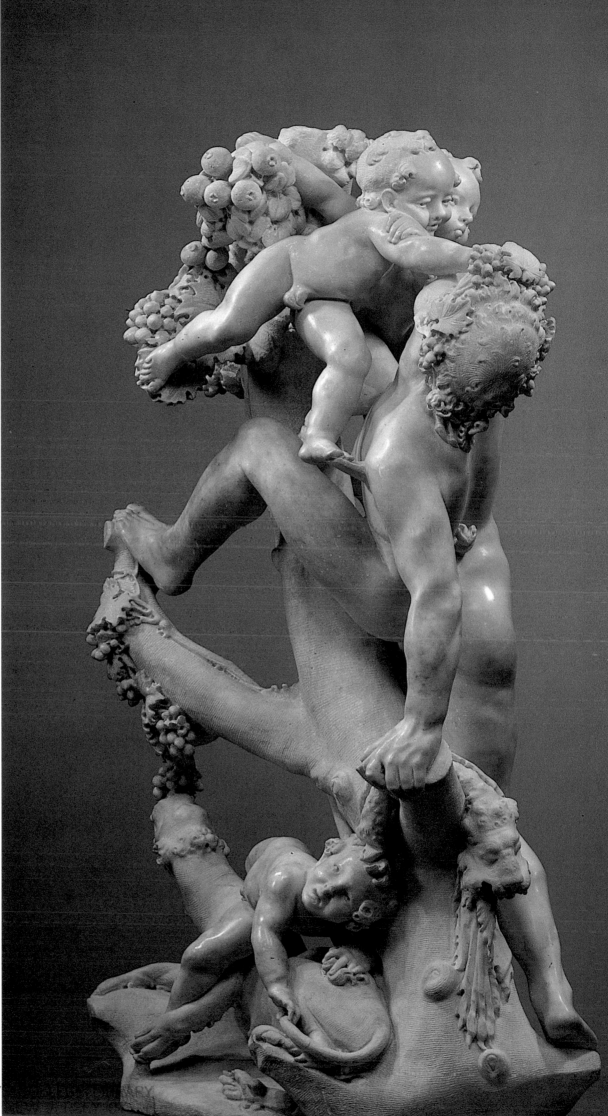

6 Bacchanal:
A Faun Teased by Children, 1616–17
Gian Lorenzo Bernini
Italian (Rome), 1598–1680
Marble; H. 52 in. (132.1 cm.)
Purchase, The Annenberg Fund,
Inc. Gift, Fletcher, Rogers and
Louis V. Bell Funds, and Gift of
J. Pierpont Morgan, by exchange,
1976 (1976.92)

Page 22: text

GIAN LORENZO BERNINI

(Pages 20–21)

Bacchanal: A Faun Teased by Children

The heroic central figure in Italian Baroque sculpture was Gian Lorenzo Bernini. The influence of his father, the Florentine-born sculptor, is manifest in the buoyant forms and cottony textures of the *Bacchanal*. But its liveliness and strongly accented diagonals are the signal contribution of the young Gian Lorenzo, aged only about eighteen. About two-thirds lifesize, *Bacchanal* remains as youthful in spirit as it was in fact. It was made after an intensive study of bacchic subject matter in ancient sculpture, notably sarcophagi.

AFTER GIAN LORENZO BERNINI

Neptune and a Dolphin

One of Bernini's early masterpieces is the marble *Neptune* made in around 1620 for Cardinal Montalto in Rome. It dominated a large oval fishpond at the villa and must have been a striking instance of Bernini's talent for the wedding of sculptural design to a broader theatrical space.

Neptune and a Dolphin presents a variant from the more-than-lifesize marble now in the Victoria and Albert Museum, London, in that the god has a dolphin between his feet rather than a triton. With majestic, furrowed countenance and billowing drapery, Neptune wields his (missing) trident to calm the waves, as in Virgil's *Aeneid* (I:125ff.)

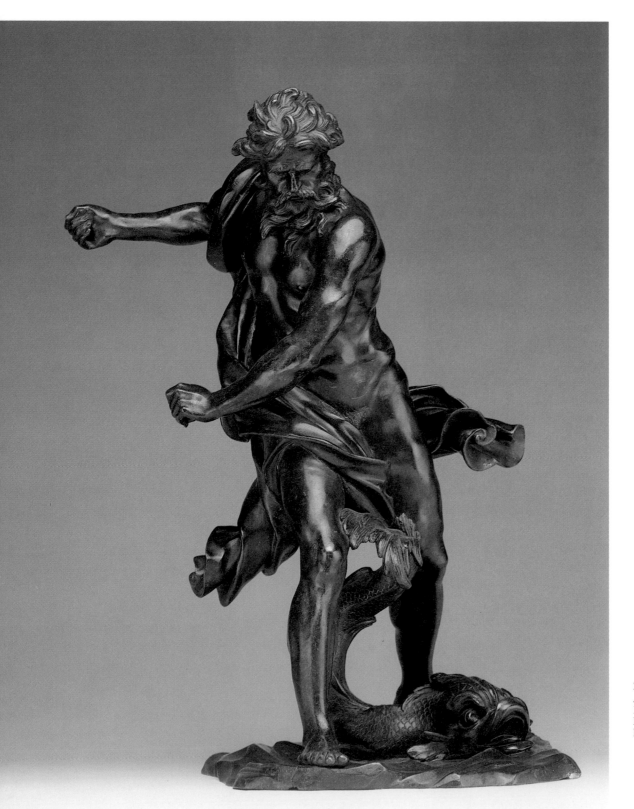

7 *Neptune and a Dolphin*, mid-17th c.
After Gian Lorenzo Bernini
Italian (Rome)
Bronze; H. 20½ in. (52 cm.)
Rogers Fund, 1946 (46.183)

GIAN LORENZO BERNINI
Study for a Triton

The vigorous red-chalk drawing reproduced here is the only surviving study by Bernini for his Triton Fountain, a work of 1642–43 that stands in the Piazza Barberini, Rome. In the fountain, the fish-legged triton blows a conch shell and sits astride a scallop shell supported by four dolphins. This splendid study is one of the finest drawings by Bernini in an American public collection.

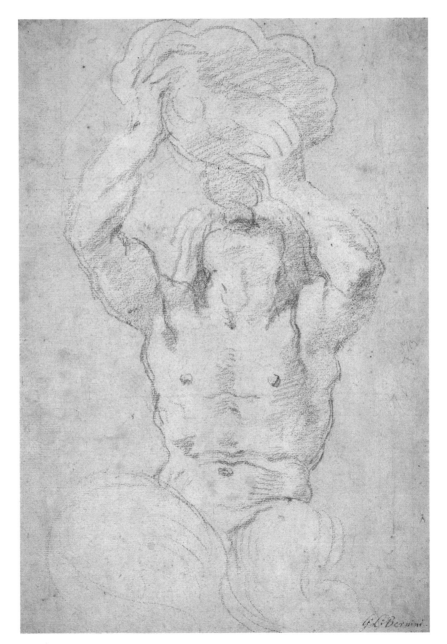

8 *Study for a Triton*
Gian Lorenzo Bernini
Italian (Rome), 1598–1680
Red chalk, background tinted
with very pale brown wash;
14⅜ x 9⅝ in. (36.4 x 24.5 cm.)
Harry G. Sperling Fund, 1973
(1973.265)

10 Marcantonio Pasqualini Crowned by Apollo
Andrea Sacchi
Italian (Rome), 1599–1661
Oil on canvas; 96 x 76½ in. (243.8 x 194.3 cm.)
Purchase, Enid A. Haupt Gift, Gwynne Andrews
Fund and Purchase, 1871, by exchange, 1981
(1981.317)

9 Study of Two Figures for the Age of Gold
Pietro Berrettini (called Pietro da Cortona)
Italian (Rome), 1596–1669
Black chalk; 12⅝ x 9³⁄₁₆ in. (32.1 x 24.9 cm.)
Bequest of Walter C. Baker, 1971 (1972.118.250)

PIETRO DA CORTONA
Study of Two Figures

Pietro Berrettini, known from his Tuscan birthplace as Pietro da Cortona, was, like Bernini, a leading genius of the High Baroque in Rome. A brilliant painter, decorator, and architect, Cortona was also an able administrator, and he supervised a large studio of assistants needed to carry out the vast commissions he received.

The lovely black-chalk drawing reproduced here is a study for the couple seated at the left in the *Age of Gold,* one of four frescoes that Cortona painted between 1637 and 1641 in the Camera della Stufa of the Pitti Palace, Florence, at the request of Ferdinando II, grand duke of Tuscany.

ANDREA SACCHI
Marcantonio Pasqualini Crowned by Apollo

Marcantonio Pasqualini (1614–91) was perhaps the most gifted male soprano (castrato) of his day as well as a composer of considerable fame. He began his career at the age of nine, and in 1630 he joined the Sistine choir under the sponsorship of Cardinal Antonio Barberini. Like Sacchi, Pasqualini became a member of the Barberini household; he was a principal singer in the operas performed in the Barberini palace. He stands before an upright harpsichord wearing the tunic of the Sistine choir. The god Apollo, whose pose is derived from the *Apollo Belvedere,* crowns him with a laurel wreath.

Sacchi inserted his portrait of Pasqualini into a story taken from Classical mythology. Marsyas, the agonized figure bound to the tree, has arrogantly challenged Apollo, the supreme judge of poetry and music, to a contest of musical skill. The winner of the contest could do as he pleased with the loser; when Marsyas was defeated, Apollo chose to have him skinned alive. The presence of the vanquished, terrified Marsyas and the heroically nude figure of Apollo add to the adulatory character of the portrait.

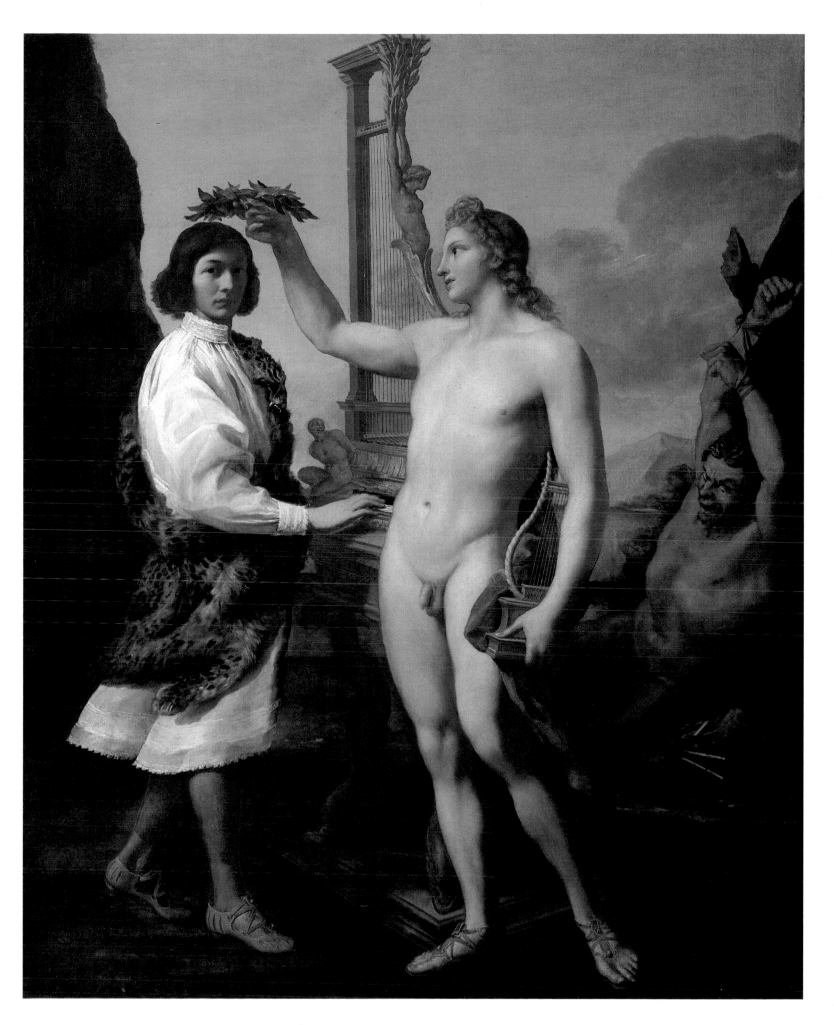

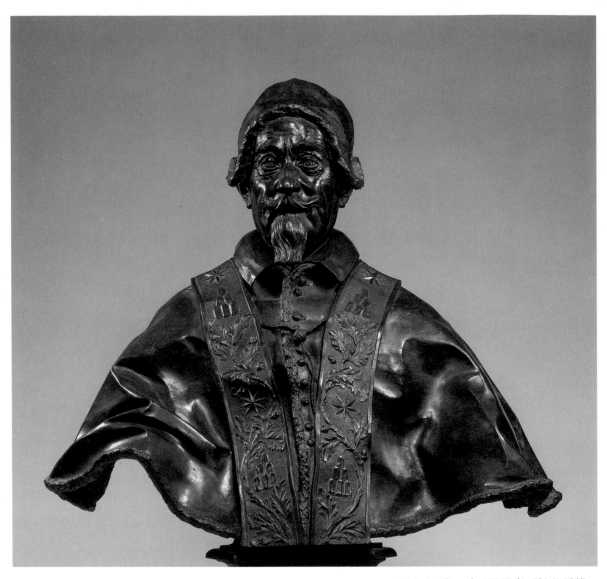

11 Pope Alexander VII [Fabio Chigi], 1667
Melchiorre Cafà
Italian (Rome), 1631–67
Bronze; H. (with base) 39½ in. (100.3 cm.)
Edith Perry Chapman Fund, 1957 (57.20)

TWO ITALIAN PORTRAIT BUSTS

The development of the Baroque portrait bust was one of the major achievements of the seventeenth century, and like many other advances in the art of sculpture, it owed much to Gian Lorenzo Bernini. But while Bernini's vivid likenesses reflected his expansive persona, quite another manner of portraiture was developed by Alessandro Algardi: less bravura, more pensive, contemplative, and Classical.

Although the sober and introspective mood of the bust of Scipione Borghese evokes the style of Algardi, to whom it was formerly attributed, it is in fact the work of Giuliano Finelli. Typical of Finelli's style are the clusters of texture punctuating the marble's broad expanse, the sharply faceted, featherlike tufts of hair and beard, and the bunch of perforated lace at the neck (remnants of which also extend down the front of the chest).

Finelli had assisted Bernini on his work for the cardinal and learned from him many of the techniques used to animate immutable stone. But while Borghese's half-parted lips,

tensed as if about to speak, and the lifelike, if somewhat weary, incline of his neck and shoulders are notes worthy of the master himself, Finelli's emphasis is on stability rather than movement. We feel the ponderous bulk of the sedentary cardinal's chest and the weight of his resting arms.

By comparison, Melchiorre Cafà's spontaneously modeled bust of Alexander VII appears all movement. The shape of the undulating cape, curving up to suggest a raised right arm, spreads out like a pair of wings, echoed by the pliant, upcurled edges of the pope's *berettino*, while its crumpled bronze surface is equally active, bouncing reflected light in all directions. Even the richly textured details contribute to this animation. A naturalistic mask of wrinkles eddies around his eyes, picking up the wave of his beard and the plushly furred lining of his garments; in his stole, embroidered with emblems of his family arms, the eight-pointed star and six-part mountain of the Chigi are entwined by branches of the della Rovere oak.

26

12 Cardinal Scipione Borghese, ca. 1632
Giuliano Finelli
Italian (Rome), 1601/2–1657
Marble; H. (with base) 39 in. (99.1 cm.)
Purchase, Louisa Eldridge McBurney
Gift, 1953 (53.201)

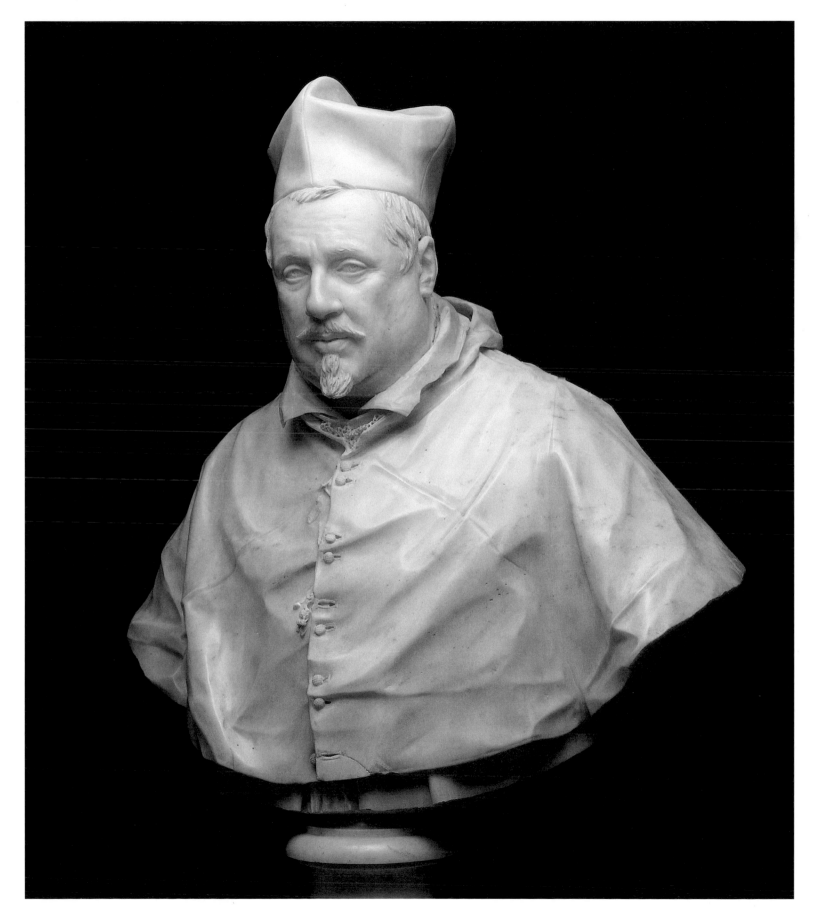

GUERCINO
Youth Kneeling Before a Prelate

Giovanni Francesco Barbieri (nicknamed Il Guercino be-
cause he was cross-eyed) was, like Domenichino and Guido
Reni, one of the most talented and successful Emilian art-
ists active in Italy during the first half of the seventeenth
century. Having established his reputation by the early 1620s
with important commissions in Rome and Bologna, Guercino
lived and worked for the better part of his life in his native
city of Cento. In 1642 he returned to Bologna where he
replaced the recently deceased Guido Reni as that city's lead-
ing artist.

The typical pen-and-ink sketch reproduced here is one
of many surviving studies for Guercino's early masterpiece
St. William of Aquitaine Receiving the Habit, painted in 1620
for the church of S. Gregorio in Bologna.

GUIDO RENI
Charity

Born in 1575 at Calvenzano near Bologna, Guido Reni was
the leading Bolognese painter of his generation, and his
works were paradigms of Classical painting for subsequent
centuries. Although engravings of his pious Madonnas had
a place in every Victorian parlor, Reni's art was highly re-
fined, not simplistic. Reni spent a brief time in Rome, but
unhappy with the competitive art world there, he returned to
Bologna, where he remained until his death.

This picture of about 1630 is an allegory of Charity, which,
in accordance with a tradition made famous by Raphael, is
personified by a woman who nurses three children. Reni's
rendering of delicate and varied flesh tones, soft modeling,
and gentle emotion are evocative of Charity's constituent
aspects: patience, amplitude, forbearance, and kindness.

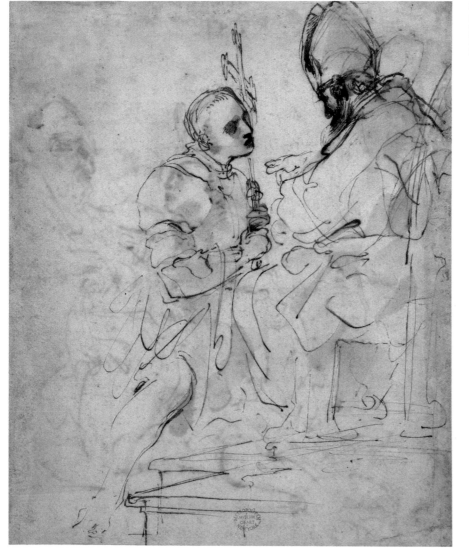

13 Youth Kneeling Before a Prelate
Giovanni Francesco Barbieri (called Guercino)
Italian (Bologna), 1591–1666
Pen and brown ink; 9¼ x 7½ in. (23.5 x 19.1 cm.)
Rogers Fund, 1908 (08.227.29)

14 Charity
Guido Reni
Italian (Bologna), 1575–1642
Oil on canvas; 54 x 41¾ in.(137.2 x 106 cm.)
Gift of Mr. and Mrs. Charles Wrightsman,
1974 (1974.348)

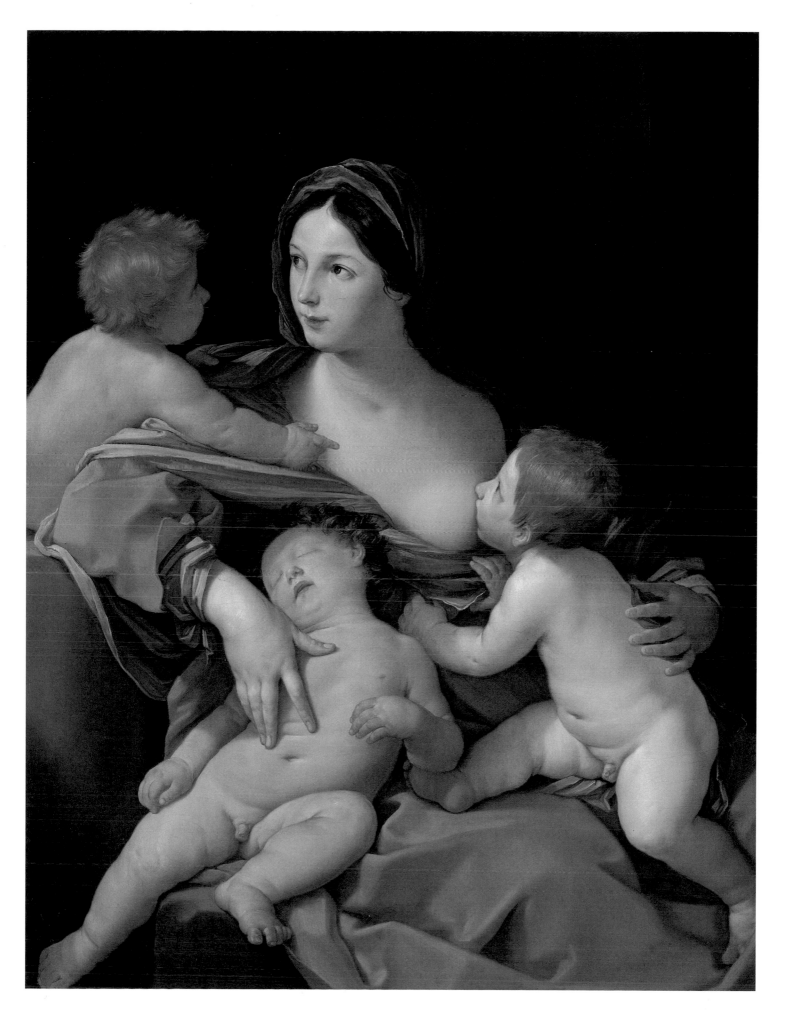

15 Witches' Sabbath
Salvator Rosa
Italian (Naples), 1615–73
Pen and brown ink, brown wash;
10¾ x 7¼ in. (27.2 x 18.4 cm.)
Rogers Fund, 1912 (12.56.13)

16 Self-Portrait
Salvator Rosa
Italian (Naples), 1615–73
Oil on canvas; 39 x 31¼ in. (99.1 x 79.4 cm.)
Bequest of Mary L. Harrison, 1921 (21.105)

SALVATOR ROSA
Self-Portrait

The painter Salvator Rosa is best known today for his dramatic and turbulent landscape scenes, but he was also a distinguished poet, satirist, and printmaker. This brooding portrait exudes the romanticism that made Rosa especially appealing to English collectors in the nineteenth century.

Rosa paints a philosopher beneath a dark sky: He wears a cypress wreath, long regarded as a symbol of mourning, and holds a skull, symbol of mortality, upon which he writes in Greek, "Behold, Whither, When?"

Rosa places this solemn image of intense philosophical reverie within the context of erudition and scholarship: The name of the Latin author Seneca can be discerned on the spine of the book upon which the skull rests, an allusion to the painter's interest in Stoic philosophy. The inscription on the paper behind the skull indicates that Rosa gave the picture to his friend Giovanni Battista Ricciardi, a Florentine poet and philosopher. Scholars question whether the sitter might not be Ricciardi himself, not Rosa.

SALVATOR ROSA
Witches' Sabbath

Born in Naples, Salvator Rosa worked principally in Rome and Florence, where he was much sought after as a painter of landscapes and battle scenes. A rather unconventional personality, Rosa was also the author of verse satires and was fascinated by such bizarre subjects as witchcraft.

The artist was a vigorous and prolific draftsman who seems to have preferred drawing with pen and ink. The *Witches' Sabbath* reproduced here is typical of Rosa's style both in its frenzied pen work and in its choice of subject. The drawing is a study for a painting in the Corsini collection in Florence.

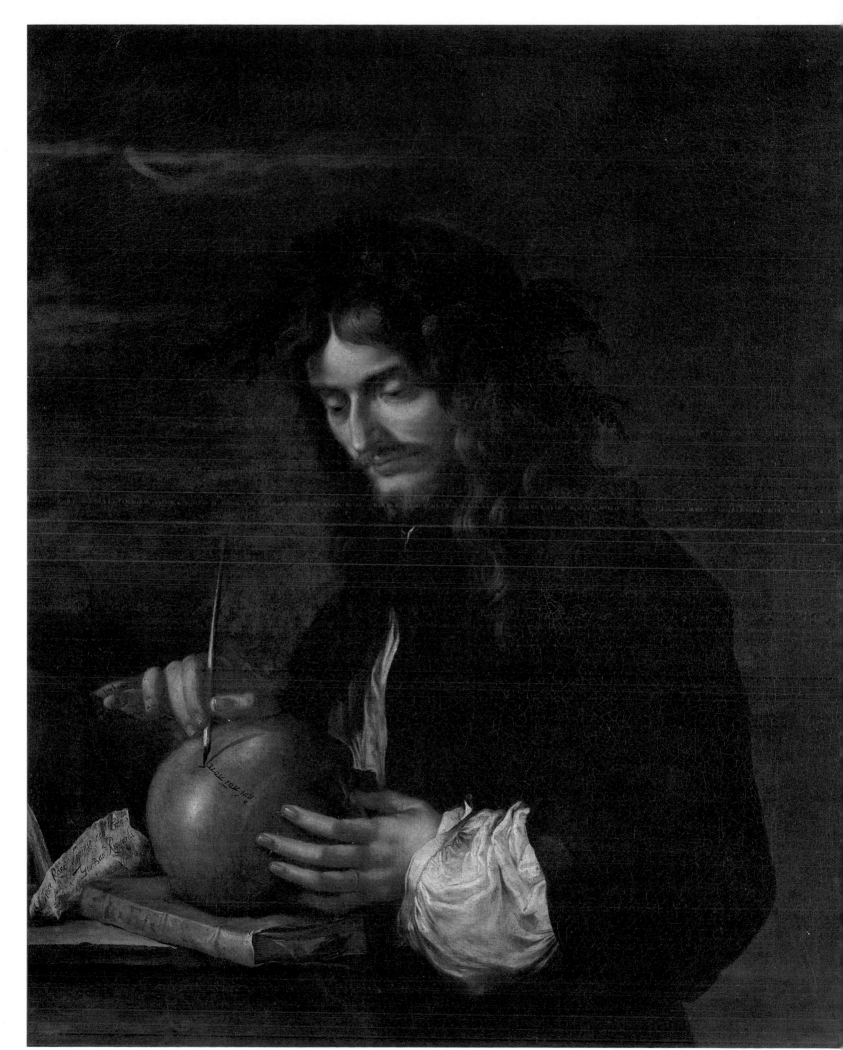

GIOVANNI BENEDETTO CASTIGLIONE
Circe Changing Ulysses's Men into Beasts

This scene is taken from the tenth book of Homer's *Odyssey*. Circe, the beautiful sorceress, enticed Ulysses's men with food and wine, then flew at them with her magic wand and transformed them into wild beasts. An eerie glow seems to emanate from Circe, who sits in a dilapidated Classical setting and presents a rather self-satisfied countenance. Before her are an open book covered with astrological symbols, a pile of discarded armor, and Ulysses's men, who by now have been transformed into an owl, a peacock, a stag, a sheep, and a dog.

Castiglione, the foremost Genoese painter of his age and inventor of the monotype, was one of the great innovators of European printmaking. Combining a knowledge of Rembrandt which was most unusual in Italy, with a predilection for the Classical imagery he had discovered in Rome, Castiglione influenced virtually all Italian printmakers of succeeding generations.

This exceptionally fine print dates from the early 1650s and is a particularly good example of Castiglione's mastery of the medium and his adaptation of Rembrandt's *chiaroscuro* lighting effects. The dense web of lines and the crisp articulation of forms are exceptionally well handled.

MATTIA PRETI
Pilate Washing His Hands

Mattia Preti based this forceful representation of Pontius Pilate on two separate moments in the Gospel according to Saint Matthew: the moment in which "Pilate saw that he was gaining nothing, that a riot was beginning, and so took water and washed his hands before the crowd, saying, 'I am innocent of this man's blood,'" and the moment in which Pilate released the robber Barabbas and, having scourged Jesus, delivered him to be crucified.

The fanciful architecture in the background and the emphasis on the exotic qualities of the Middle Eastern costumes of the old armored soldier and of the young black attendant behind him relieve what would otherwise be a psychological portrait of almost unbearable intensity. The helpless Pilate looks not to the crowd that swells before him, but to the viewer, and Christ, virtually lost in shadow, is led away to his crucifixion.

Preti, who was born in the remote town of Taverna in Calabria, painted this exceptionally fine work in 1663. The unusually direct psychological character of this work reflects his youthful studies of Caravaggio. Though Preti was remarkably prolific, the quality of his work remained consistently high. The present work is one of his finest paintings.

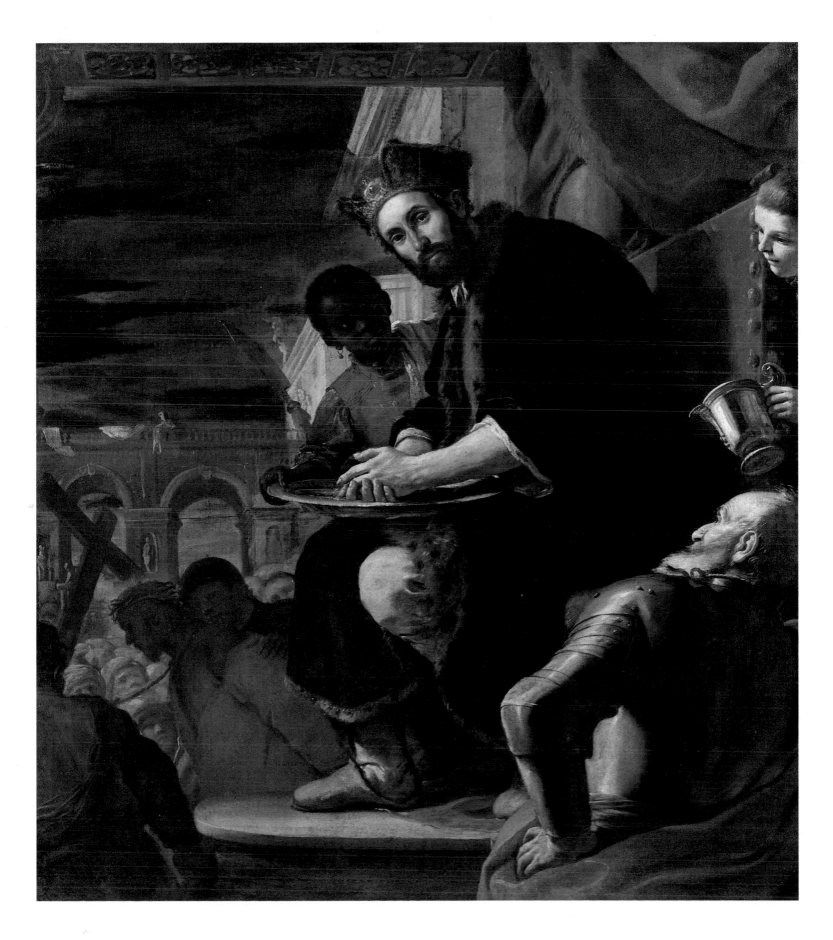

19 The Flight into Egypt
Luca Giordano
Italian (Naples), 1632–1705
Oil on canvas; 24¼ x 19¼ in. (61.6 x 48.9 cm.)
Gift of Mr. and Mrs. Harold Morton Landon,
1961 (61.50)

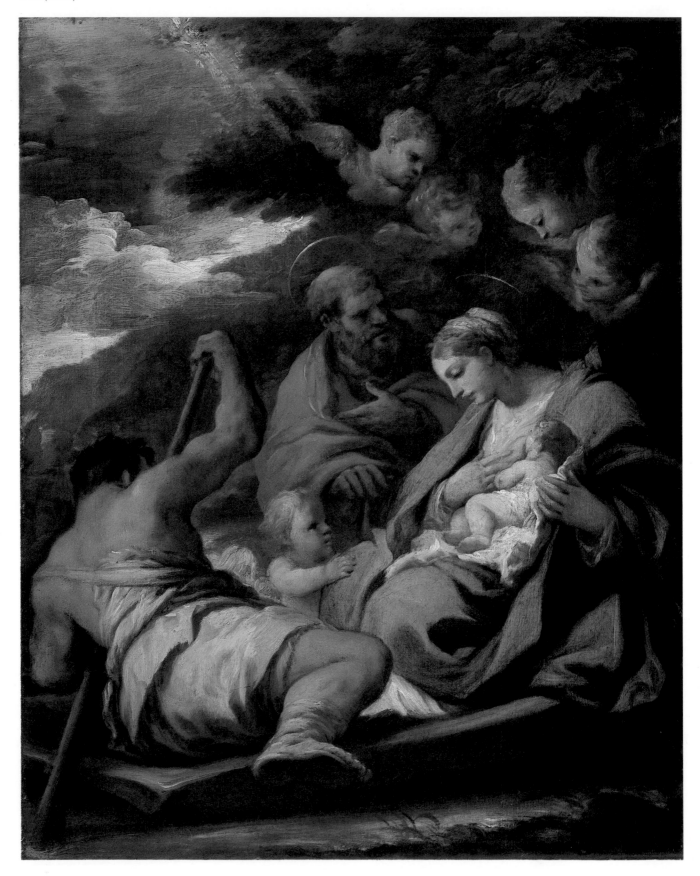

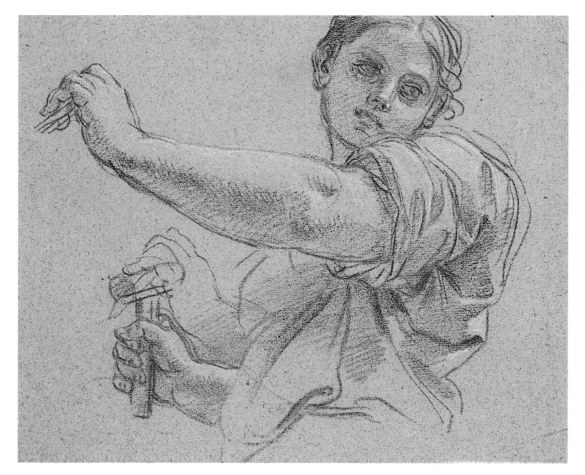

20 *Study for Jael Slaying Sisera*
Carlo Maratti
Italian (Rome), 1625–1713
Red chalk, heightened with white,
on gray-green paper;
8¹³⁄₁₆ x 10¾ in. (22.3 x 27.2 cm.)
Harris Brisbane Dick Fund, 1936
(36.101.2)

LUCA GIORDANO
The Flight into Egypt

Born in Naples, Luca Giordano was first the pupil of Ribera; later, he independently studied the work of Pietro da Cortona. He incorporated ideas about color from his study of Venetian painting. Giordano's precocity and prodigious versatility earned him the nickname *Luca fa presto* (Do it quickly). His enormous production, independent of his work in fresco, numbers more than five thousand canvases.

This scene illustrates the passage from the New Testament in which Saint Joseph rises and takes the Christ Child and the Virgin Mary into Egypt. The highly unusual iconography of this image—the Holy Family crossing a river by boat—is an invention wholly peculiar to the Baroque. It was devised without any Scriptural basis and used primarily for its pastoral charm.

Giordano was primarily active in Naples, though he traveled extensively through Italy until 1692, when he was summoned to Spain as court painter to King Charles II. Charles was succeeded in 1700 by Philip V Bourbon, on whose commission a number of paintings—the present work included—were executed by Giordano for the French court. In 1702 Giordano returned to Naples by way of Genoa, Florence, and Rome. His extensive travels and productivity made him one of the founders of the decorative style known as the Late Baroque.

CARLO MARATTI
Study for Jael Slaying Sisera

A pupil of Andrea Sacchi, Carlo Maratti emerged as the most important and influential painter in Rome during the latter half of the seventeenth century. He remained that city's leading artist until his death in 1713, and his style was continued well into the eighteenth century by a host of followers trained in the Maratti studio.

About 1677, Maratti was commissioned to supply cartoons for mosaic decorations on the vault of the second bay of the left aisle in Saint Peter's, Rome. One of the six half-lunette compositions designed by the artist for this project represents the biblical heroine Jael slaying the Canaanite general Sisera. This red-chalk study by Maratti differs somewhat from his final solution for the pose of Jael. In the cartoon and finished mosaic, Jael holds a hammer in her right hand, as here; but instead of holding up a tent spike with her left hand, she points to the lifeless body of Sisera, whose head she has already pierced with the spike.

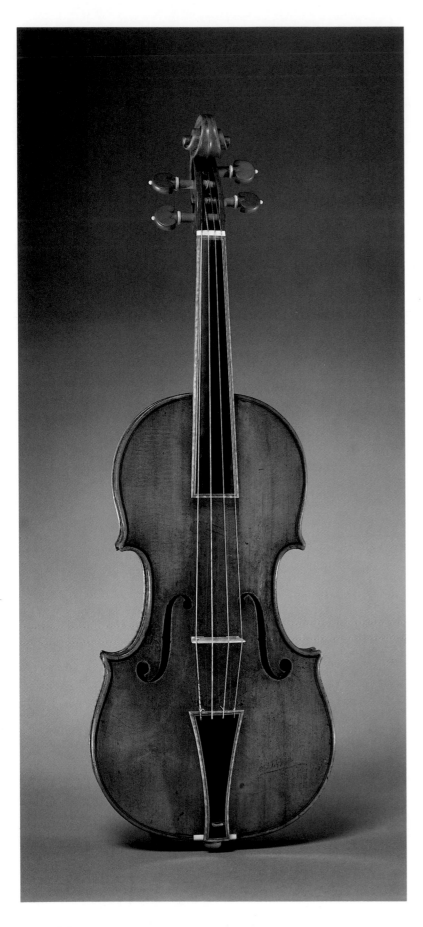

21 *Violin*, 1691
Antonio Stradivari
Italian, 1644–1737
Maple, spruce, various other materials;
L. 23⅜ in. (60.1 cm.)
Gift of George Gould, 1955 (55.86)

ANTONIO STRADIVARI
Violin

During the Baroque era instrumentalists strove for clarity rather than for dynamic nuance. The supreme Italian luthiers valued warmth of tone above all, and their durable masterworks retain this quality after three centuries.

This Stradivari is the finest of all Baroque violins. Made in Cremona in 1691, it is unique in having been restored to its original appearance and tone. All other violins by this great master show later modifications that exaggerated their loudness and brilliance, qualities remote from the maker's intent. This violin is robust but not shrill, its gut strings producing a sound ideal for chamber music.

BOOKCASE ON A STAND

The prominent pair of bookcases to which this one originally belonged was recorded in an inventory of 1722 as standing in the new wing of Palazzo Rospigliosi on Rome's Quirinal Hill. Prince Giovanni Battista Rospigliosi, who acquired the palace in 1687, most likely commissioned the bookcases around 1715. The monumental proportions, undulating contours, and the use of architectural elements suggest that an architect, perhaps Nicola Michetti, who added the wing to the Rospigliosi palace, was responsible for their design. Executed by an unknown master carver, the bookcases, with their broken pediments, elaborate crests, and richly carved stands, are first-rate examples of Italian High Baroque furniture.

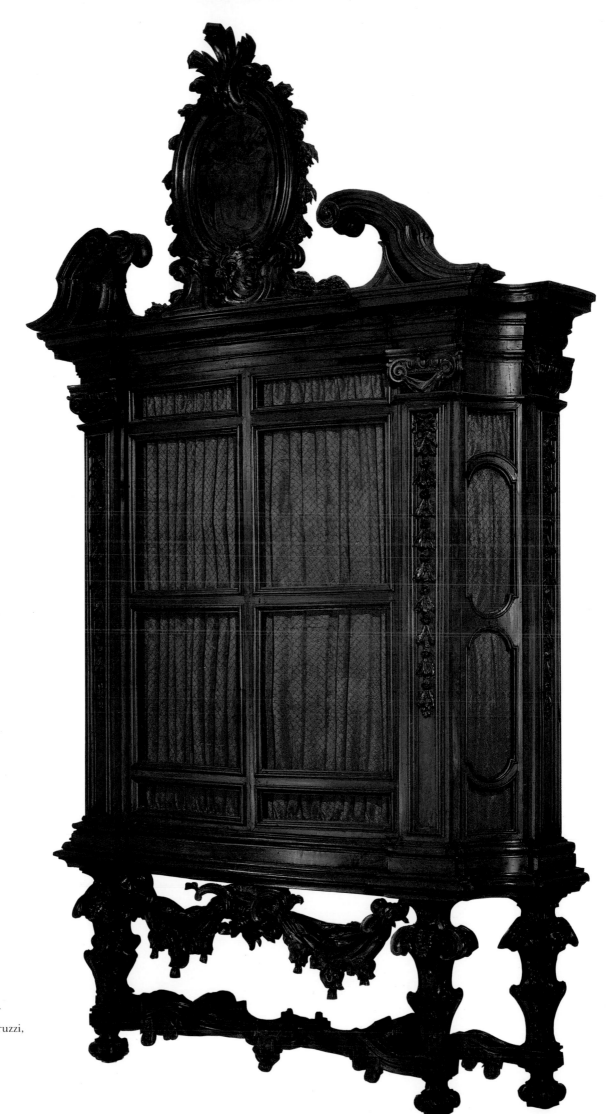

22 Bookcase on a Stand
Italian (Rome), ca. 1715
Walnut and poplar;
13 ft. 3 in. x 2 ft. x 7 ft. 10 in.
(4.04 x .61 x 2.39 m.)
Gift of Madame Lilliana Teruzzi,
1969 (69.292.1,2)

Massimiliano Soldani Benzi
The Sacrifice of Jephthah's Daughter

This scintillating bronze group shows the tragic culmination of an episode from the Book of Judges. The mighty warrior Jephthah had been cast out from the house of Gilead on account of his illegitimate birth, but the kinsmen who once rejected him were then compelled to seek his aid in battling their Ammonite foes. This he agreed to do in exchange for their promise to make him lord over their house once victory was achieved. In his ambition to secure this victory, Jephthah made a vow to God to sacrifice the first creature he saw upon his return from battle. As fate would have it, he was greeted by his only child, and to fulfill his vow he had to sacrifice her.

The story, in its epic grandeur, seems drawn more from the pages of Greek tragedy than from the Bible. Its theatrical qualities are particularly suited to the complex rhetorical style of Late Baroque Florentine sculpture. Soldani's figures act out the drama as if upon a little stage: The tenderly languid interaction between the victim and her companion, their gestures simultaneously signaling despair and acceptance of their roles in the ritual sacrifice, provide a moving counterpoint to the violent energy with which the father executes his vow.

Behind the figures a barren tree springs up from the faceted rockwork base; it reminds the viewer that Jephthah's sacrifice ended not only his daughter's life but also his own hopes for posterity. Decked out with the trophies of his hollow victory, the leafless tree is a visual metaphor for the extinction of his line.

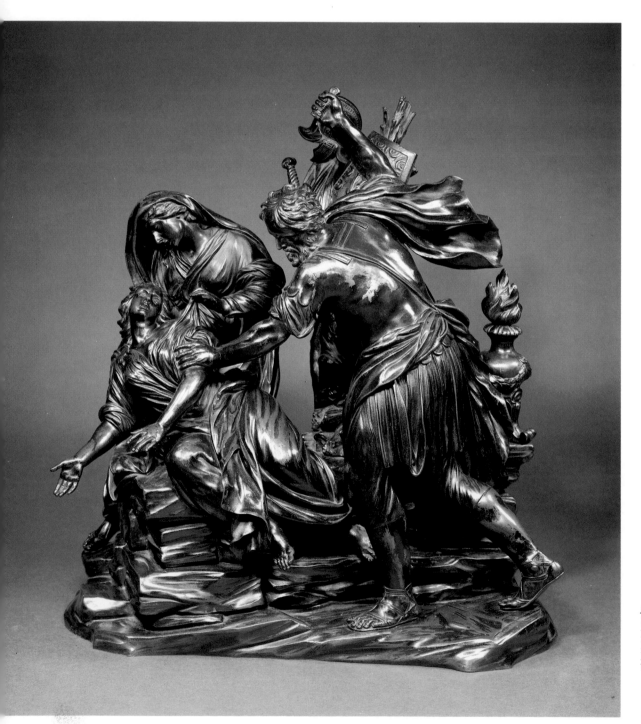

23 The Sacrifice of Jephthah's Daughter,
1722–23
Massimiliano Soldani Benzi
Italian (Florence), 1665–1740
Bronze; H. 18⁵⁄₁₆ in. (46.5 cm.)
Wrightsman Fund, 1985 (1985.238)

BARTOLOMMEO CRISTOFORI
Piano

This, the oldest piano in existence, is one of three that survive from the workshop of Bartolommeo Cristofori, who invented the piano at the Medici court in Florence around 1700. The Museum's example is dated 1720 and remains in playable condition thanks to successive restorations that began in the eighteenth century.

Outwardly plain, this piano is nevertheless a marvel of technology and tone. Its complex mechanism prefigures the modern piano's, but its keyboard is shorter and no pedals exist to provide tonal contrast. Instead, the compass comprises three distinct registers: a warm, rich bass; more assertive middle octaves; and a bright, short-sustaining treble. Intended chiefly for accompanimental use, Cristofori's invention was called *gravicembalo col piano e forte* (harpsichord with soft and loud), referring to its novel dynamic flexibility. Lodovico Giustini exploited its expressive qualities in composing the first published piano music (Florence, 1732), which was inspired by Cristofori's ingenious instruments.

24 Piano, 1720
Bartolommeo Cristofori
Italian, 1655–1731
Wood, various other materials; L. 90 in. (228.6 cm.)
The Crosby Brown Collection of Musical Instruments,
1889 (89.4.1219)

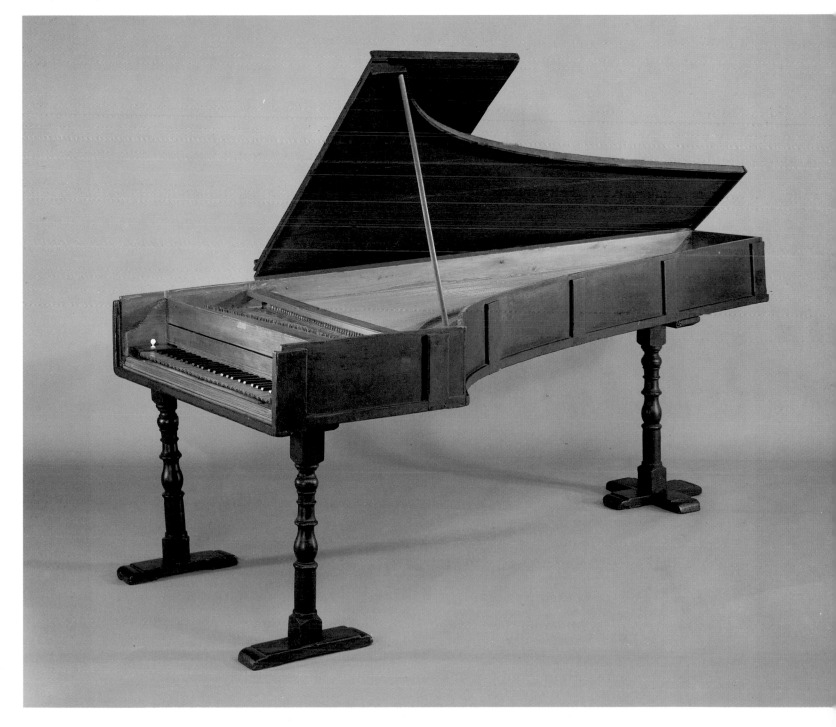

25 *Baptism of Christ*
Sebastiano Ricci
Italian (Venice), 1659–1734
Oil on canvas; 26 x 40 in. (66 x 101.6 cm.)
Purchase, Rogers and Gwynne Andrews
Funds, and Purchase, 1871 and Gift of
Mrs. Jane L. Melville, by exchange, 1981
(1981.186)

SEBASTIANO RICCI

Baptism of Christ

After beginning his training as a painter in Venice and working throughout Italy, Sebastiano Ricci traveled to London in 1712, where he met with an unprecedented popular and financial success. Ricci had amassed such an immense fortune that by the time he left England in 1716, he was forced to pay a special export tax on his earnings.

His most important undertaking during his stay in En-

gland was the chapel frescoes for the duke of Portland at Bulstrode House in Buckinghamshire. This chapel, now destroyed, was described by Vertue in 1733, from which we know that the program originally included an Ascension of Christ, an Annunciation, a Baptism of Christ, and a Last Supper, "the whole a noble, free invention [with] great force of lights and shade, with variety and freedom in the compo-

sition of the parts." The Metropolitan Museum's painting is the most brilliant of three known studies for the Baptism of Christ.

Christ stands in the center of the River Jordan while John the Baptist kneels on a rock to baptize him. They are surrounded by neophytes who anxiously await their own baptism and by angels who move before the light of the opening heavens. The statues that flank the scene have been identified as Meekness (holding a lamb) and Penitence (with a scourge). The inscription across the top is from Luke 3:22: *Hic est fillivs mevs dilectv[s]* (This is my beloved son). The especially lively treatment of the figures and the animated, tumultuous environment are hallmarks of the Venetian Rococo style with which the artist's name is synonymous.

26 *The Triumph of Marius*, 1729
Giovanni Battista Tiepolo
Italian (Venice), 1696–1770
Oil on canvas;
17 ft. 10¾ in. x 10 ft. 7¾ in.
(5.45 x 3.24 m.)
Rogers Fund, 1965 (65.183.1)

Left: detail

GIOVANNI BATTISTA TIEPOLO
The Triumph of Marius

In January, 104 B.C., the heroic Roman general Gaius Marius defeated the North African king Jugurtha, who had been an invincible foe of Rome for several years. Here, Jugurtha, whose hands are bound, stands obstinately before the chariot of the victorious Marius, who holds a general's baton in his right hand and a palm leaf in his left. Behind the chariot walk several soldiers, one blowing a trumpet, while on the wall in the distance is a group of onlookers from the jubilant Roman populace. Spears and standards, one including *SPQR*, the initials of the Roman state, are silhouetted against the sky. On the standard of the victor's

wreath appears the date 1729, the year in which the work was made. A boy with a tambourine leads the crowds who gleefully display the spoils of war: oriental carpets, precious metals, a marble bust, bronze figures, and a bowl overflowing with coins. The heightened use of color, the variegated dynamism of the figures, and the emphasis given to gorgeous detail are all typical of the young Tiepolo, who has also included his own portrait at left, in front of the torchbearer.

Among his most important youthful works, this vast canvas was created as one of ten decorative panels for the *salone* of the Venetian palace of the Dolfin family.

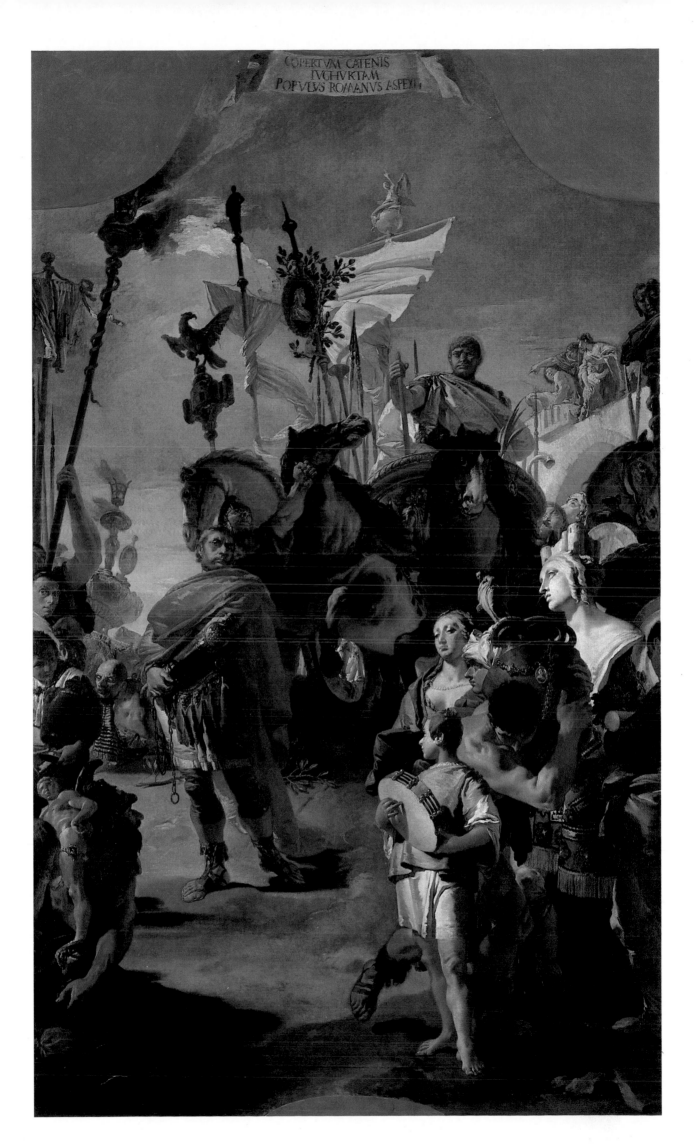

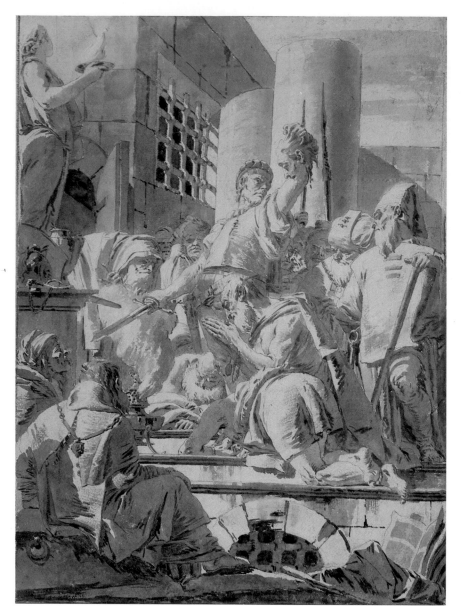

27 *The Beheading of St. Nazarius and St. Celsus in Milan*
Giovanni Battista Tiepolo
Italian (Venice), 1696–1770
Pen and brown ink, brown wash, heightened with
white, over black chalk; 19¹¹⁄₁₆ x 14⁷⁄₁₆ in. (50 x 36.8 cm.)
Rogers Fund, 1937 (37.165.14)

28 *Allegory of the Planets and Continents*
Giovanni Battista Tiepolo
Italian (Venice), 1696–1770
Oil on canvas; 73 x 54⅞ in. (185.4 x 139.4 cm.)
Gift of Mr. and Mrs. Charles Wrightsman,
1977 (1977.1.3)

GIOVANNI BATTISTA TIEPOLO
The Beheading of Saints Nazarius and Celsus

The great Venetian painter Giovanni Battista Tiepolo was
an outstanding presence in the art world for at least half a
century. As the last giant of Italian fresco painting, he pro-
vided a glorious conclusion to the grand-manner tradition
of Raphael and Michelangelo, Titian and Veronese. Tie-
polo's brilliant use of color, virtuoso handling of paint, and
speed of execution won him many important court and
church commissions throughout Europe. One of his most
breathtaking achievements was the fresco decoration in the
Kaisersaal and Grand Staircase of the new Residenz in Würz-
burg, which he executed for the prince-bishop in 1751–53
in close collaboration with his son, Domenico.

Tiepolo was also a prolific draftsman. This large sheet
belongs to a group of early presentation drawings. The mas-
sive heroic figures are seen in steep perspective and ren-
dered in strong contrasts of light and shadow. The drawing
represents two martyrs who were beheaded in Milan dur-
ing the persecution of Christians under Nero.

GIOVANNI BATTISTA TIEPOLO
Allegory of the Planets and Continents

Giovanni Battista Tiepolo was the most famous Italian paint-
er of the eighteenth century. This is one of the sketches he
presented to Carl Philipp von Grieffenklau, prince-bishop
of Würzburg, for the decoration of his palace.

Apollo is shown about to embark on his daily course across
the sky. The deities around Apollo symbolize the planets,
and the figures on the cornice represent the four continents:
Africa, to the right, is represented by a black woman who
wears a turban, leans on a camel, and is attended by figures
in North African costume. At the bottom is Europe, who
sits on a throne with a bull on her right, a Greek temple on
her left; she is surrounded by figures representing science
and art. To the left is Asia, who sits astride an elephant and
is accompanied by turbaned attendants. America is at the
top, personified by a woman in feathered headdress who,
surrounded by wild animals, is seated on an alligator.

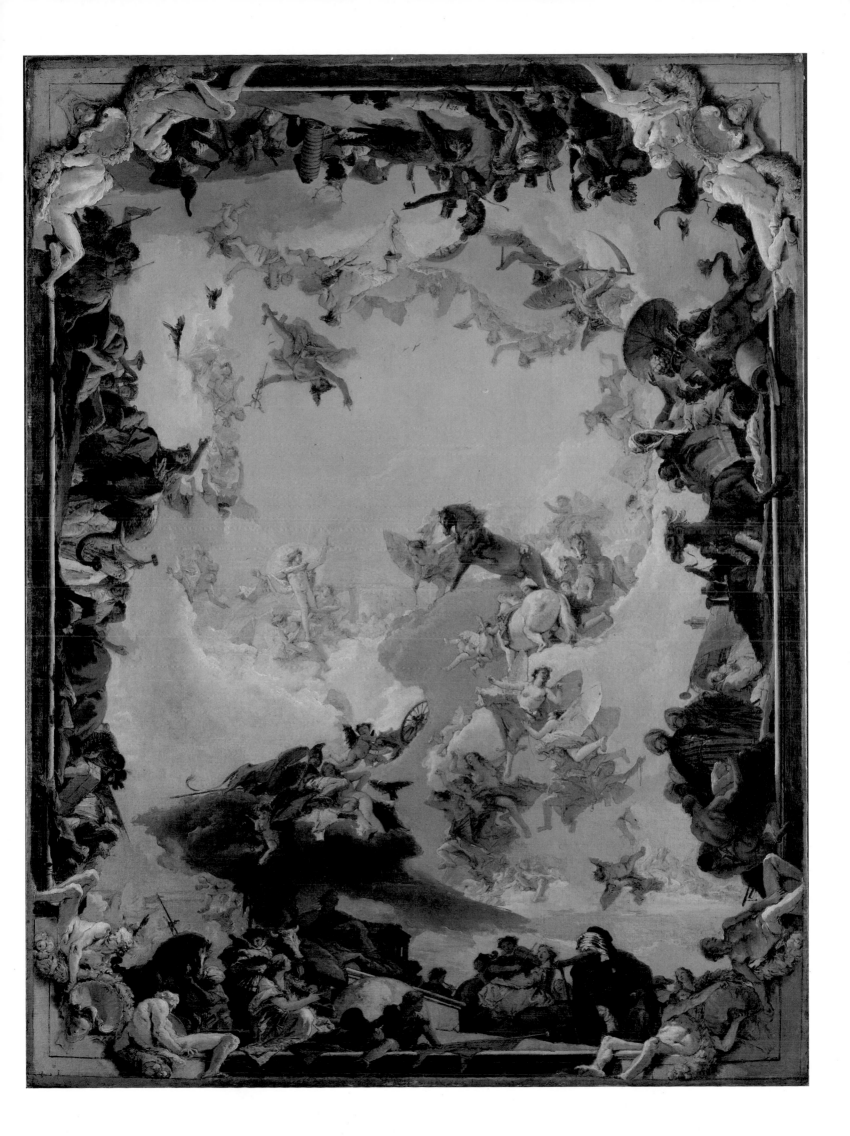

29 Punchinello Talking to Two Magicians (from the series
Scherzi di Fantasia)
Giovanni Battista Tiepolo
Italian (Venice), 1696–1770
Etching; 13⁷⁄₁₆ x 9⁷⁄₃₂ in. (34.1 x 23.4 cm.) Purchase,
The Elisha Whittelsey Collection, The Elisha Whittelsey
Fund, Dodge and Pfeiffer Funds; Joseph Pulitzer
Bequest and Gift of Bertina Suida Manning and Robert L.
Manning, 1976 (1976.537.18)

30 *Reclining River God, Nymph, and Putto*
Giovanni Battista Tiepolo
Italian (Venice), 1696–1770
Pen and brown ink, dark brown and
lighter brown wash, over black chalk;
9¼ x 12⁵⁄₁₆ in. (23.5 x 31.3 cm.)
Rogers Fund, 1937 (37.165.32)

GIOVANNI BATTISTA TIEPOLO
Punchinello

In addition to enjoying remarkable success as a painter, Tiepolo was a prolific printmaker. This print is taken from the series that Tiepolo called *scherzi*, a term usually applied to playful musical compositions made up of several small phrases. The scene takes place amid a clearing of fir trees and the crumbling foundations of a Classical building. Two middle-aged magicians confront Punchinello, who sits down next to a long sword. Behind the two magicians stands a nude young man, in a pose like that of a young Greek god. A hoot owl looks out impassively before a Classical frieze, which depicts soldiers and horsemen, while several of the figures behind Punchinello appear transfixed by this odd and slightly unsettling encounter. The contrast between the youthful beauty of the nude boy and the decrepitude of the aged magicians may be a key to the image's meaning. Tiepolo made his *scherzi* for private collectors, and whatever meaning they may have had is now impossible to discover.

GIOVANNI BATTISTA TIEPOLO
Reclining River God, Nymph, and Putto

This is one of many sketches that survive for Giovanni Battista's important ceiling decoration, *The Course of the Chariot of the Sun*, in the Palazzo Clerici in Milan, painted in 1740. Assembled along the perimeter of the composition is a pageant of allegorical and mythological figures. The river god and nymph rendered in this drawing, atop a luminous cloud and bathed in brilliant sunlight, appear without the putto and the oar on the south cornice. Much of the vast ceiling is given over to sky, creating a sense of dazzling light and infinite space. A feeling of the celestial is conveyed here in this fine drawing through Tiepolo's extraordinary skill as a draftsman. The golden brown color of the wash and his use of the white of the paper to suggest the highlights are characteristic of his drawing technique.

31 *Bedroom from the Palazzo Sagredo*
Italian (Venice), ca. 1718
Wood, stucco, marble, and glass;
H. 13 ft. (3.96 m.)
Rogers Fund, 1906 (06.1335.1a-d)

32 *Mater Dolorosa*, ca. 1744
Giuseppe Gricci
Italian (Capodimonte), 1700–70
Soft-paste porcelain; H. 15½ in. (39.4 cm.)
Gift of Douglas Dillon, 1971 (1971.92.1)

33 *Saint John the Evangelist*, ca. 1744
Giuseppe Gricci
Italian (Capodimonte), 1700–70
Soft-paste porcelain; H. 18 in. (45.7 cm.)
Gift of Douglas Dillon, 1971 (1971.92.2)

BEDROOM FROM THE PALAZZO SAGREDO

In 1694 Zaccaria Sagredo acquired the old Morosini Palace in Venice. Sagredo renovated this building early in the eighteenth century. The walls of this room are covered in eighteenth-century brocatelle. The lavish and illusionary stucco decorations were most likely executed by Carpoforo Mazetti and Abondio Statio, who were responsible for similar stucco work in other rooms of Palazzo Sagredo. Both anteroom and alcove are decorated with beautifully modeled amorini. Some of them bear the gilded frame of the ceiling painting depicting Aurora, the allegorical figure of Dawn triumphant over Night, by Gasparo Diziani. Others, along the architrave, carry floral garlands or are surrounded by heavily fringed and tasseled draperies. Above the entry to the alcove, several amorini lift the cartouche with the cipher of Zaccaria Sagredo. The domed ceiling of the bed-alcove is surmounted by a gilt medallion of a cloud-borne nymph. The bed is raised on the original marquetry dais, and the doors in the recesses, leading to closets, show delicately carved arabesques. This well-preserved Venetian interior manifests one of the most joyful moments in Late Baroque art.

GIUSEPPE GRICCI

Mater Dolorosa and *Saint John*

The *Mater Dolorosa* is the only signed work by Giuseppe Gricci and was produced shortly after the soft-paste factory founded by Charles III was opened at Capodimonte in 1743. Modeled as a free-standing element for a Crucifixion or Deposition group, the Virgin is seated with her head lifted and her hands folded loosely in her lap in prayer. She strains to look once more at the son she mourns, releasing a silent, tearful cry as her eyes behold the tragic vision.

The figure of Saint John the Evangelist in sorrow is similarly datable to the factory's first full year of production and can be attributed to Gricci as well. The young Saint John the Evangelist is conventionally portrayed as beardless, with long, flowing, curly hair and a slender graceful form. He stands absorbed in the tragedy of the event he has witnessed, one hand at his chin in a gesture of contemplation, his confusion and anguish apparent only in the furrowed brow and barely trembling lips. The figures are emotional counterparts: the Virgin, the embodiment of a mother's unconsolable grief, and Saint John, an expression of the more rational or philosophical response to tragedy and loss.

49

34 *The Visit*
Pietro Longhi
Italian (Venice), 1702–85
Oil on canvas; 24 x 19½ in. (61 x 49.5 cm.)
Frederick C. Hewitt Fund, 1914 (14.32.2)

PIETRO LONGHI
The Visit

Pietro Longhi painted the pastimes and amusements of eighteenth-century society in Venice. *The Visit* is one of his characteristic comedies of manners, orchestrated with all the delicacy of a *scherzo*. A pretty lady, attended by a weary-looking priest, has been reading her breviary in her parlor. The lady's gown, the elegant furnishings, and the heirloom portrait by Tintoretto on the wall suffice to set the scene in a patrician household. A host of attentive guests has arrived: Of these suitors, the most adroit is a young man who subtly distracts the company by offering biscuits to the lapdog.

Longhi and William Hogarth were the great satirists in eighteenth-century painting prior to Goya; however, where the Englishman set out after his targets with Calvinist fury, the Venetian Longhi preferred to point out his compatriots' foibles without finding fault with the social system as a whole. The novelty of his conversation pieces was instantly appreciated, and Longhi's pictures soon adorned the parlors of the same aristocrats at whom he was gently poking fun.

FRANCESCO GUARDI
Figure Studies

Francesco Guardi began as a figure painter long before he devoted himself almost exclusively to view painting. His interest shifted soon after the celebrated view painter Canaletto left Venice for England in 1746 for a ten-year sojourn.

This signed sheet of studies is a typical example of Guardi's rapid figure notations. The couple in the lower right foreground appear in several view paintings and in two drawings, including another sheet in the Metropolitan Museum. The lady's extravagantly plumed headdress—fashionable in the 1780s—date the drawing to Guardi's last years. The figures lack substance and seem to dance in the shimmering play of light, like reflections in a lagoon. Guardi called his figure studies *macchiette*, meaning "specks," and he used them in his scenes—both real and imaginary—primarily to further animate the composition.

35 Figure Studies
Francesco Guardi
Italian (Venice), 1712–93
Pen and brown ink, brown wash, on blue paper; faint black chalk sketch of a figure at lower left; 6⅜ x 8⅝ in. (16.2 x 11.8 cm.)
Gift of Harold K. Hochschild, 1940 (40.91.3)

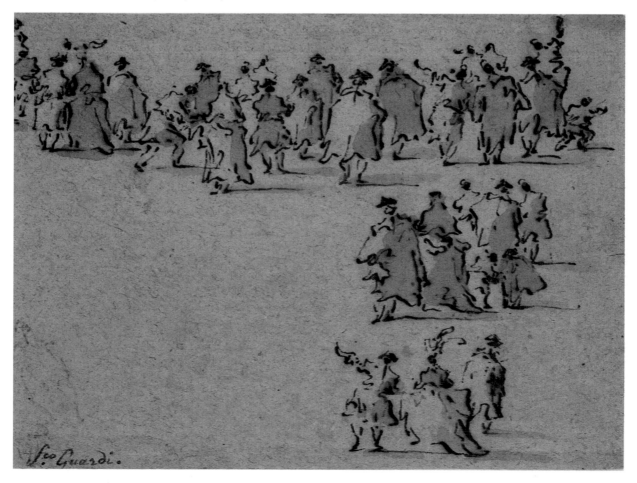

GIOVANNI DOMENICO TIEPOLO
Punchinello as Dressmaker

Domenico was the eldest surviving son and principal assistant to Giovanni Battista Tiepolo. His work is often judged solely on the merits of his father, who was the more gifted of the two. Domenico's true artistic personality emerged in his later years when the demand for works in the style of his father subsided with the emergence of classicism. Domenico's contribution to eighteenth-century Venetian art as a painter and as a draftsman is in the subject of genre and contemporary life in Venice. An aspect of this interest is present in the delightful drawing shown here—one of nine acquired by the New York collector Robert Lehman—from the celebrated Punchinello series.

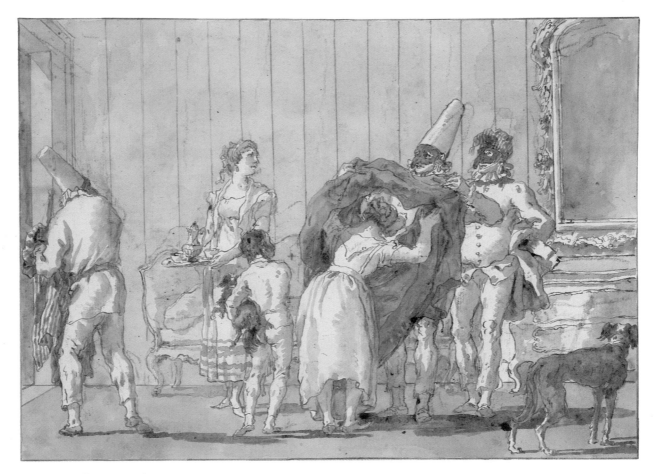

36 *Punchinello as Dressmaker*
Giovanni Domenico Tiepolo
Italian (Venice), 1727–1804
Pen and brown ink, brown wash, over
black chalk; 13⅞ x 18⁷⁄₁₆ in. (35.2 x 46.8 cm.)
Robert Lehman Collection, 1975 (1975.1.466)

Punchinello, a comical commedia dell'arte character of the seventeenth and eighteenth centuries, was popular in the Tiepolo household. In 1793, Domenico decorated the walls of a room in the family villa at Zianigo—to which he retired —with frescoes devoted to Punchinello. There, a few years later, he returned to the same theme in a cycle of 104 finished pen-and-ink drawings entitled *Divertimento per li Regazzi* (Entertainment for the Children). The story, for which no literary source is known, takes Punchinello from his birth to his death, through daily activities and adventures—both good and bad. Punchinello is shown trying his hand at various trades and occupations, such as carpenter, peddler, tavern keeper, barber, schoolmaster, portrait painter, and, in this drawing, inscribed "no. 12," dressmaker.

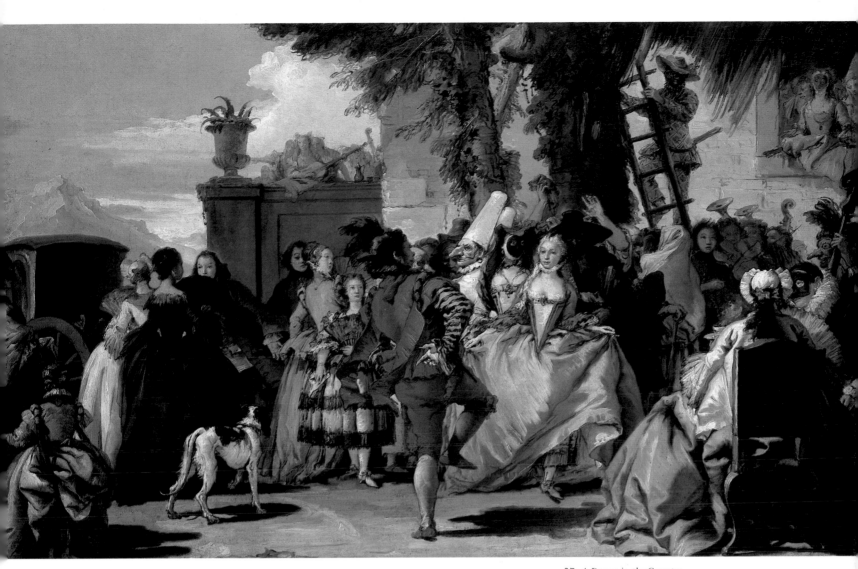

37 *A Dance in the Country*
Giovanni Domenico Tiepolo
Italian (Venice), 1727–1804
Oil on canvas; 29¾ x 47¼ in. (75.6 x 120 cm.)
Gift of Mr. and Mrs. Charles Wrightsman,
1980 (1980.67)

GIOVANNI DOMENICO TIEPOLO

A Dance in the Country

Although Giovanni Domenico Tiepolo assisted his father, Giovanni Battista, in such major decorative enterprises as the frescoes at the Residenz at Würzburg and the Royal Palace in Madrid, he revealed his most individual talent in his informal depictions of contemporary life.

In the eighteenth century, *villegiatura*—extended weekends—were taken by the merchant classes into the surrounding countryside for clean air and new impressions. These city dwellers enjoyed the spontaneous entertainment provided by wandering performers of the commedia dell'arte. In this splendid and joyful canvas, Domenico has created a robust and earthy celebration of free-wheeling activity, successfully capturing the ambience and exuberance of the troupe's special brand of street theater. In the center of the canvas, Mezzetino, here in his guise as arrogant rake, dances with the darling of the troupe, the character known as the Inamorata. Set into the haphazardly arranged group of Venetian tourists are other members of the motley troupe: Punchinello, the cruel and misshapen womanizer; Pantalone, the miserly husband who will inevitably be cuckolded; the lovably boyish Arlecchino, who hoists himself up on a ladder; and in the lower right-hand corner, Il Dottore, the epitome of pompous pedantry.

The genius of Domenico's father resided in his ability to create powerful allegories based on the heroics of legendary figures from ancient history or mythology. Domenico's best paintings are far more down-to-earth. They celebrate the simple pleasures of the common man.

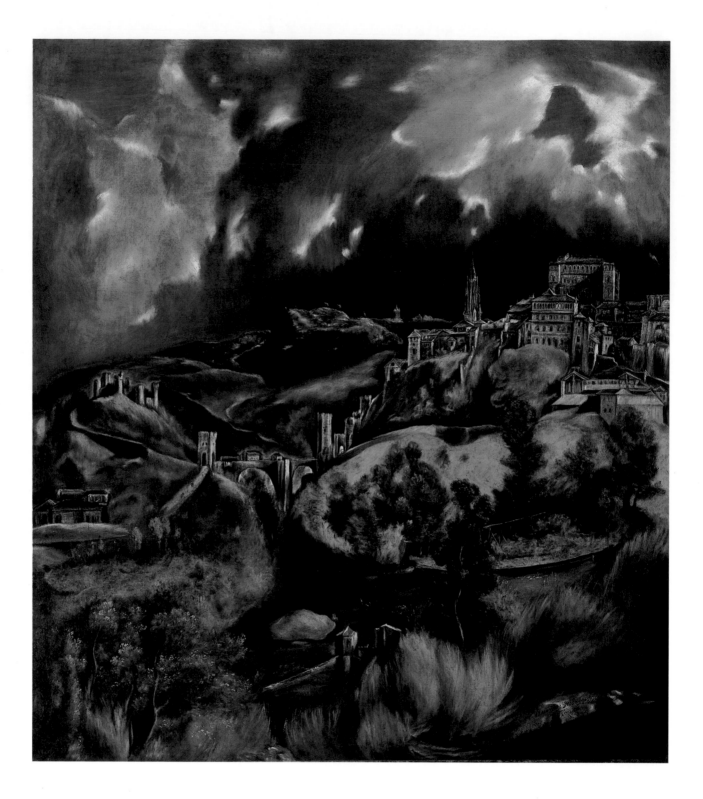

EL GRECO
View of Toledo

El Greco was born Domenicos Theotocopoulos in Crete and received much of his early artistic training in Venice, possibly in the workshop of Titian. In 1577, after a brief stay in Rome, he settled in Spain, where he spent the rest of his life.

This painting of about 1597 is El Greco's highly personal and emblematic vision of the city of Toledo, which had long been the center of Spain's artistic, intellectual, and religious life. The empassioned fury of the storm clouds suggests the mysticism that had long been part of Toledo's religious and spiritual history. In this portrait of his adopted home, which is one of the earliest pure landscapes in European painting, El Greco has liberally rearranged the actual skyline of the city, giving greater weight to pictorial psychology than to simple topography.

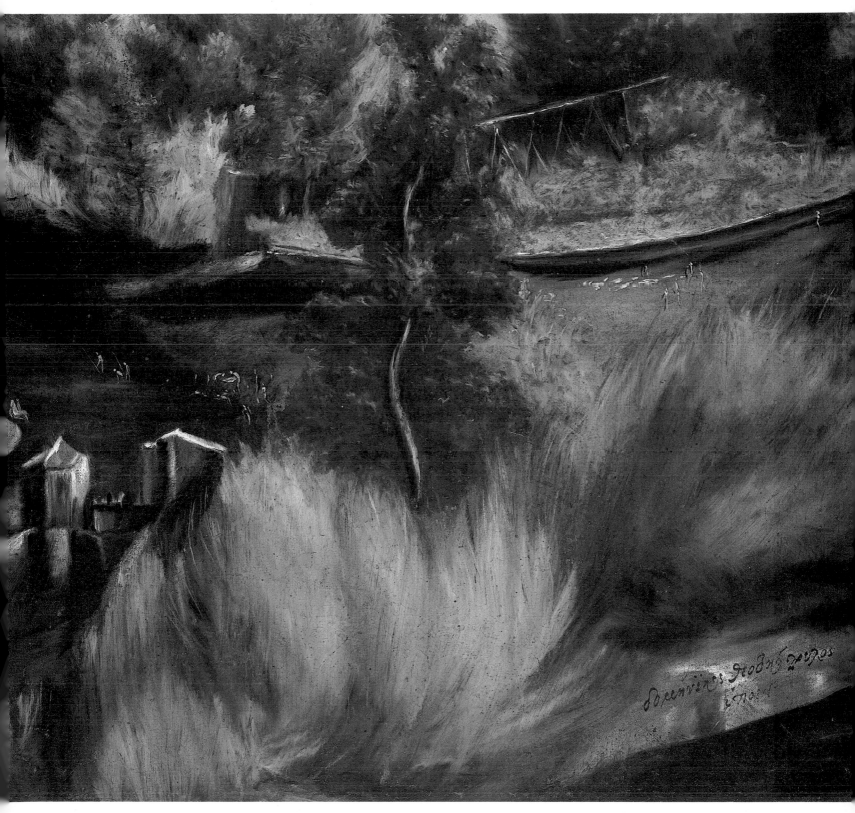

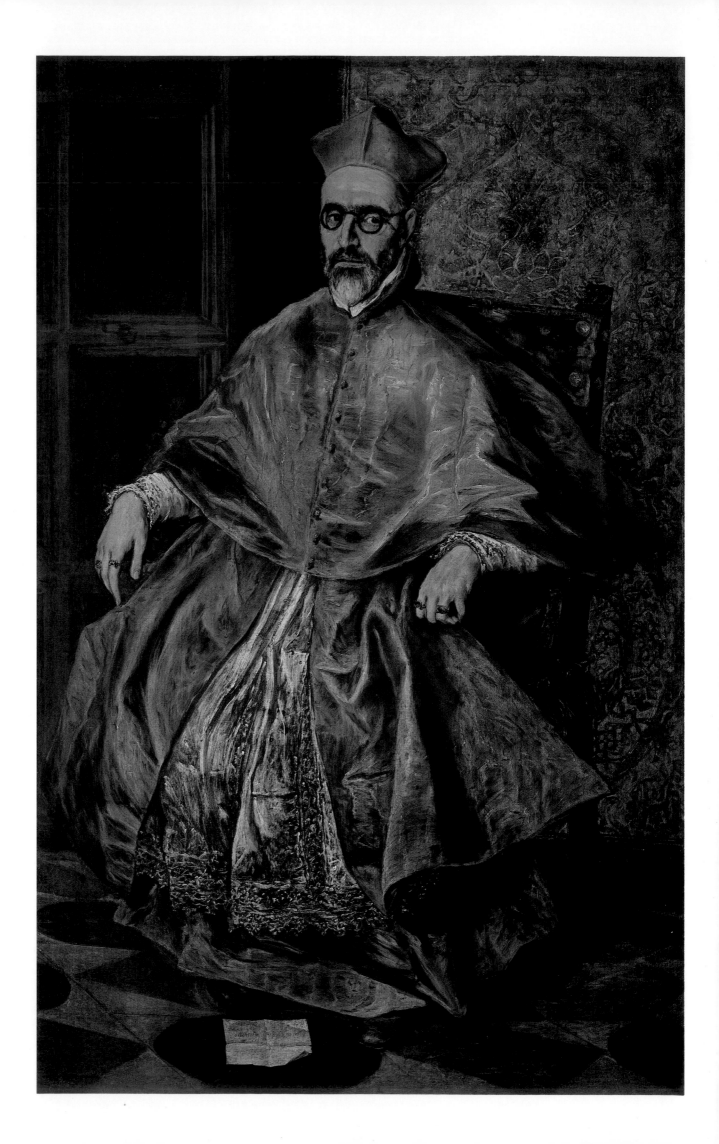

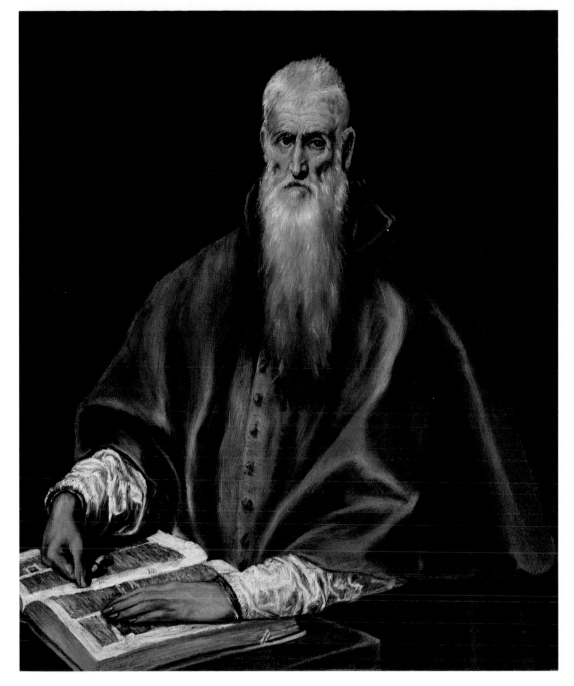

39 *Portrait of a Cardinal*
Domenicos Theotocopoulos (called El Greco)
Spanish, 1541–1614
Oil on canvas; 67¼ x 42½ in. (170.8 x 108 cm.)
Bequest of Mrs. H.O. Havemeyer, 1929,
H.O. Havemeyer Collection (29.100.5)

40 Saint Jerome as a Cardinal
Domenicos Theotocopoulos (called El Greco)
Spanish, 1541–1614
Oil on canvas; 42½ x 34¼ in. (108 x 87 cm.)
Robert Lehman Collection, 1975 (1975.1.146)

EL GRECO
Portrait of a Cardinal

This portrait had long been thought to represent Cardinal
Don Fernando Niño de Guevara, who lived in Toledo from
1599 to 1601. Recently, however, the figure has been iden-
tified as either Don Gaspar de Quiroga or Don Bernardo
de Sandoval y Rojas, both cardinal archbishops of Toledo.

El Greco uses a series of pictorial oppositions in order to
express the figure's dynamic and contradictory psychologi-
cal bearing. The animate and seemingly airborne quality of
his carmine robes is juxtaposed with the rigidly fixed pos-
ture and unrelenting gaze of the sitter; his gnarled right
hand is contrasted to his relaxed left hand. Even the setting
for this man seems to echo this dual nature: The paneled
door to the left is static, regularized, and dark, while the
wall to the right is bright, and the abstract shapes printed
on it mirror the dynamic quality of the cardinal's robes.

EL GRECO
Saint Jerome as a Cardinal

El Greco's high-keyed color, brilliant use of white, and flame-
like touches of paint turn what otherwise might have been a
sedate image of an ascetic scholar into a vividly mystical vi-
sion of an immensely powerful and saintly man. The artist
banished all distracting details from this religious portrait
and redirected light so that it appears to be emanating from
the figure itself.

The extreme elongation of El Greco's figures and his ab-
stract rendering of the drapery folds have led many schol-
ars to believe that, though he eclectically incorporated aspects
of Venetian and Roman painting, El Greco never completely
dispensed with the Byzantine style of his native Greece.

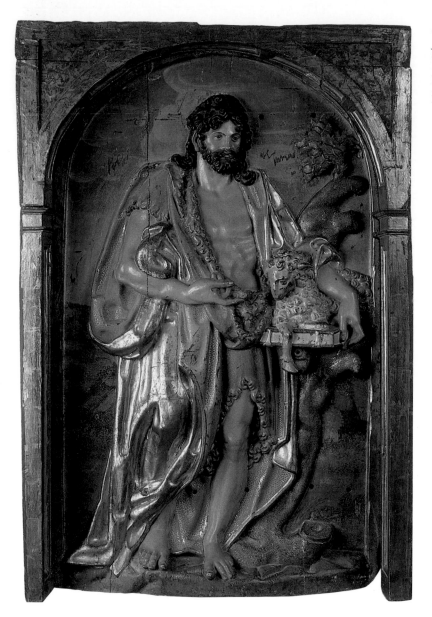

41 Saint John the Baptist, ca. 1580–92
Juan de Ancheta
Spanish (Navarre), 1540–92
Framed relief panel from a retable;
polychromed and gilded wood;
H. 44¼ in. (1.10 m.)
Rogers Fund, 1968 (68.173)

42 Saint John the Baptist, ca. 1625–35
Juan Martínez Montañés
Spanish (Seville), 1568–1649
From the Convent of
Nuestra Señora de la Concepción (Seville)
Polychromed and gilded wood; H. 61 in. (155 cm.)
Purchase, Joseph Pulitzer Bequest, 1963 (63.40)

Two Spanish Sculptures

The iconography of Saint John the Baptist, hirsute, bare-foot, and dressed in animal skins, is as formulaic as the description, repeated in all the Gospels, which presents him as the fulfillment of Isaiah's messianic prophecy.

In both carvings, the Baptist's ascetic image is tempered by the luxurious finish, used on Spanish wood sculpture, known as *estofado* (from the word for cloth). In this technique, the carved wood was first gilded, then covered with paint, which was then scratched through in elaborate patterns to reveal the gold beneath. Another polychrome technique, *encarnación*, was used to capture the quality of skin tones and to achieve the realism that provides this powerfully emotional carving style with its special impact.

In Juan de Ancheta's composition (Plate 41), the gilded clothing of the Baptist melds with the background landscape, also executed in a delicately textured *estofado*; the overall golden shimmer of the surface and the nervous calligraphic whorl of the drapery combine to compress the sculptural forms into a single plane. This is characteristic of Span-ish Renaissance sculpture; it is in part a legacy of Spain's Moorish artistic heritage and in part a result of the sculpture's function as part of a *retablo*, the multitiered screen typically mounted behind Spanish church altars. Despite this planar emphasis and despite, too, the feverish intensity of the Baptist's gaze—his sensual face and pale forehead glow below the fleecy mound of ebony curls—Ancheta's figure is imbued with a heroic, idealized stability.

From the succeeding generation of sculptors, the Baptist of Juan Martínez Montañés (Plate 42) exists on a different plane altogether. Majestically calm and serene, its intensity is internalized, concentrated within a fully three-dimensional figure of austere poise and balance. Its emotional impact derives not from any Mannerist exaggeration or agitated composition but from its vivid corporeal presence. This Baptist's absolutely frontal, direct gaze rivets the viewer, while his clearly pointed finger directs attention to the unseen presence of Christ. The *estofado* here is comparatively restrained but highly refined.

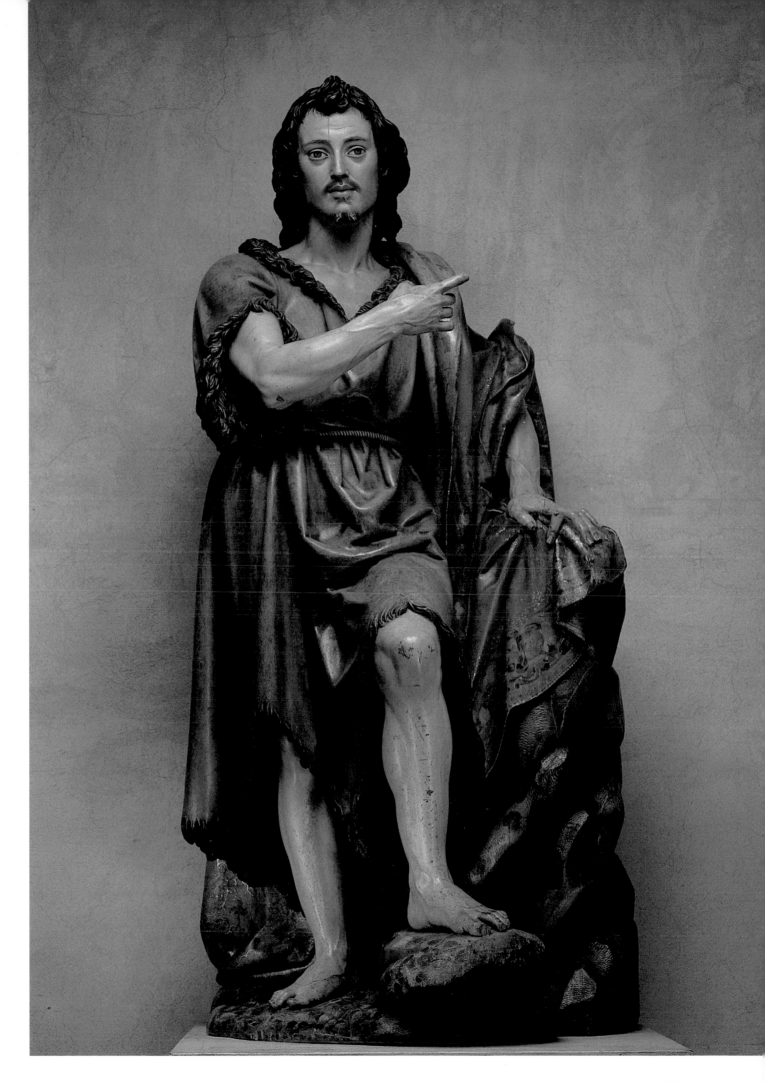

VELAZQUEZ
Juan de Pareja

Exceptional powers of observation and psychological interpretation made Diego Velázquez the greatest Spanish painter of his century. His precocious genius was quickly recognized, and in October 1623, at the age of twenty-four, Velázquez was appointed royal painter to King Philip IV.

In 1648 Philip dispatched Velázquez to Rome to buy works of art for the newly renovated royal palace of the Alcazar in Madrid. While in Rome, Velázquez made two of his greatest portraits: that of Pope Innocent X and that of his slave and studio assistant, Juan de Pareja (ca. 1610–70). Pareja, of Moorish descent, was born in Seville and was himself a painter. He is believed to have studied with Velázquez, though the only paintings of his that survive, dating from 1650 to 1659, suggest that he learned very little from his teacher.

Velázquez's eloquent portrait of his companion eschews fanciful ornament, allowing the painter to concentrate more forcefully on the sitter's powerful and enigmatic countenance. The deft handling of paint and the restricted color tonalities imbue Pareja's penetrating eyes with an intelligence and self-confidence that would befit a king.

This picture was exhibited in Rome on March 19, 1650. Palomino, in his life of Velázquez (1724), writes that this painting "was generally applauded by all the painters from different countries who said that the other pictures in the show were art, but this alone was 'truth.'"

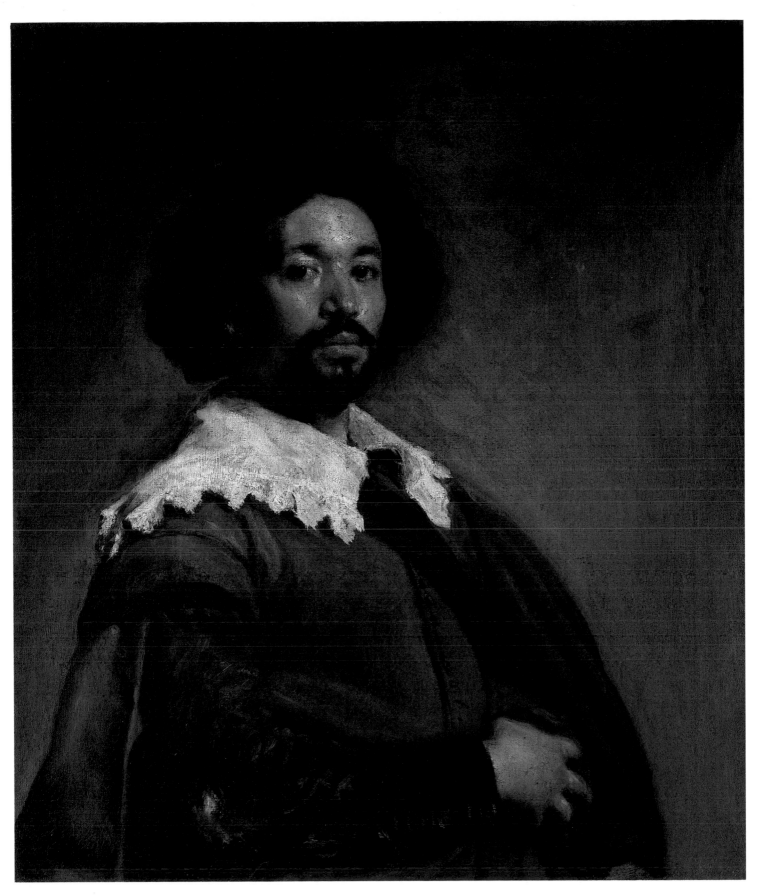

43 Juan de Pareja
Diego Rodríguez de Silva y Velázquez
Spanish, 1599–1660
Oil on canvas; 32 x 27½ in. (81.3 x 69.9 cm.)
Purchase, Fletcher Fund, Rogers Fund, and Bequest of
Miss Adelaide Milton de Groot (1876–1962), by exchange,
supplemented by gifts from friends of the Museum, 1971
(1971.86)

*44 The Holy Family with Saints Anne
and Catherine of Alexandria*
Jusepe Ribera
Spanish, 1591–1652
Oil on canvas; 82½ x 60¾ in.
(209.6 x 154.3 cm.)
Samuel D. Lee Fund, 1934 (34.73)

Above: detail *Page 64:* text

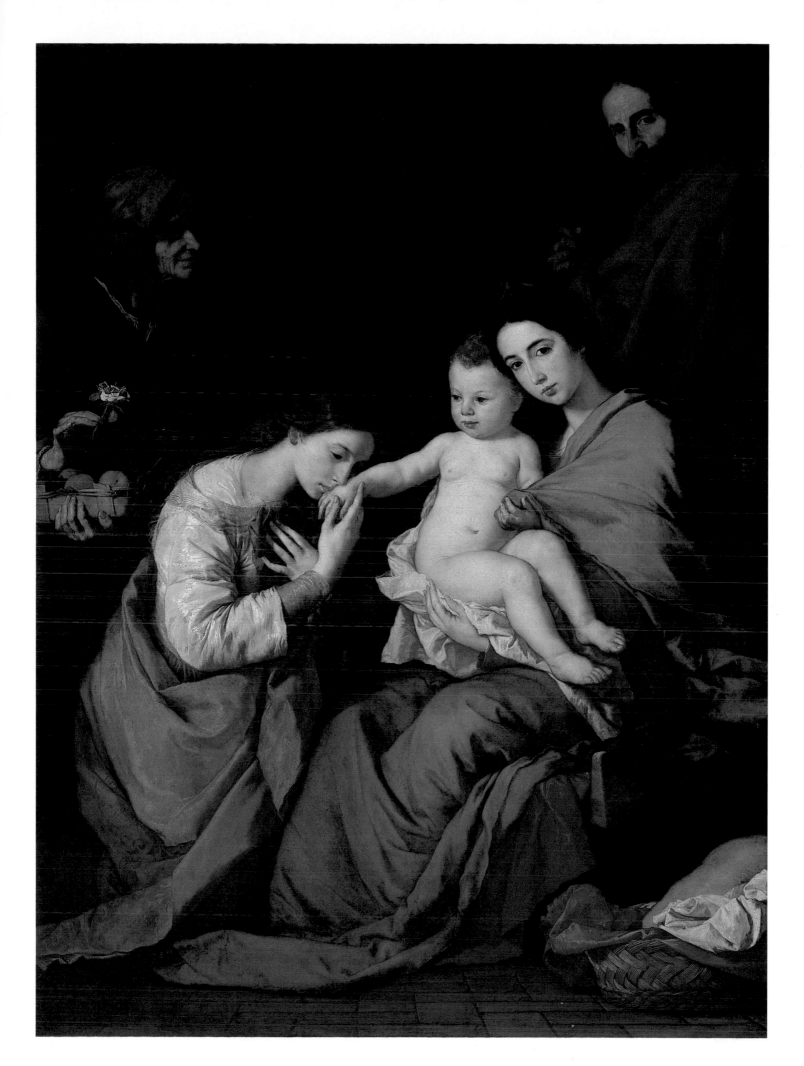

JUSEPE RIBERA

(Pages 62–63)

The Holy Family with Saints Anne and Catherine

Ribera's *Holy Family with Saints Anne and Catherine of Alexandria* is an exceptionally fine example of the paintings Ribera did late in life as he moved away from the brutal realism of his earlier religious images toward scenes that were gentle in mood and understated in presentation.

Born near Valencia in 1591, Ribera was profoundly influenced by the work of the Italian masters Correggio, Carracci, and Caravaggio. In 1616, he settled in Naples, where he worked as court painter to a succession of Spanish viceroys until his death in 1652.

The central figures in this almost-life-size painting are bathed in light, while the background figures of Saints Joseph and Anne are allowed to slip into deep shadow. Saint Anne holds a basket with peaches and grapes and extends a rose to the Christ Child. The beautiful, almond-eyed Virgin gazes out at the viewer and holds the triumphant young Christ on a brilliant white cloth. Christ confidently reaches out toward the future martyr Saint Catherine, who swoons before him with a loving, slightly anguished face of transcendent beauty.

The power of Ribera's figures depends not upon his use of symbolic presentation or sentimental display, but on his ability to evoke the intensely human qualities of humility, compassion, and love.

BARTOLOME ESTEBAN MURILLO

Virgin and Child

Bartolomé Murillo, the most prominent painter of the late Baroque in Spain, achieved recognition at a very young age. His fame crossed national boundaries and lasted long after his death in 1682. This painting dates from the early 1670s. It formed part of the altarpiece of the chapel in the palace of the Marquis de Santiago in Madrid, and it hung in the private chapel of the Santiago family until 1808.

The Virgin Mary sits on a stone bench inside a dark and empty interior and holds the almost-naked Christ Child on her lap. She wears a rust-colored robe and deep blue mantel and, casting her eyes down lovingly on her son, appears unusually serious. In contrast to this tender sadness and immobility, the Christ Child looks rather animated. He does not return his mother's gaze, but looks out at the viewer, thus making us part of the devotional image itself. A diffuse light surrounds their heads like a halo, a subtle allusion to their divinity. Murillo often chose Andalusian peasants for his models, but he portrayed their simple features with a Raphaelesque grace and dignity.

45 Virgin and Child, ca. 1672
Bartolomé Esteban Murillo
Spanish, 1617/18–1682
Oil on canvas; 65¼ x 43 in.
(165.7 x 109.2 cm.)
Rogers Fund, 1943 (43.13)

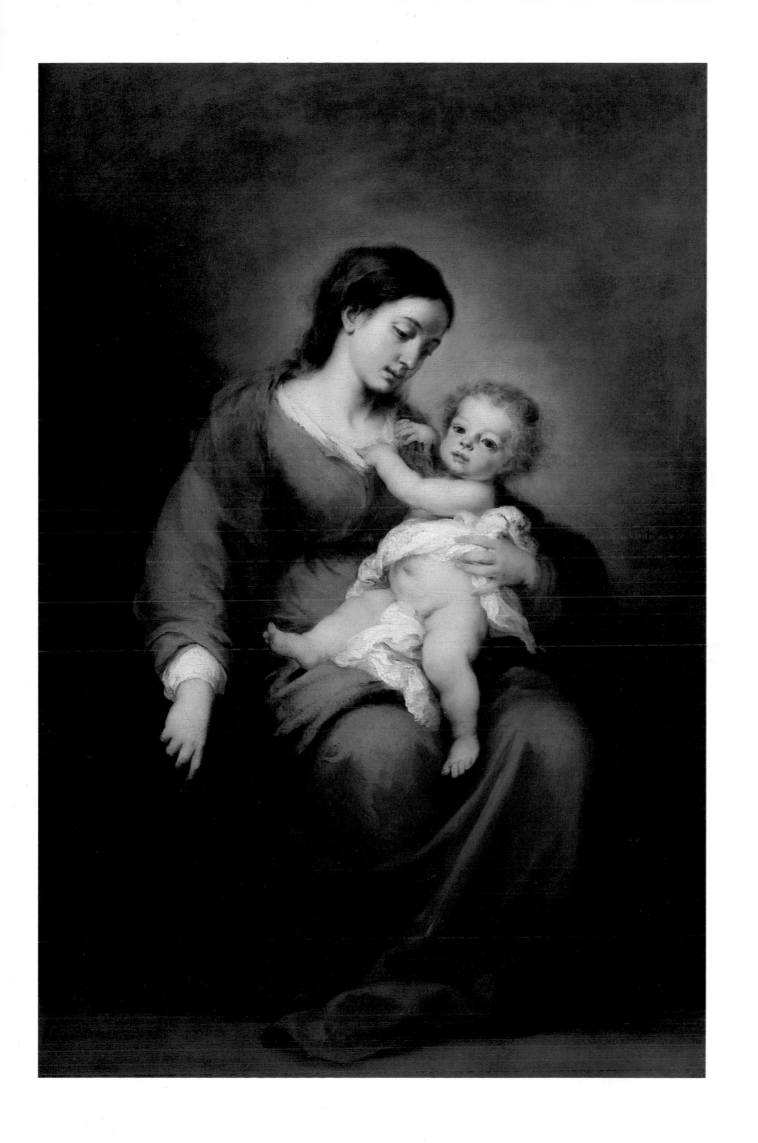

46 *Portrait of a Man, possibly an Architect
or Geographer*, 1597
Peter Paul Rubens
Flemish, 1577–1640
Oil on copper; 8½ x 5¾ in. (21.6 x 14.6 cm.)
The Jack and Belle Linsky Collection, 1982
(1982.60.24)

47 *Study for a Standing Female Saint*
Peter Paul Rubens
Flemish, 1577–1640
Brush and light brown wash over traces of
black chalk; certain contours reinforced in
pen and dark brown ink; 18⅜ x 12⅛ in.
(46.7 x 30.9 cm.)
Rogers Fund, 1965 (65.175)

PETER PAUL RUBENS
Portrait of a Man

The unidentified sitter for this portrait, Rubens's first autograph work, holds a square and compass, probably signifying his occupation as a geographer, architect, or astronomer. Rubens completed this work in 1597, the year before he entered the guild in Antwerp at the age of twenty-one.

The delicate and extremely precise handling of the elements of this portrait betrays Rubens's indebtedness to his teacher, Otto van Veen. However, there is much in this portrait that distinguishes it from the work of Rubens's contemporaries and prefigures his own unique genius: the independent vitality imparted to the hands and face of the sitter, for instance, and Rubens's ability to create a profoundly intellectual gaze in the eyes of the sitter.

The miniature scale, the sparing use of color, and the extremely disciplined handling were foreign to Rubens's nature and may have been the result of van Veen's attempt to discipline what he saw as his student's inherently impetuous approach.

PETER PAUL RUBENS
Study for a Standing Female Saint

This large and impressive drawing was made toward the end of Rubens's stay in Rome, where he was studying the great Italian masters and the Classical antique. It represents Saint Domitilla, a first-century martyr, and is preparatory for the artist's most important Roman commission, the high altarpiece for the Oratorian Chiesa Nuova, also called Santa Maria in Vallicella. The painting, executed in 1607–08 and entitled *Saint Gregory the Great with Saints Domitilla, Maurus and Papianus*, proved unsuitable once it was installed in the church. The light reflections in the choir made the painting almost invisible. Three panels painted on slate were substituted by Rubens and remain *in situ* to this day. The rejected picture, however, returned to Antwerp with the artist in 1608, and it was placed above the grave of Rubens's mother, who died shortly before her son's return. It is now in the Musée des Beaux-Arts, Grenoble.

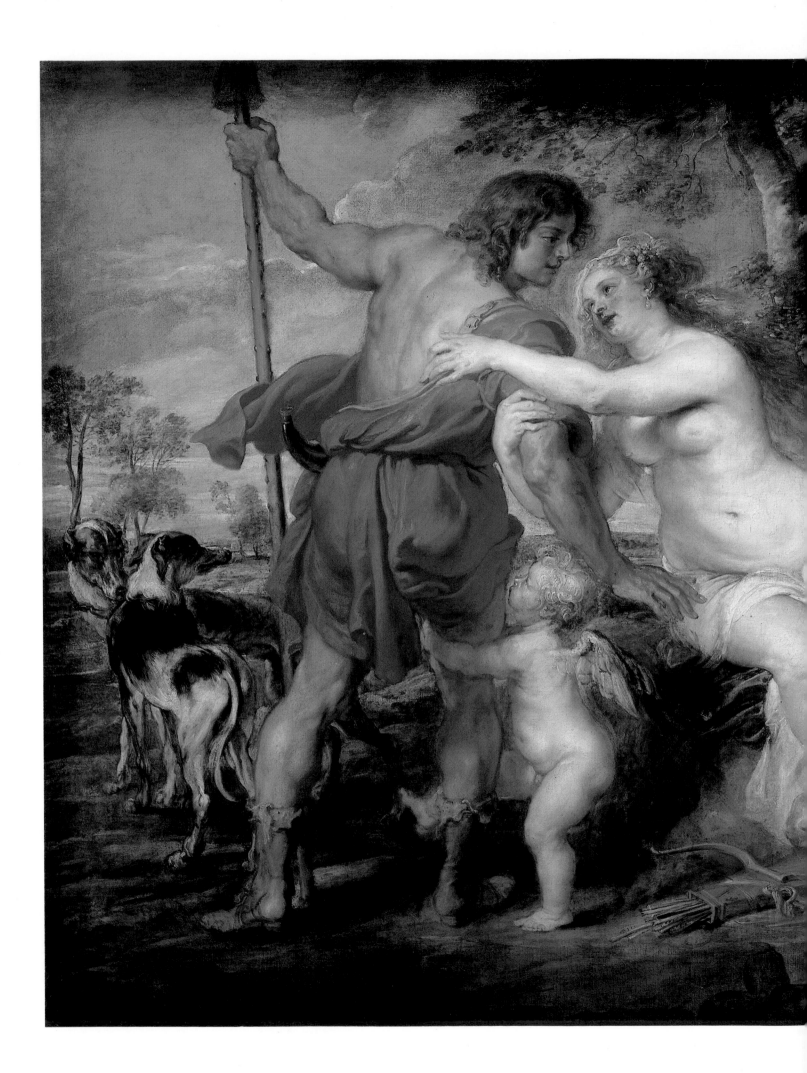

PETER PAUL RUBENS
Venus and Adonis

Much of Rubens's genius resided in his ability to blend his innate northern sense of realism with the grandeur and monumentality he found so awe-inspiring in the work of the Italian masters Michelangelo, Tintoretto, and Titian.

The scene depicted is taken from Ovid's *Metamorphoses* (Book 10, line 519). Venus, grazed by Cupid's arrow, fell in love with Adonis, a handsome hunter. She took up hunting herself and in this way immediately won his affection. Soon, however, she grew to fear his passion for this dangerous sport. Venus "reclined upon the ground and, resting her head against his breast and mingling kisses with her words," told Adonis the tale of Hippomenes and Atalanta, which warns against hunting dangerous beasts. Unsuccessful in her attempt to dissuade him, she set off broken-hearted on her swan-driven chariot for the island of Cyprus. The impetuous Adonis promptly set off boar hunting and, as Venus had feared, was instantly gored to death.

The "leave-taking" scene is an embellishment of the tale, first used in the Renaissance in a painting by Titian. Rubens's 1628–29 copy of an original by Titian is now lost, and though the present painting is by no means a copy, it does reflect Titian's influence. Both artists concern themselves with the dramatic moment in which Adonis is held back not merely by the clasp of Cupid and the embrace of Venus, but by his own conflicting emotions as well.

48 Venus and Adonis
Peter Paul Rubens
Flemish, 1577–1640
Oil on canvas; 77¾ x 95⅝ in.
(197.5 x 242.9 cm.)
Gift of Harry Payne Bingham,
1937 (37.162)

Peter Paul Rubens
The Garden of Love

Rubens's *joie de vivre* permeates all his artistic productivity and is expressed most eloquently in this large and magnificent drawing, one of the two final preparatory drawings for a woodcut, which was executed in reverse by Christoffel Jaegher, who cut all nine of Rubens's woodcuts in the 1630s. The drawing was designed in two sheets: Each half is self-contained, yet together they form a greater whole. The sheet shown here corresponds almost exactly to the right half of the print. The study for the other half (not shown) differs from the woodcut in a number of details.

The composition, first formulated on canvas and then somewhat altered in the woodcut, is of a personal nature. Here at left, Rubens lovingly escorts his young wife, with the assistance of a putto pushing from behind, into a luscious garden where other elegant ladies and courtiers have gathered. The scene continues in the second sheet with more merrymakers and putti on the other side of the grotto.

Peter Paul Rubens
Rubens, His Wife, and Son

In 1630, at the age of fifty-three, Rubens married his second wife, the exceptionally beautiful sixteen-year-old Helena Fourment. This painting was conceived as a tribute to their marriage, and the luminosity of the colors and the ebullient presentation of the figures make this one of Rubens's most magnificent achievements.

Rubens has inserted the portrait of his family into the theme of the Garden of Love. The fountain, the foliated trellis, and the caryatid are symbols of fertility. The warm, intimate expression of the painter and the gentle caress of his hand attest to his love for her, a beautiful, loving mother and wife.

The style of this painting would suggest a date of 1635 and thus indicates that the child shown is Peter Paul, who was the last of Rubens's children to be born in his lifetime; a fifth child was born more than eight months after the painter's death.

49 *The Garden of Love* (left side)
Peter Paul Rubens
Flemish, 1577–1640
Pen, brown and gray-green wash, over traces of black chalk, touched with indigo, green, yellowish, and white paint on paper; 18¼ x 27¾ in. (46.3 x 70.5 cm.) Fletcher Fund, 1958 (58.96.1)

50 *Rubens, His Wife, Helena Fourment, and Their Son Peter Paul*
Peter Paul Rubens
Flemish, 1577–1640
Oil on wood; 80¼ x 62¼ in. (203.8 x 158.1 cm.)
Gift of Mr. and Mrs. Charles Wrightsman, 1981 (1981.238)

51 *Portrait of a Man, probably Lucas van Uffel*, 1622
Anthony van Dyck
Flemish, 1599–1641
Oil on canvas; 49 x 39⅝ in. (124.5 x 100.6 cm.)
Bequest of Benjamin Altman, 1913 (14.40.619)

52 *James Stewart, Duke of Richmond and Lennox*
Anthony van Dyck
Flemish, 1599–1641
Oil on canvas; 85 x 50¼ in. (215.9 x 127.6 cm.)
Marquand Collection, Gift of Henry G. Marquand,
1889 (89.15.16)

ANTHONY VAN DYCK
Portrait of a Man

Anthony van Dyck was born in Antwerp in 1599 and, before his eighteenth birthday, became first assistant to Peter Paul Rubens. This portrait, assuredly one of van Dyck's finest, is believed to be of Lucas van Uffel, a wealthy Flemish merchant who lived and conducted a vast trading empire in Venice. In addition to establishing his success in the business world, van Uffel was a passionate patron of the arts and spent much of his fortune amassing a collection of paintings. When his financial dealings were called into question by the Venetian government, he fled Italy and returned to Holland, taking his collection with him.

Painted during a visit to Venice in 1622, van Dyck's picture portrays van Uffel as a man of learning as well as a patron of the arts. The celestial globe and the compass allude to his knowledge of geography, navigation, and astronomy. The antique bust and red-chalk drawing on the table before him attest to his appreciation for the plastic and pictorial arts; the recorder signifies his love of music.

Van Dyck's remarkable ability to capture the energetic pose of the sitter and the sense of instantaneous movement was entirely new in his work of this time and reveal the influence of the Italian Baroque. The colors and saturated technique result from his study of Venetian portraiture.

ANTHONY VAN DYCK
James Stewart, Duke of Richmond and Lennox

In 1620 van Dyck entered the service of King Charles I of England. The same year he was knighted and named "principalle paynter" of the court. This portrait of James Stewart, duke of Richmond and Lennox, shows van Dyck at the height of his creative powers.

The composition is based loosely on those used by Titian, whose works van Dyck had studied during his frequent sojourns in Italy. The aura of refined elegance and noble bearing is enhanced by the addition of the duke's greyhound, an animal long associated with the ruling class, though here it may also refer to Stewart's faithful service to the Crown; he actively supported the king during the Civil War. This painting may very well have been commissioned in order to celebrate Stewart's investiture into the Order of the Garter in November 1633.

Van Dyck uses a subdued palette throughout most of the canvas and reserves the brightest colors for the insignia of the Order of the Garter: a red-and-gold jewel set into a silver cross emblazoned on Stewart's cloak, the silver star at the left shoulder, and the garter itself on Stewart's left knee. Under Charles, the importance of the order was revived and began to be awarded for especially dedicated service to the king.

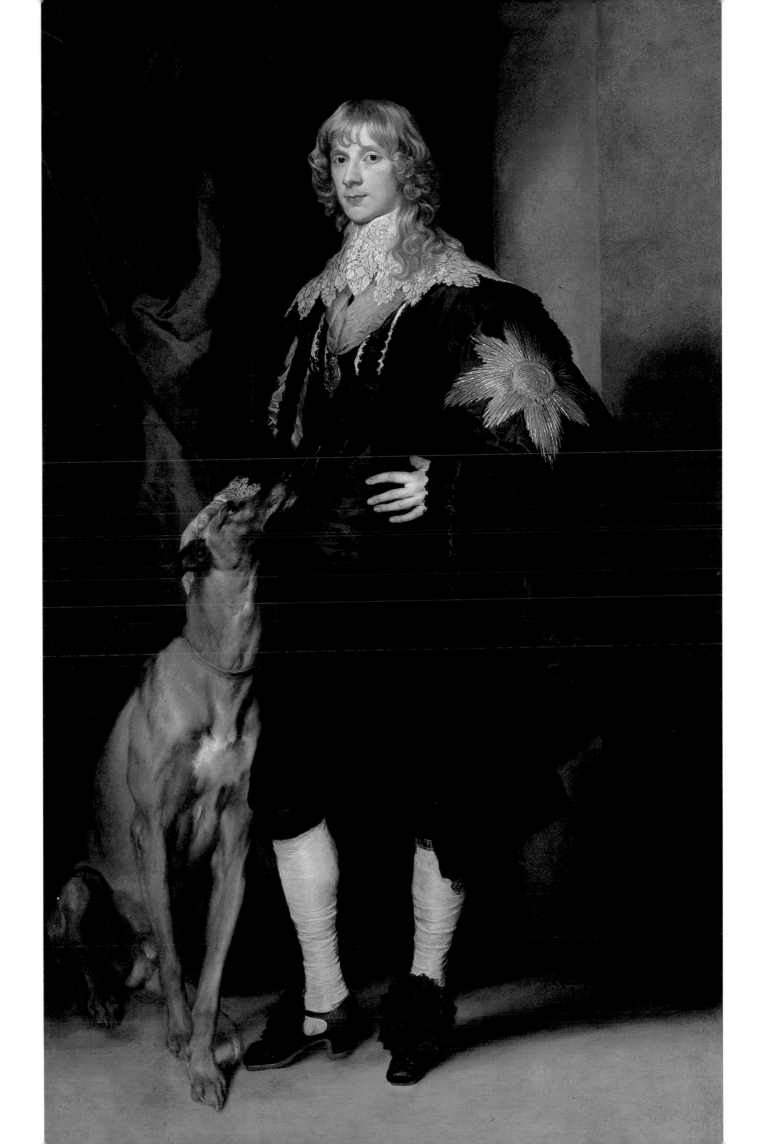

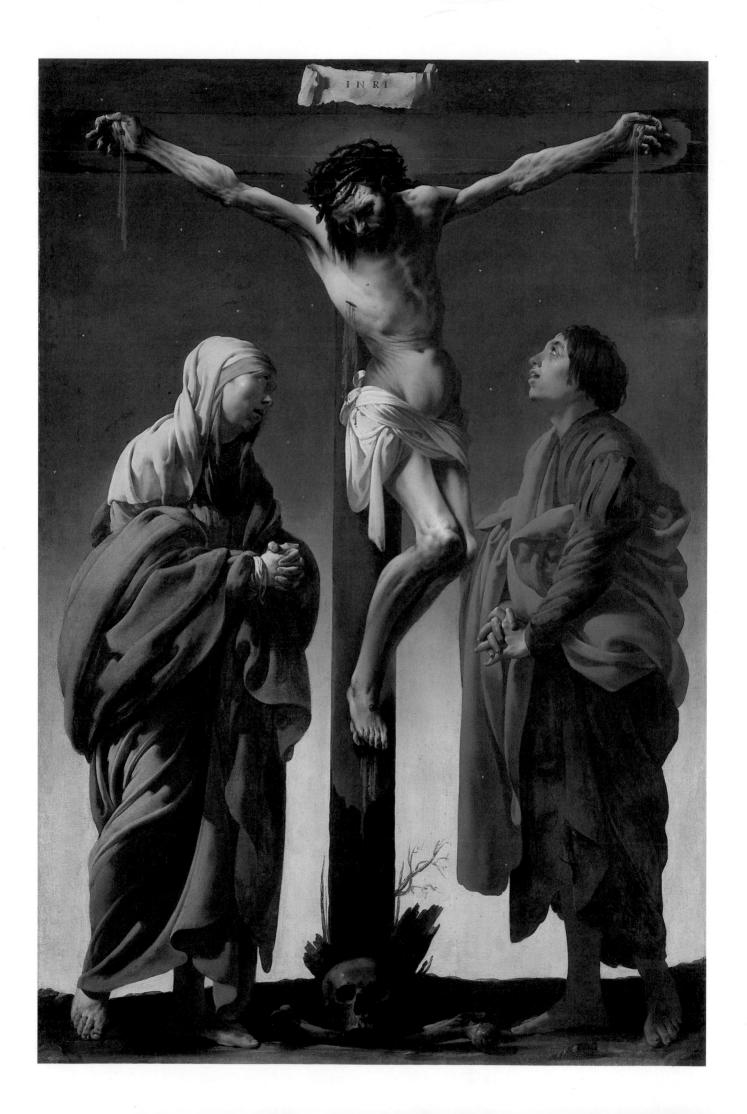

HENDRICK TER BRUGGHEN
The Crucifixion, with the Virgin and Saint John

Hendrick ter Brugghen spent ten years in Rome and was there profoundly influenced by the revolutionary and realistic painting of Caravaggio. After reestablishing himself in his native Utrecht, ter Brugghen was hailed as the greatest northern practitioner of Caravaggesque realism. In 1627, on a visit to Utrecht, Peter Paul Rubens praised ter Brugghen as the "only real painter" he had found in the Netherlands.

Painted in the third decade of the seventeenth century, this powerful work is an astonishing example of the integration between two completely different and seemingly antithetical pictorial styles. Like Caravaggio, ter Brugghen used ordinary people—perhaps Dutch peasants—as models for the figures of the Virgin Mary and Saint John. The inten-

sity of Saint John's anguish, expressed by his open mouth and twisted hands, is made even more poignant by his plain face and red nose. But the attention given to the twisted, angular corpse, with its green-gray face and belly and gaping wounds, is far more disturbing than anything painted in Italy. This emphasis demonstrates that ter Brugghen did not rely exclusively on Caravaggesque realism and lighting but also borrowed from the repertory of traditional northern Gothic imagery.

Recent scholarship has shown that ter Brugghen was not a Catholic but a Protestant. This impassioned devotional image was painted to satisfy the wishes of his patrons in Utrecht, a city that had a higher concentration of Catholics than any other in the northern Netherlands.

53 The Crucifixion, with the Virgin and Saint John
Hendrick ter Brugghen
Dutch, 1588–1629
Oil on canvas; 61 x 40¼ in. (154.9 x 102.2 cm.)
Funds from various donors, 1956 (56.228)

JACOB JORDAENS
Holy Family with Saint Anne, and the Young Baptist and His Parents

Jacob Jordaens was an industrious and well-regarded Flemish painter who, like Rubens, worked for many European rulers. He became one of the most active Flemish painters of the seventeenth century, and from 1640 to the early 1660s he was in greater demand than any other artist in northern Europe. Though born a Catholic, Jordaens converted to Calvinism in his middle age, and the change in his religious orientation had a profound influence on the way he chose to present religious imagery.

This painting is a product of two widely separate periods in Jordaens's career, and it reflects the shift in his religious sentiment during the intervening years. The first version of the composition, painted about 1620–25, showed the Virgin and Child with Saints Joseph and Anne. The figures of Saint John the Baptist, his parents, the archangel Gabriel, as well as the lamb, the serpent, the globe, and the Latin inscription at the base were all added in the 1660s. Paintings such as the earlier version of this one were criticized by Calvinists who opposed the use of paintings as devotional images. Jordaens's reworked image has a strong didactic rather than devotional quality, and the addition of the quotation from Romans 11:16 had particular appeal to Protestants. It reads, "If the root be Holy, so are the Branches," a metaphor suggesting that a believer's relationship to God should be as natural as that of branches to a root.

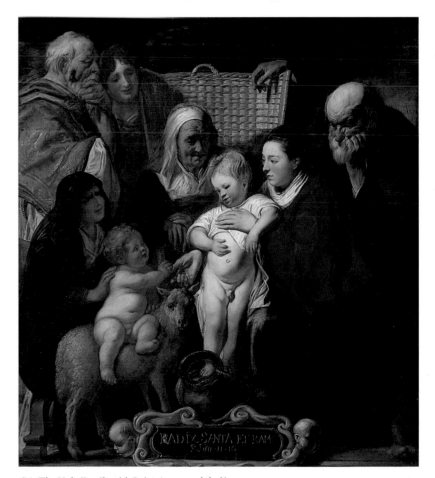

54 The Holy Family with Saint Anne, and the Young Baptist and His Parents
Jacob Jordaens
Flemish, 1593–1678
Oil on canvas; 66⅞ x 59 in. (169.9 x 149.9 cm.)
Purchase, 1871 (71.11)

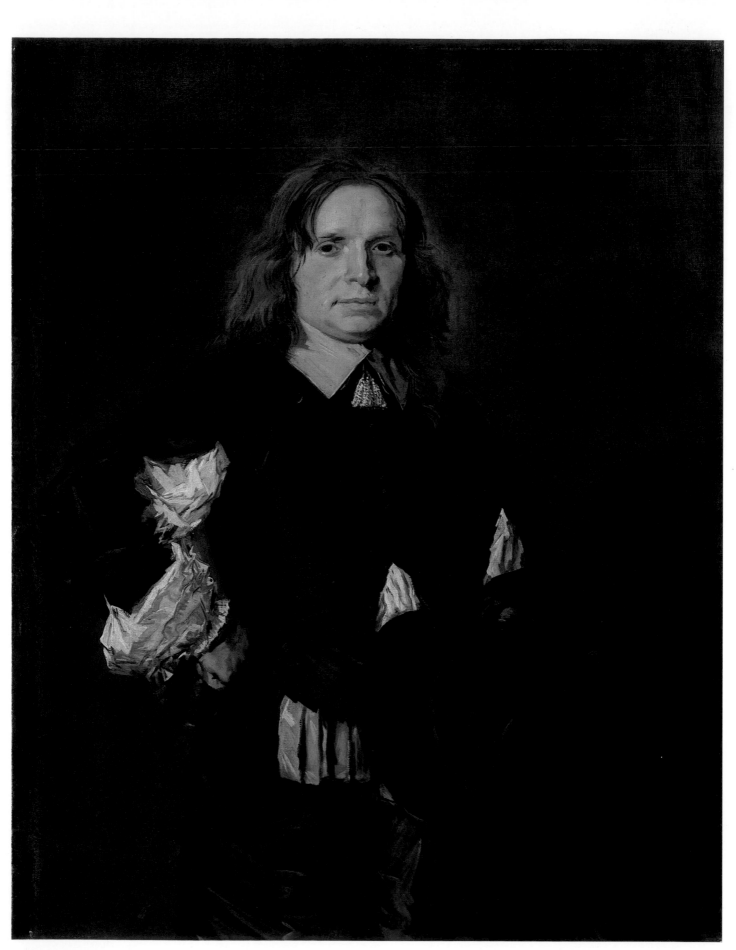

55 Portrait of a Man
Frans Hals
Dutch, b. after 1580–d. 1666
Oil on canvas; 43½ x 34 in. (110.5 x 86.3 cm.)
Marquand Collection, Gift of Henry G.
Marquand, 1890 (91.26.9)

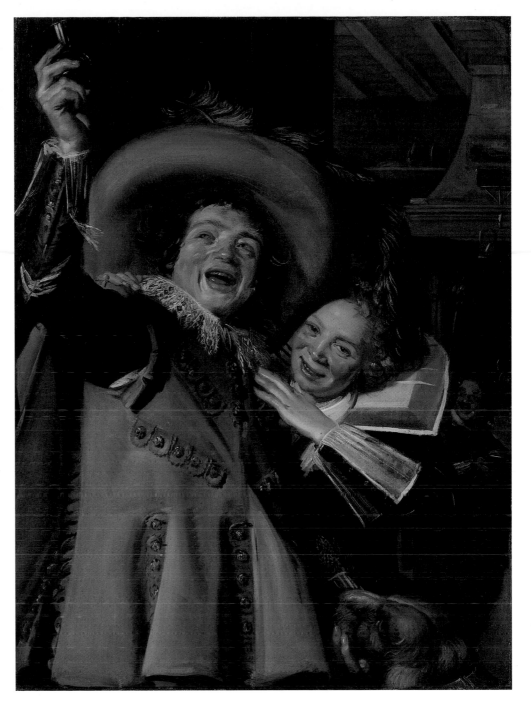

56 *Young Man and Woman in an Inn
(Yonker Ramp and His Sweetheart)*, 1623
Frans Hals
Dutch, b. after 1580–d. 1666
Oil on canvas; 41½ x 31¼ in.
(105.4 x 79.4 cm.)
Bequest of Benjamin Altman, 1913
(14.40.602)

FRANS HALS

Portrait of a Man and *Young Man and Woman in an Inn*

Frans Hals was an influential pioneer of genre scenes, although he is most famous today as the first great portrait specialist in Dutch Baroque painting. In *Portrait of a Man* (Plate 55), the imposing gentleman stands with his right hand on his hip, his left hand holding a wide-brimmed black hat and cloak, and he regards the viewer with far less disdain than do most sitters depicted in this very stately "classical" pose, so popular in Dutch portraiture of the 1650s. Having placed his figure in a setting more neutral and less atmospheric than those used by Rembrandt, Hals calls our attention to this individual through exuberant brushwork and the imaginative use of a subdued palette. The rich flesh tones and the mauve and green of the ribbons at the gentleman's waist offer striking contrasts to the gradations of black, white, and gray in his costume. The brushwork on his cuffs, slashed black doublet, and long unruly brown hair, and the

"impressionistic" touches near the corners of the mouth and in the definitions of the nose are especially impressive.

In *Young Man and Woman in an Inn* (Plate 56), near the hearth at a public inn, a young gallant raises his glass in a toast to wine, women, and the joys of life. A tradition that dates back to the eighteenth century identifies this irrepressible youth as Yonker Ramp, but there is no corroborative evidence that Hals's painting is a portrait. Some scholars have recently suggested that this painting may be a disguised representation of the wasteful ways of the Prodigal Son. Signed and dated in 1623, *Yonker Ramp* was a pivotal picture in the artist's career and in Netherlandish painting of this century. Hals, born in Antwerp and familiar with Flemish art, was the first to integrate the Baroque vitality of Rubens with the native realism of Dutch art. In doing so, Hals prepared the way for Rembrandt.

Rembrandt van Rijn
The Toilet of Bathsheba

The subject of this painting is taken from the Book of Samuel and depicts Bathsheba, the beautiful wife of Uriah the Hittite, as she was seen bathing by King David. Her beauty so stirred King David that he forced her to yield to him and later made certain that Uriah would be killed in battle.

Rembrandt's knowledge of the Bible was exhaustive, but he took liberties with the biblical version in order to enhance the voluptuous and exotic qualities that so appealed to him. The peacock, the jewelry, the Turkish carpet, and the lavish costumes of the coiffeuse and the pedicurist are all embellishments on the biblical account of the story. The artist chose to have Bathsheba gaze out at the viewer so that, in addition to her physical charms, one is aware of her personality as well. The painting has darkened considerably with age, and the figure of King David is now only barely discernible on the roof of the house at the upper left.

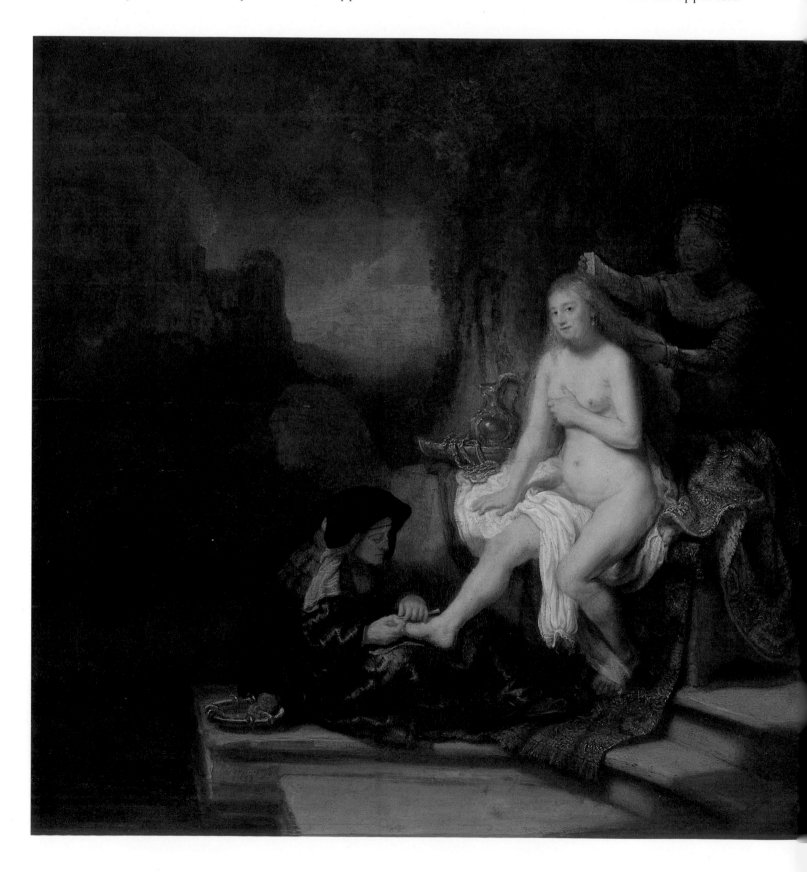

57 *The Toilet of Bathsheba*
Rembrandt Harmensz. van Rijn
Dutch, 1606–69
Oil on canvas; 22½ x 30 in. (57.2 x 76.2 cm.)
Bequest of Benjamin Altman, 1913 (14.40.651)

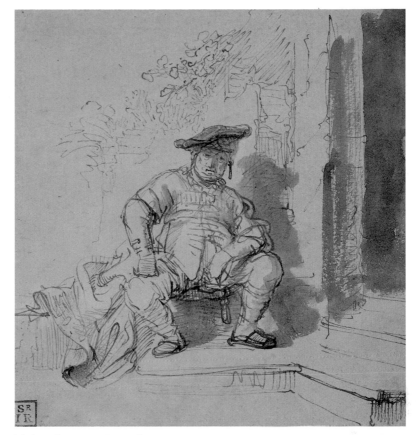

58 *Seated Man Wearing a Flat Cap*
Rembrandt Harmensz. van Rijn
Dutch, 1606–69
Pen and brown ink, brown wash, white
gouache; 5¹³/₁₆ x 5⁷/₁₆ in. (14.8 x 13.8 cm.)
Bequest of Mrs. H.O. Havemeyer, 1929,
H.O. Havemeyer Collection (29.100.935)

REMBRANDT VAN RIJN
Seated Man Wearing a Flat Cap

Rembrandt's paintings and prints have reached a wider public than his drawings, which for centuries interested only a small circle of collectors and connoisseurs. A prolific draftsman, working predominantly in pen and brown ink, Rembrandt kept his drawings in albums for private use. They have come to be regarded as highly as his "official" production and indeed are an equal measure of his genius.

Rembrandt drew people constantly, whether they were members of his immediate household, beggars in the street, or studio models. Rarely did his drawings serve as preliminary studies for paintings or prints, though they were preparatory insofar as the act of drawing from life stimulated his imagination. A moment of inspiration came to him when this glum-faced man, seated on a tasseled cushion by the entrance to a house, caught his eye. With great authority and conviction, the artist captured the distinctive pose and demeanor, and conveyed the substantiality of the figure in space. The man was probably an actor, one of the many theatrical figures Rembrandt drew in the late 1630s that have been associated with productions in Amsterdam of Dutch classical drama and the commedia dell'arte.

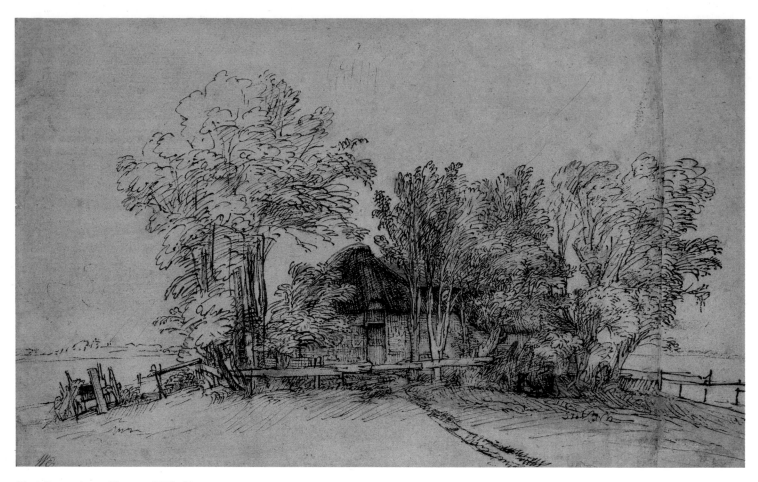

59 *A Cottage Among Trees*, ca. 1650–51
Rembrandt Harmensz. van Rijn
Dutch, 1606–69
Pen and brown ink, brown wash, on tan
paper; 6¾ x 10¹³⁄₁₆ in. (17.1 x 27.5 cm.)
Bequest of Mrs. H.O. Havemeyer, 1929,
H.O. Havemeyer Collection (29.100.939)

REMBRANDT VAN RIJN
A Cottage Among Trees

When Rembrandt turned to the landscape as a subject in
the 1640s, he approached it with the same originality and
probing intensity that characterize his portraiture and his
scenes from the Bible. With a fine quill pen, he transformed
this solitary cottage, partially hidden by trees, into an image
of pictorial richness and monumental grandeur. Alternat-
ing between broad pen strokes and tightly rendered ones,
he captured the movement in the trees as the wind blew
across the lowlands. The spectator is drawn to the firmly
rooted dwelling receding into the space of the composition;
cast in shadow, it seems shrouded in mystery. This extraor-
dinary drawing belongs to a series of landscape studies that
Rembrandt executed around 1650–51 (the high point of his
classical period), and it is somewhat indebted, in its tech-
nique and poetic mood, to the sixteenth-century Venetian
masters, whose landscape prints he collected.

REMBRANDT VAN RIJN
Aristotle with a Bust of Homer

This imaginary portrait of Aristotle in contemplation is
among Rembrandt's best-known works. It was painted in
1653 for Don Antonio Ruffo, a wealthy Sicilian nobleman
and Rembrandt's only foreign patron, who had asked Rem-
brandt for a portrait of a philosopher. Rather than choose a
single figure, however, the enormously inventive Rembrandt
found a way to present three of the greatest heroes of antiq-
uity: Aristotle, Homer, and Alexander the Great.

Aristotle, the great philosopher of the fourth century B.C.,
is shown in his library dressed in the robes of a Renaissance
humanist. He rests his hand on a bust of the blind poet
Homer. Aristotle's gifts for intellectual organization were
greatly admired in seventeenth-century Holland. Homer,
too, whom seventeenth-century Italians had found too crude,
was especially well liked by the Dutch for his realism. The
splendid chain threaded through Aristotle's fingers bears a
medallion of Alexander the Great, who had at one time
been Aristotle's pupil.

While the figure of Homer was certainly based on one of
the several Hellenistic busts owned by Rembrandt, the fig-
ure of Aristotle is reminiscent of Rembrandt's portraits of
the Jews of the Amsterdam ghetto, whom he had often used
as models in his biblical paintings.

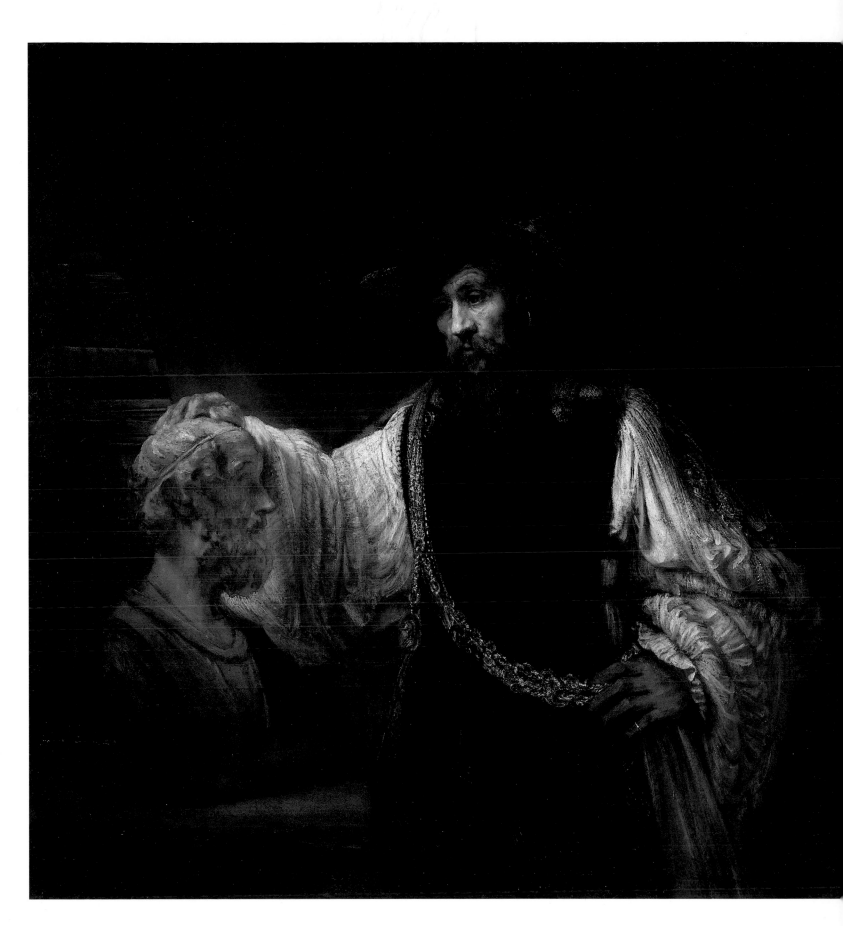

60 Aristotle with a Bust of Homer, 1653
Rembrandt Harmensz. van Rijn
Dutch, 1606–69
Oil on canvas; 56½ x 53¾ in.
(143.5 x 136.5 cm.)
Purchased with special funds and gifts
of friends of the Museum, 1961 (61.198)

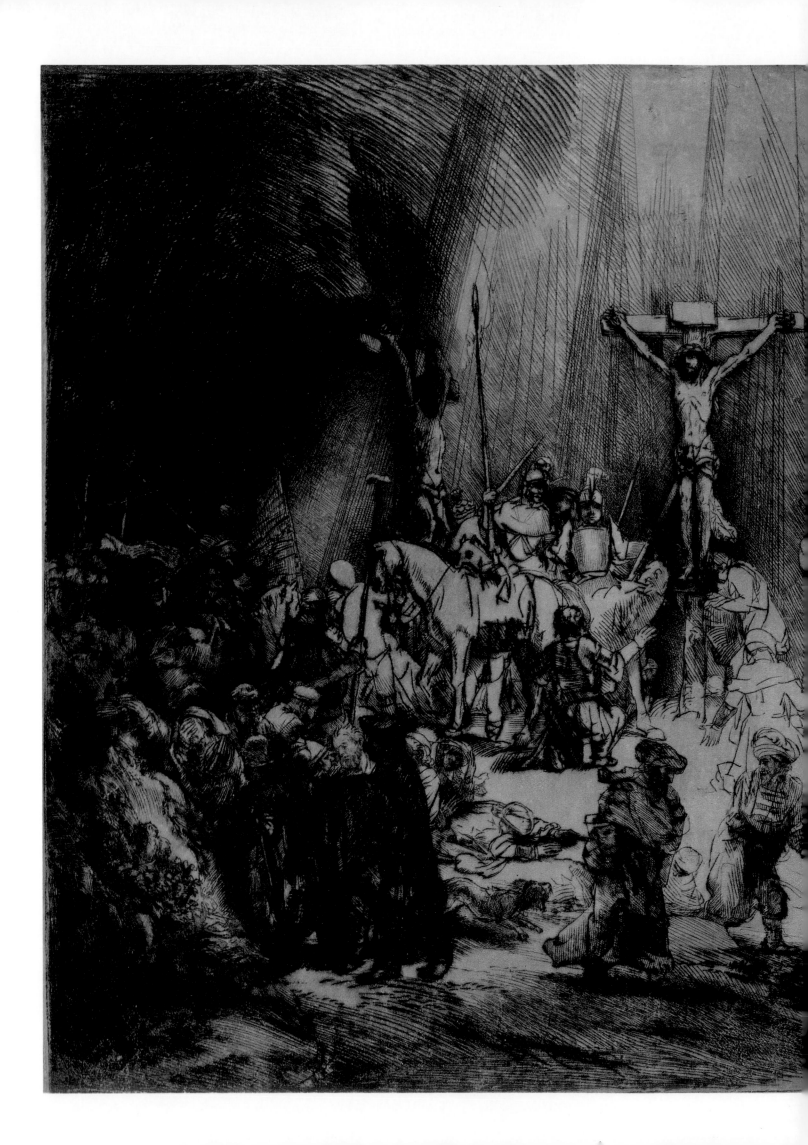

61 *The Three Crosses*, 1653
Rembrandt Harmensz. van Rijn
Dutch, 1606–69
Drypoint and burin; second state; printed on
vellum; 15 x 17¼ in. (38.1 x 43.8 cm.)
Gift of Felix M. Warburg and his family, 1941
(41.1.31)

REMBRANDT VAN RIJN
The Three Crosses

"And when they came to a place which is called The Skull, there they crucified Him, and the criminals, one on the right and one on the left" (Luke 23:33).

Rembrandt's positioning of the three crosses and his dynamic use of light help to establish the polarities of good and evil that had long been associated with the two criminals crucified next to Christ. The robber on our left, the unrepentant, is shrouded in darkness, his face cast down and his body awkwardly straining. The cross on our right bears the repentant robber, whose body is heaved forward as if willfully surrendering his spirit. The enormous crowd of people before them—Jews, Romans, and Christ's followers—displays an incredibly vast range of human emotion and activity. Some appear conspiratorial, others anguished or frightened; a few of them flee, and many pray. The brilliant white light that bursts down from Heaven promises both redemption and resurrection.

Rembrandt's romance with drypoint in the 1650s and 60s is one of the important milestones in the history of printmaking. His inventiveness in this medium led to the creation of compositions that offered more complex visual information and variety of drama than had previously been imagined, and where earlier intaglio prints had been translucent and in general rather bodiless, Rembrandt's had a structure and richness of surface that approximate many of his great oil paintings.

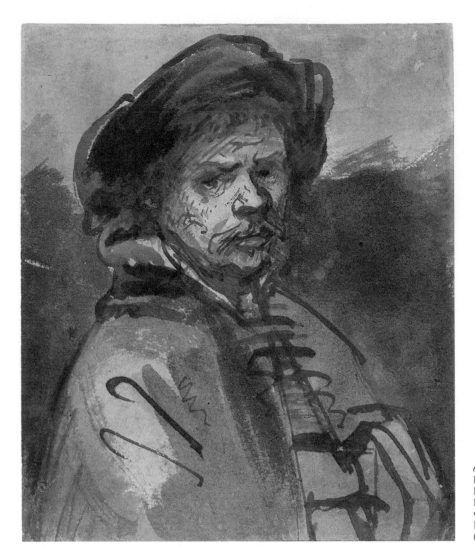

62 *Self-Portrait*, mid-1630s
Rembrandt Harmensz. van Rijn
Dutch, 1606–69
Pen and brown ink, brown and gray
wash; 5¾ x 4¾ in. (14.5 x 12.1 cm.)
Robert Lehman Collection, 1975
(1975.1.800)

REMBRANDT VAN RIJN
Two Self-Portraits

Rembrandt's portraiture, the second major category in his oeuvre, is dominated by his extraordinary self-portraits. Over sixty paintings, more than twenty etchings, and about ten drawings preserve Rembrandt's likeness, from his youth to old age. They are unique: no other artist has left such an extensive and varied visual account of his outward appearance.

The young Rembrandt often used his self-portraits as demonstrations of his precocious ability in handling various effects of dramatic lighting, modulation in shades of color, and the distinctions among the textures of fur, silk, precious metals, and exotic materials. But the inevitable ravages of time and the unexpected loss of his fortune, his reputation, and his young wife took their toll on Rembrandt and left an impression on his painting as well.

The gloomy, penetrating stare of the artist in this rare drawing of the mid-1630s (Plate 62) is rendered with spontaneity and power. Although the washes were probably added by a later hand, Rembrandt's moving characterization of himself has remained undisturbed. A monumental and com-pelling image, it anticipates the mood as well as the broad and expressive technique of his later self-portraits on canvas.

The powerful self-portrait of 1660 (Plate 63) shows Rembrandt at fifty-four, the brazen self-confidence of his youth utterly extinguished. Gone are the ornate and superficial aspects of appearance he was once so gleefully at pains to present; gone are the forced smile and the complicated juxtapositions of light and dark, the rich and delicate renderings of finery, and the lively play of colors. The somber tones of brown and black and the dark, mottled surface of the canvas faithfully convey not only the appearance of the aging painter but his emotions as well.

The prominence of Rembrandt's late self-portraits in the history of art is due both to their indisputable primacy as profoundly penetrating studies of old age, and to their revelation of the artist's mercilessly acute investigation of his own psychology. They are also Rembrandt's analogues for one of the most formidable questions one can ask oneself: Who am I?

63 Self-Portrait, 1660
Rembrandt Harmensz. van Rijn
Dutch, 1606–69
Oil on canvas; 31⅜ x 26½ in. (80.3 x 67.3 cm.)
Bequest of Benjamin Altman, 1913 (14.40.618)

64 Man with a Magnifying Glass
Rembrandt Harmensz. van Rijn
Dutch, 1606–69
Oil on canvas; 36 x 29¼ in. (91.4 x 74.3 cm.)
Bequest of Benjamin Altman, 1913 (14.40.621)

REMBRANDT VAN RIJN

Man with a Magnifying Glass and *Lady with a Pink*

Rembrandt refused to distract his viewers with conventional notions of beauty. His aim in portraiture was to create an image that faithfully captured the internal as well as the external reality of the sitter. The unanswerable question is, did Rembrandt's sitters really have these qualities of introspection and intelligence, or are these qualities of Rembrandt's own mind?

Rembrandt's later work can be characterized by the at-tempt to probe beyond the surface of things, to investigate the world beyond appearance. The composition of the dark, brooding *Man with a Magnifying Glass* and its pendant, *Lady with a Pink*, are complementary, and in both paintings the faces seem to exude an inner radiance at once mysterious and poetic. The magnifying glass that the gentleman holds may refer to his trade as a jeweler or silversmith, though no conclusive identification has yet been proposed.

65 Lady with a Pink
Rembrandt Harmensz. van Rijn
Dutch, 1606–69
Oil on canvas; 36¼ x 29⅜ in. (92.1 x 74.6 cm.)
Bequest of Benjamin Altman, 1913 (14.40.622)

The rich variety of warm earth tones, the heavy surface texture, and the broad brushwork in *Lady with a Pink* are characteristic of Rembrandt's late period. He had begun to construct his portraits in such a way that figures would not communicate directly with the viewer, but rather draw him into their own private worlds of reverie and contemplation. The unidentified sitter in this portrait is clad in the exotic clothing common to a number of Rembrandt's latter por-

traits of close friends and family members. The special meaning of these garments must have been personal and is lost to us. X-ray analysis has revealed the head of a child near the left hand of the woman, which apparently was painted out by the artist, perhaps after the child's death and before the completion of the portrait. Rembrandt has chosen to highlight the dianthus, a symbol traditionally associated with marriage. Here, it may refer to the brevity of life.

HERCULES SEGERS
Rocky Landscape

Many scholars find Hercules Segers the most inventive landscape artist in the history of Dutch painting. Reacting against the cheerful and optimistic landscapes of the early seventeenth century, Segers used a unique blend of natural observation and imaginative reconstruction to create a new kind of landscape that would reflect inner feelings rather than simply capture outward appearances. He was also one of the most innovative printmakers of all time. His technical mastery over the medium of printmaking led him to experiment with alternative chemical procedures. These

66 *Rocky Landscape*
Hercules Pietersz. Segers
Dutch, ca. 1589/90–ca. 1638
Etching and drypoint printed in dark blue-green on paper prepared with a gray-green ground with colored washes; 4⁵⁄₃₂ x 5⁵⁄₁₆ in. (10.5 x 13.5 cm.)
Harris Brisbane Dick Fund, 1923 (23.57.3)

innovations were never taken up by younger artists, however, since Segers, an erratic and very private person, jealously guarded his discoveries. Many of his procedures have yet to be properly understood.

This image depicts a small mountain plateau seen from a considerable distance. To the right is a cluster of mountainside vegetation, to the left a deep ravine. Upon the plateau are a few small houses and, further back, the tower of a church. That which Segers chose not to depict through the use of line, he instead suggested through the forceful and imaginative application of color.

These brooding, enigmatic landscapes were praised by numerous Dutch artists, most notably Philips Koninck and Rembrandt, both of whom owned several of his prints.

PHILIPS KONINCK
Wide River Landscape

Philips Koninck was active as a portraitist and painter of history pictures, but he is chiefly noted today as the foremost painter of landscapes in the style of Rembrandt. Koninck's activity in this light is especially appreciated in view of the extreme rarity of pure landscapes by Rembrandt himself. Following his training in Rembrandt's Amsterdam studio during the 1640s, Koninck painted panoramic views of imaginary landscapes, clearly under the influence of Rembrandt and of the earlier Hercules Segers.

Wide River Landscape is a fine example of Koninck's characteristic style: From horizon to horizon, a vast, level plain falls away from our bird's-eye point of view. A brooding atmosphere—penetrated here and there by feeble sunlight—hovers over this microcosmic perspective.

67 *Wide River Landscape*
Philips Koninck
Dutch, 1619–88
Oil on canvas; 16¼ x 22⅞ in.
(41.3 x 58.1 cm.)
Anonymous Gift, 1963 (63.43.2)

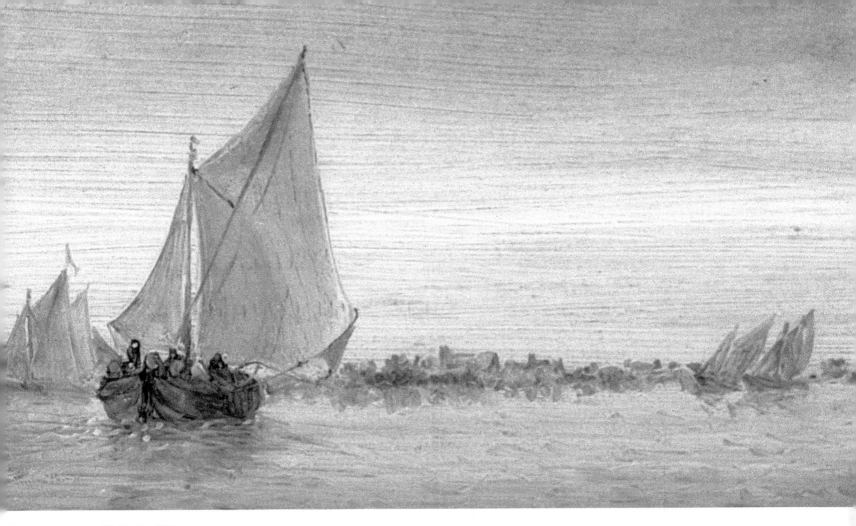

68 Marine, 1650
Salomon van Ruysdael
Dutch, b. between 1600–03–d. 1670
Oil on wood; 13⅝ x 17⅛ in. (94.6 x 43.5 cm.)
Purchase, 1871 (71.98)

Above: detail

SALOMON VAN RUYSDAEL
Marine

The expansion in Dutch overseas explorations during the seventeenth and eighteenth centuries doubtless contributed to the rise of a new genre of painting, namely, the marine. This magnificent 1650 work by Salomon van Ruysdael is an exceptional demonstration of the artist's skill in capturing the effects of light and atmosphere through the use of animated brushwork and dramatic composition. Ruysdael made the sky in his paintings almost the most dominant element of the design. He was a painter who delighted in painting the various moods of nature: the fury of approaching storms, the serenity of a sunny day, and the reflective peace indissolubly linked to the waning light of dusk. The remarkable tonal unity of this lively work has been achieved by the dissolution of local colors into the prevailing tones of silver and blue.

Van Ruysdael played an influential role in Dutch landscape painting at mid-century. The impact of his style on younger artists was considerable, notably on his most gifted student, his nephew Jacob van Ruisdael.

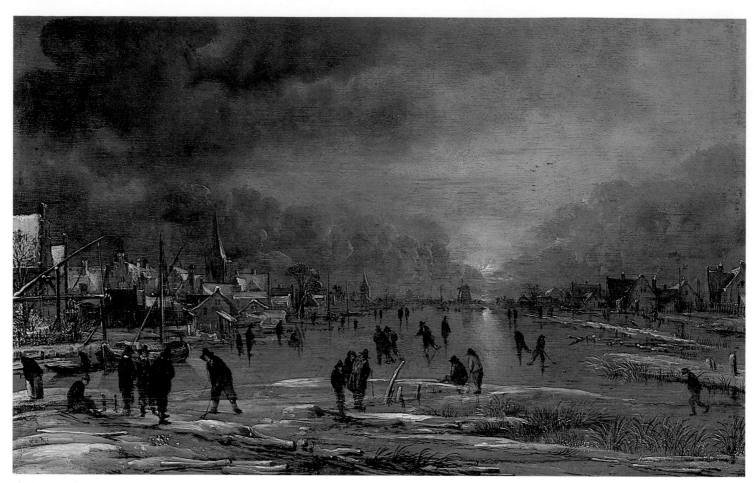

69 Sports on a Frozen River
Aert van der Neer
Dutch, 1603/4–1677
Oil on wood; 9⅛ x 13¾ in. (23.2 x 34.9 cm.)
The Friedsam Collection, Bequest of
Michael Friedsam, 1931 (32.100.20)

AERT VAN DER NEER
Sports on a Frozen River

Aert van der Neer originally took up painting as an ama-
teur. By 1632, when he settled in Amsterdam, he devoted
all his time to painting, though he later ran a small wine
shop in order to supplement his meager income and
support a wife and six children. He is recognized as a mas-
ter of winter scenes and nocturnes. *Sports on a Frozen River* is
among his finest paintings.

 This very small and exquisitely painted work demonstrates
van der Neer's special interest in the effects of light and
atmosphere in winter scenes. Small, humble houses, their
roofs covered with snow, line the banks of a frozen river, on
which several young men skate, playing a game akin to mod-
ern ice hockey. In the distance, a small, solitary windmill is
set against a crimson sunset. Van der Neer's keen eye for
the nuances of color and his remarkable ability to handle
paint are especially evident in the glowing tints of the dis-
tant winter sunset and their diffusion into the crisp air above
the frozen landscape. In this poetic winter scene numerous,
seemingly unrelated activities are united by the dominance
of a single natural motif.

FRANS POST
Brazilian Landscape

Throughout the seventeenth century, Dutch political and economic strategists urged the formation of trading companies that would extend Dutch interests into the Western Hemisphere. In 1636, an expedition left Europe under the command of Count Johan Maurits van Nassau-Siegen (1604–79). In addition to soldiers, Nassau's company included painters, naturalists, botanists, and cartographers. The greatest of the painters to accompany Nassau was Frans Post, who had been recommended by his elder brother, the architect Pieter Post, a favorite of the Dutch court. Post traveled widely with Nassau's expedition and made copious drawings of Dutch colonies, forts, military outposts, and native villages in South America. These drawings furnished him with rich material for the illustration of Nassau's exploits in Brazil, which he began in Haarlem in 1644. The exotic subjects of these views made them widely appreciated.

Post adopted the landscape style used by Haarlem painters in this serene image of native life in the Brazilian wilderness. The interest Post took in topographical and botanical accuracy and his fascination with exotic plant and animal life confirm his reputation as the first and certainly the finest painter of the New World.

70 *Brazilian Landscape*
Frans Post
Dutch, 1612–80
Oil on wood; 24 x 36 in. (61 x 91.4 cm.)
Purchase, Rogers Fund, Gift of Edna H. Sachs and other gifts and bequests, by exchange, supplemented by Museum purchase funds, 1981 (1981.318)

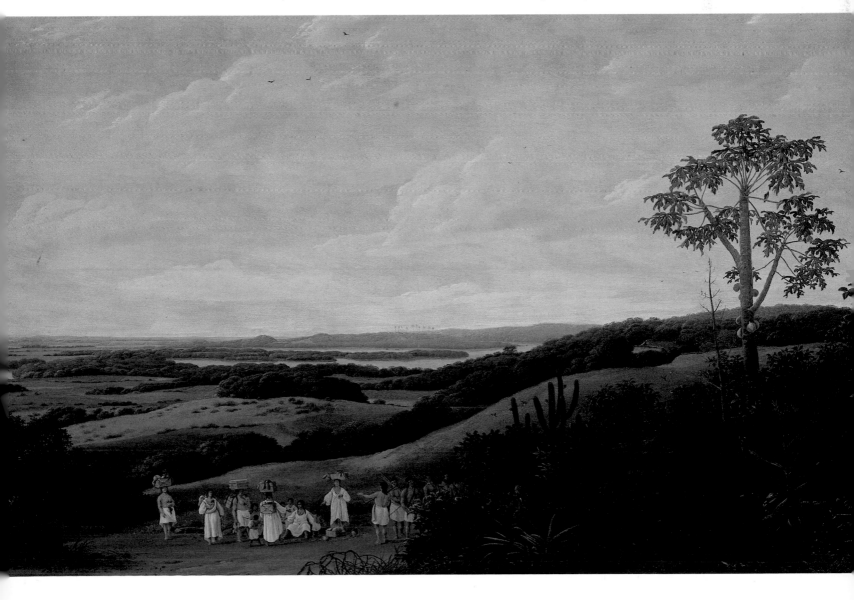

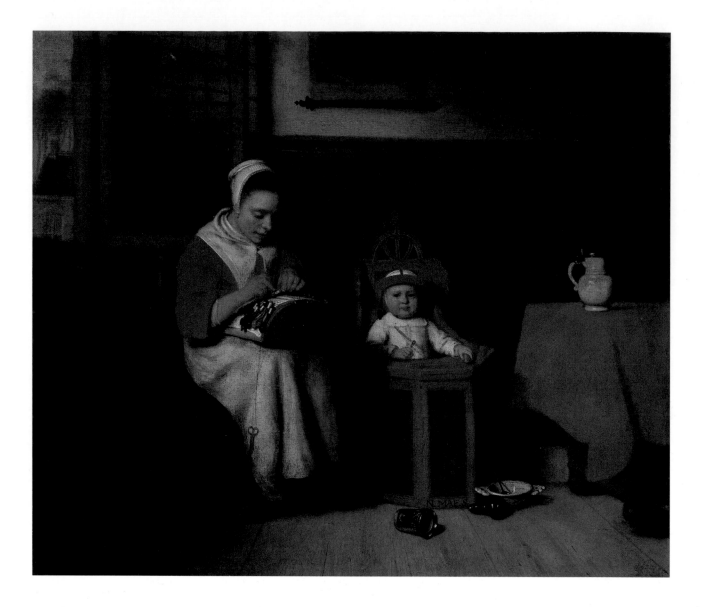

NICOLAES MAES
The Lacemaker

Early in his career during the 1650s, Nicolaes Maes made a specialty of small genre scenes that are usually set in the kitchen.

This painting shows us a young woman making lace as she minds a child who sits beside her. A house and some trees under a fine blue sky can be seen through the open window at left. The child may be responsible for the disarray on the floor—the jug and spoon and two black glasses —the haphazard arrangement of which is countered by the strict horizontals and verticals of the wainscoting, the map, and the window and its lattice work.

Maes's intelligent and charming use of color and the happy and harmonious effect of light and shade suggest the work of de Hooch, but also betray Maes's obvious debt to his teacher, Rembrandt van Rijn. Maes achieved moderate fame with these quiet interior scenes but in the 1660s gave up genre painting and concentrated on elegant portraits done in a courtly manner. These later images rarely have the unaffected appeal of his small, reflective images of domestic tranquillity.

GERARD TER BORCH
Curiosity

Although ter Borch worked in Deventer, outside the larger artistic centers of the United Provinces, he traveled widely and knew contemporary art. This picture of three ladies in a spacious, richly furnished interior shows the increased elegance and complex action that ter Borch developed in his genre scenes of about 1660. The most "aristocratic" of the Dutch genre painters of his generation, ter Borch added to his innate sense of elegance an extraordinary mastery of technique in the rendering of textures and surfaces.

Yet, for all of their exquisite refinement and sense of privacy, ter Borch's genre scenes are never without a touch of humor. This painting, from about 1660, shows a woman wearing an ermine-trimmed dress of midnight blue. She is writing a letter at a table upon which a candle, an inkstand, a pocketwatch, and a second letter (the seal of which has already been broken) are prominently displayed. The letter —it is usually understood to be a love letter—has excited not only the curiosity of one of her two friends, who peers over her shoulder, but also that of the little dog, who looks up inquisitively from his perch on the ottoman.

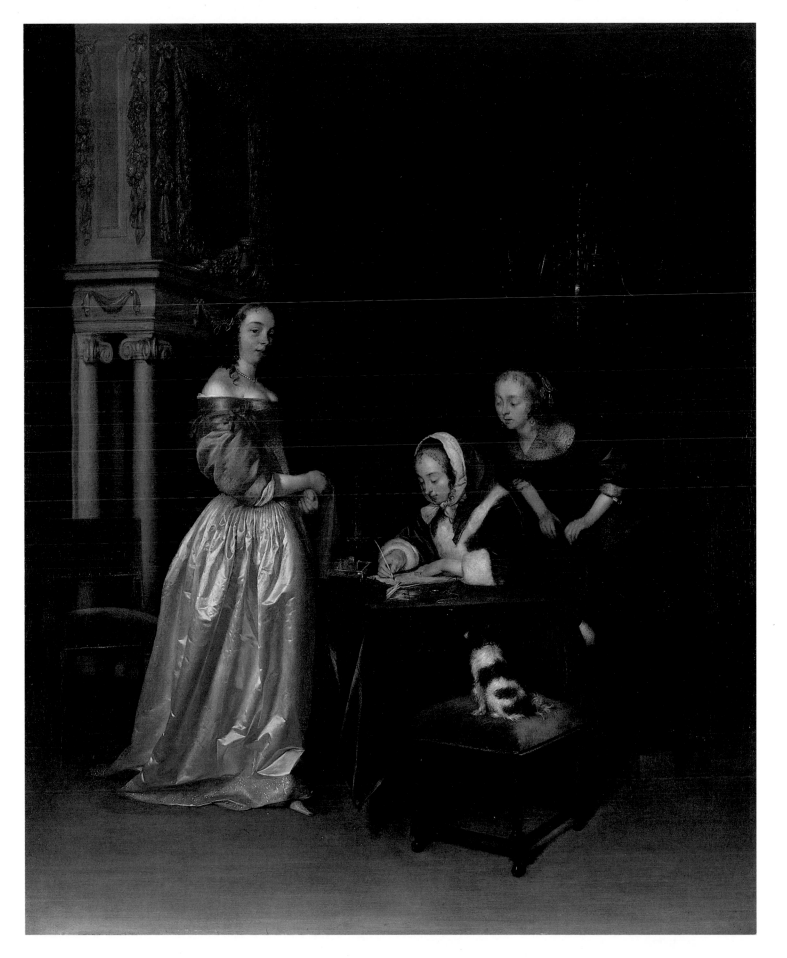

71 *The Lacemaker*
Nicolaes Maes
Dutch, 1634–93
Oil on canvas; 17¾ x 20¾ in. (45.1 x 52.7 cm.)
The Friedsam Collection, Bequest of Michael
Friedsam, 1931 (32.100.5)

72 *Curiosity*, ca. 1660
Gerard ter Borch
Dutch, 1617–81
Oil on canvas; 30 x 24½ in. (76.3 x 62.3 cm.)
The Jules Bache Collection, 1949 (49.7.38)

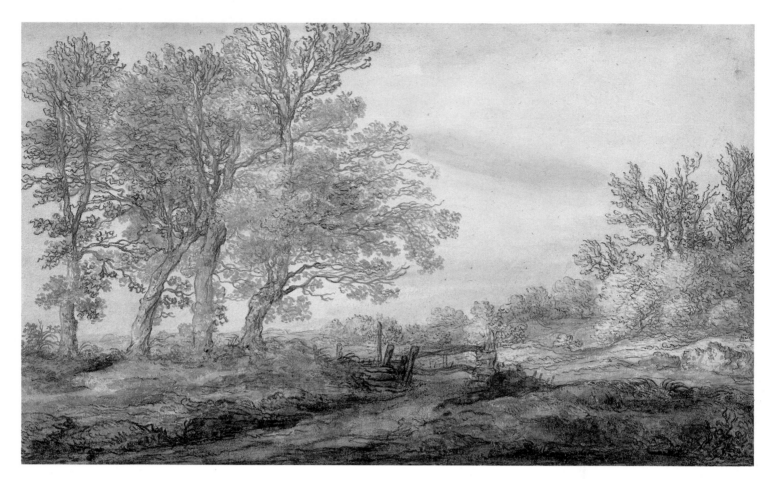

73 Landscape with Trees
Aelbert Cuyp
Dutch, 1620–91
Watercolor and gouache, black chalk;
7⅜ x 12¹/₁₆ in. (18.6 x 30.7 cm.)
Rogers Fund, 1907 (07.282.14)

AELBERT CUYP
Landscape with Trees

Cuyp was probably in his early twenties when he made this fine drawing of the Dutch countryside. The Metropolitan's sheet and a companion study formerly in the Brower Collection at Central College, Pella, Iowa, belong to a group of drawings executed in and around Utrecht, his mother's hometown. The artist would have visited that city on a number of occasions because it is also where his father, Jacob Gerritz. Cuyp, had been apprenticed to the Dutch Mannerist painter Abraham Bloemaert.

While the pendant study is close to this one in subject, technique, and size, and is related to a painting in Vienna, the Metropolitan's drawing is an independent work of exceptional quality. Stylistically, it pays homage to Bloemaert in the flickering, broken lines that render the gate and trees and in the stippled application of wash in the foliage and lush undergrowth. The washes of mustard yellow unifying the softly undulating ground and trees also reflect the influence of the great Dutch landscape painter Jan van Goyen.

AELBERT CUYP
Young Herdsman with Cows

Aelbert Cuyp enjoyed considerable success during his career, and he was held in high esteem by his colleagues. He became a prominent figure in the society of his native town of Dordrecht. In 1660 he became deacon of the Dutch Reformed community and later served as a member of the Dordrecht High Court. Though he was regarded in his own time as a portraitist, he is best known today for his pastoral landscapes and river scenes.

This painting shows a harmoniously balanced group of cows bathed in the limpid hues of fading sunlight. Behind and to the right of the cows, a jovial young herdsman converses with a young woman and a little boy in a wide-brimmed hat. A river and several hills recede into the distance, and a stork flies overhead.

The ruminating cows that are the true protagonists of this picture are stately and graceful. Cuyp often chose to paint cows of warmish brown and tan hues, perhaps out of his preference for golden tonalities, since most all cows in Holland then were black and white. Cuyp strove to convey a sense of warmth and repose in the Dutch countryside.

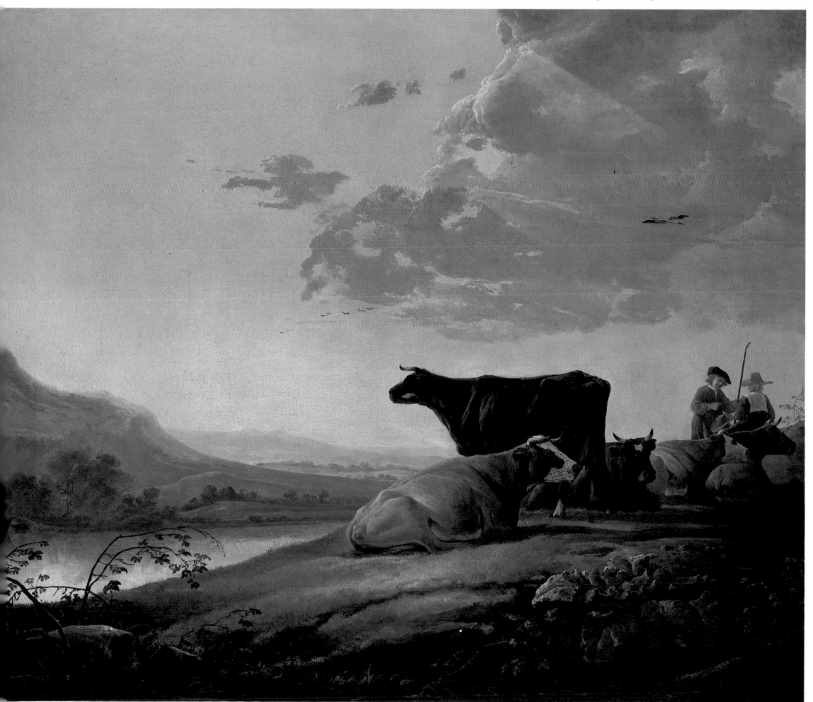

74 Young Herdsman with Cows
Aelbert Cuyp
Dutch, 1620–91
Oil on canvas; 44⅛ x 52⅛ in. (112.1 x 132.4 cm.)
Bequest of Benjamin Altman, 1913 (14.40.616)

75 *Merry Company on a Terrace*
Jan Steen
Dutch, 1625/26–1679
Oil on canvas; 55½ x 51¾ in.
(141 x 131.4 cm.)
Fletcher Fund, 1958 (58.89)

Page 100: text

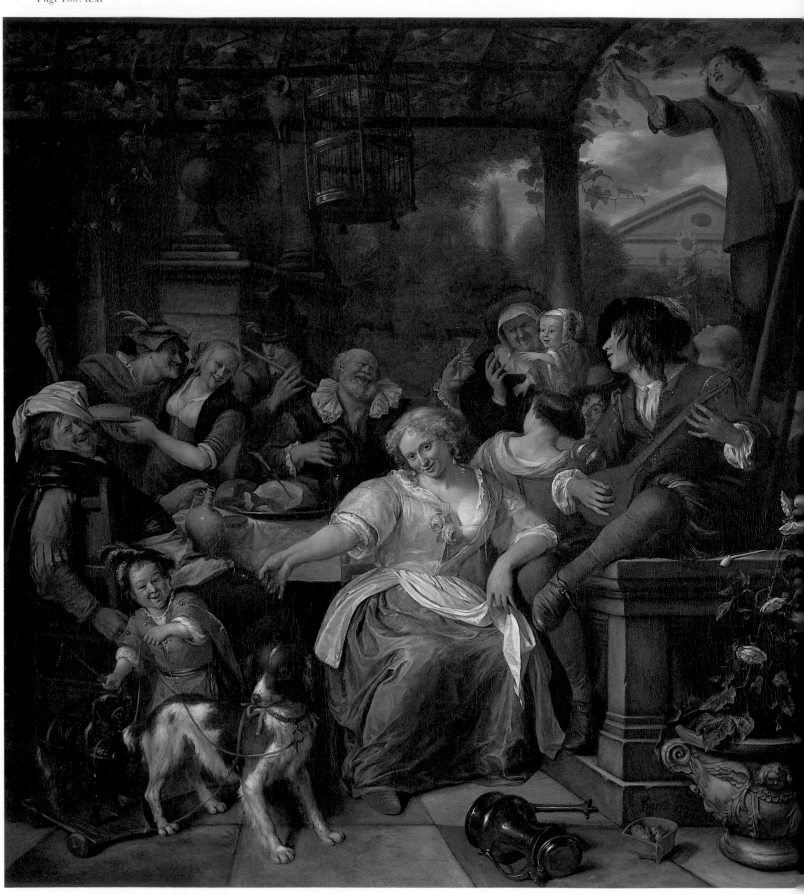

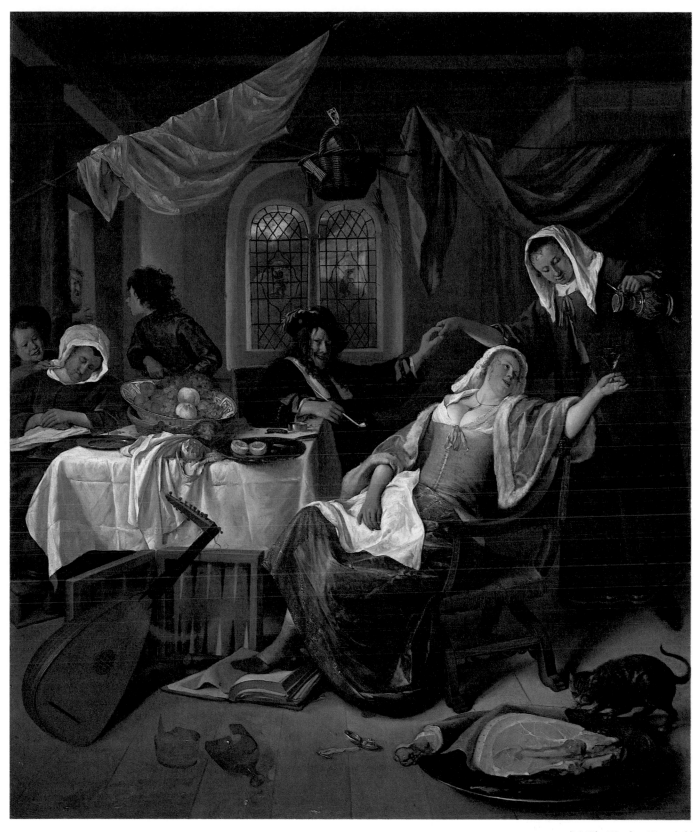

76 The Dissolute Household
Jan Steen
Dutch, 1625/26–1679
Oil on canvas; 42½ x 35½ in.
(108 x 92.2 cm.)
The Jack and Belle Linsky
Collection, 1982 (1982.60.31)

Page 100: text

JAN STEEN (Pages 98–99)

Merry Company on a Terrace and
The Dissolute Household

Merry Company (Plate 75) is a wonderful example of the cheerful yet sardonic works Jan Steen made late in life, when he turned what was originally a moralizing motif into an earthy investigation of how people seek and find enjoyment. Steen supplemented the meager income he made as a painter by running a tavern, and he was well acquainted with the dubious morality that abounded in such places.

The vulgar man dressed as a fool in the background with protruding tongue and lecherous stance is Hans Worst, a stock character of Dutch comedy. He seems to be vying with the flautist and the dissolute and disheveled man for the attentions of the young blond. To the right, a grandmother holds a child who reaches for a glass of sherry held by a huge, barrel-chested man. The sunflower above the head of the woman at the far right traditionally had two very different symbolic meanings: respectful admiration or outright lust. In the center, a buxom, cheerful, and somewhat tipsy young woman smiles broadly. The jovial and rotund fellow at the left is a self-portrait of Steen himself.

The owl that watches over the merry group should not be interpreted as a symbol of the wisdom that stands apart from this recklessness and disorder. In Holland, the owl symbolized stupidity and drunkenness.

Jan Steen's *Dissolute Household* (Plate 76) is a seventeenth-century heir to the domestic allegories of Pieter Bruegel and his school. The wealthy, satiated middle-class family in this painting has just finished a sumptuous meal. The malevolently grinning and inebriated head of the household smokes a pipe. The housekeeper, who is placed before the bed, lewdly joins her hand in his and simultaneously pours the wife another glass of wine. The upturned backgammon set in the center may refer either to idle pleasures or a change in fortune. Dutch scholars have proposed that the lute with broken strings may also refer to the character of the woman in the foreground: The word "lute" (*luit*) was a slang term for female private parts, and the immodestly dressed woman, whose foot tramples the Bible, is arranged in a position that mirrors that of the instrument. As one of the two young boys on the left tickles the sleeping woman, the other draws his sword in an effort to repel a beggar. The food for which the latter begs is neglected by everybody but the industrious family cat.

The fate of these infinitely corruptible figures is indicated by the basket overhead, which holds instruments of justice (the sword and the switches) suggesting impending judgment, as well as articles long associated with the sick and the lame, a reference to the inevitable result of sloth and indolence. The military flag refers to a career in the service, and its presence here suggests neglected duty.

JOHANNES VERMEER
Young Woman with a Water Jug

Little is known about Johannes Vermeer of Delft, the man universally recognized as the artist who raised Dutch genre painting to its highest level. He supported himself by working as an art dealer since the care he took in the creation of his paintings and his long working time severely limited his artistic output as well as his income. Vermeer painted no more than forty works, but no artist can claim a higher percentage of masterpieces.

This painting dates from the early 1660s, when Vermeer began to simplify the structure of his interior settings so that he could concentrate more fully on his primary interests: the careful rendering of the distinctions between direct and indirect sunlight as they are reflected off polished and matte surfaces, the diffusion of outdoor light in an interior space, and the variability of qualities in surface textures. The basin and ewer are thought to have signified purity to seventeenth-century viewers and, if so, would be the only symbolic or allegorical features in what is otherwise an optically precise study of a pleasant Dutch interior. The quiet, utterly peaceful subject matter, the perfectly balanced composition, the crystalline clarity of the light, and the calm and subtle tonalities of blue and silver make this an exceptionally fine example of Vermeer's genius.

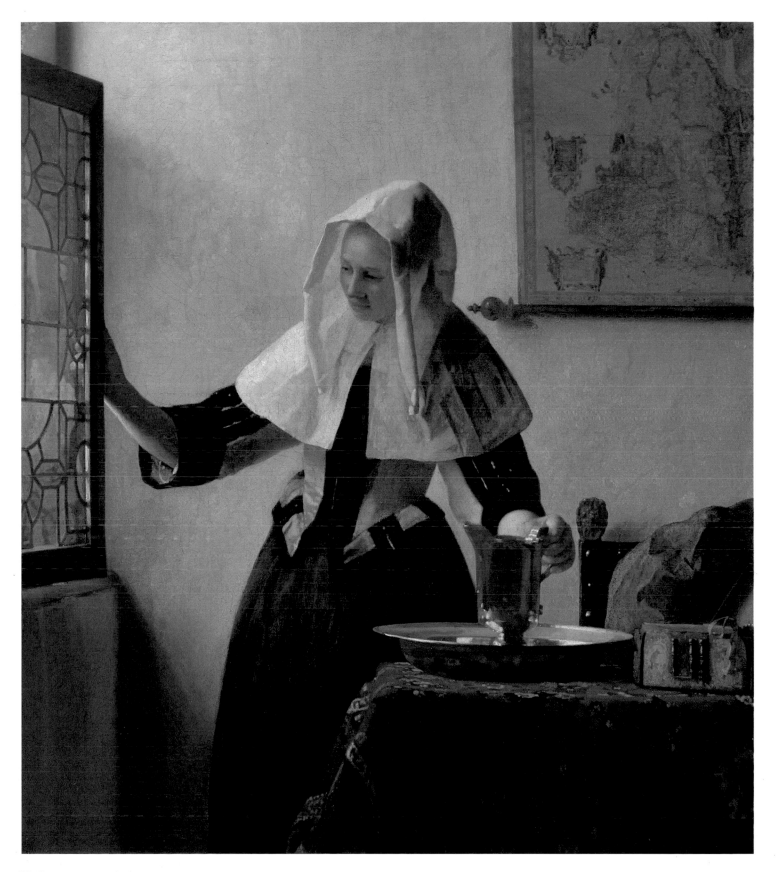

77 *Young Woman with a Water Jug*
Johannes Vermeer
Dutch, 1632–75
Oil on canvas; 18 x 16 in. (45.7 x 40.6 cm.)
Marquand Collection, Gift of Henry G.
Marquand, 1889 (89.19.21)

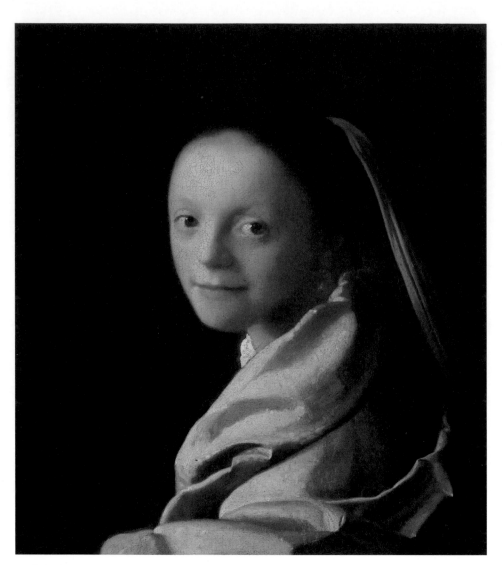

78 Portrait of a Young Woman
Johannes Vermeer
Dutch, 1632–75
Oil on canvas; 17½ x 15¾ in. (44.5 x 40 cm.)
Gift of Mr. and Mrs. Charles Wrightsman,
1979 (1979.396.1)

79 Allegory of the Faith
Johannes Vermeer
Dutch, 1632–75
Oil on canvas;
45 x 35 in. (114.3 x 88.9 cm.)
The Friedsam Collection, Bequest of
Michael Friedsam, 1931 (32.100.18)

JOHANNES VERMEER
Portrait of a Young Woman

The figures in Vermeer's paintings are usually presented in a meticulously arranged interior, surrounded by a variety of props and illuminated by a still, golden light. On occasion, however, Vermeer painted isolated portraits, among them this startlingly eloquent and haunting painting of a young woman, which is recognized as one of his finest achievements.

Vermeer uses a deceptively simple composition. The young lady is posed with her head turned to a three-quarter position over her left shoulder. Her dark brown hair is pulled back tightly from her high white forehead, revealing a beautiful pearl earring. Her lips are slightly parted as if she were ready to speak. The young lady's searching, expectant expression seems to be a response to the viewer and imparts a quality that is both immediate and remote. The enigmatic smile of this solitary figure is enhanced by subtle nuances of shade, the subdued palette of blues and grays, and the timeless, Classical costume in which she is presented.

In technique and lighting, this painting is closely related to Vermeer's celebrated *Portrait of a Girl* in the Mauritshuis, The Hague.

JOHANNES VERMEER
Allegory of the Faith

This work, known as *Allegory of the Faith*, was painted during a period in Dutch history when allegories were beginning to replace overtly religious pictures. An unusually large canvas for Vermeer, this is one of the two known paintings of his that have explicit allegorical content. Vermeer is believed to have been a Catholic, and this work may have been commissioned by a Catholic institution.

Northern allegories of the Catholic faith were limited to a rather specific iconography. The woman here is a personification of Faith; the crushed snake in the foreground represents the triumph over sin. The colors worn by Faith, white and blue, may represent the virtues of purity and truth.

Despite the allegorical subject matter, Vermeer remains concerned with the depiction of objects, space, and light. The simplification and hardening of the light in this painting are characteristic of the artist's late style; the depiction of light on out-of-focus foreground objects such as the tapestry curtain may be due to the artist's use of a camera obscura, a light-tight box with a convex lens at one end and a screen at the other, which Vermeer could have used as an aid in the creation of difficult optical effects.

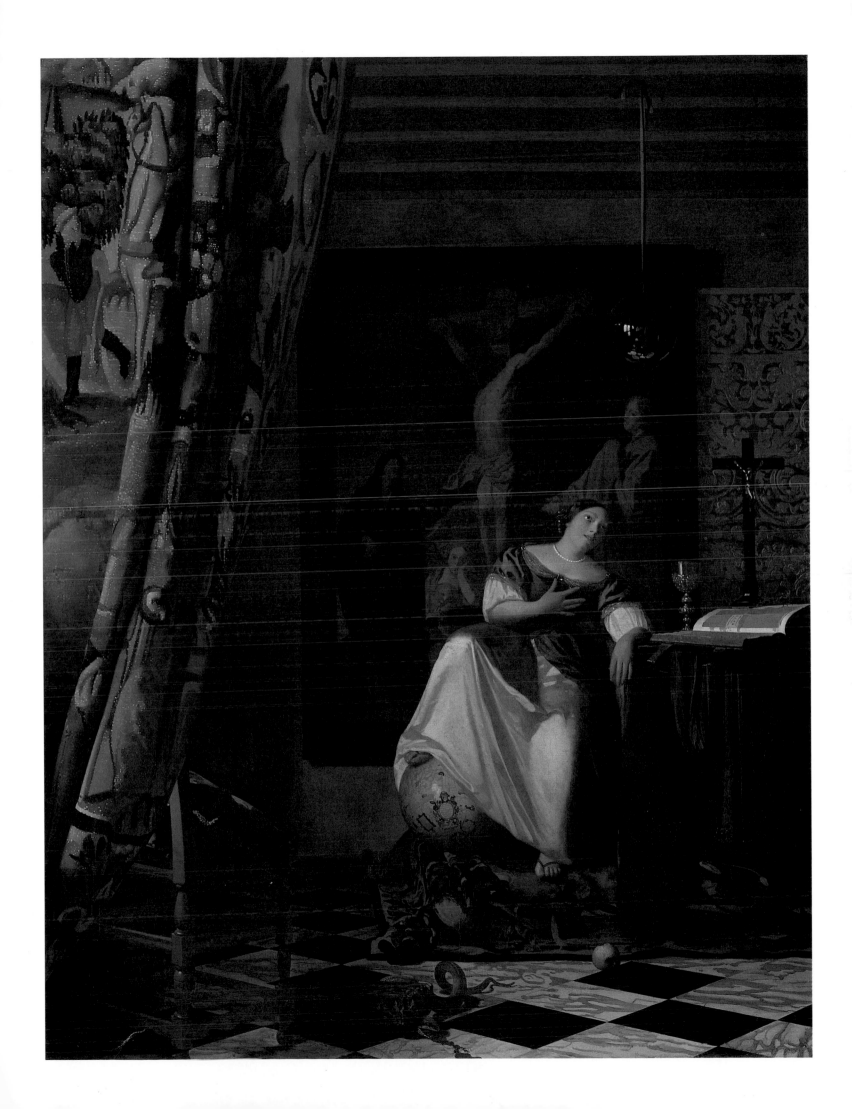

HENDRICK VAN VLIET
Interior of the Oude Kerk, Delft

Church interiors were important motifs in Dutch painting, especially in the 1660s and 70s. The interior space of the Oude Kerk in Delft was a special favorite of architectural painters due to its unusual complexity and consequent effects on light and shade. Van Vliet painted several interior views of the Oude Kerk and the Metropolitan's picture is one of his very finest.

The viewpoint is from the south side aisle looking northeast toward the crossing where the pulpit and box are located and beyond into the Chapel of the Virgin at center and the transept at left. The crisp architectural detailing and light tonalities of the background are contrasted with the gently diffused light of the middle ground where the figure of a man can be seen digging to prepare a grave.

Paintings such as this had a twofold purpose: They were intended to be literal descriptions of actual churches and to contain rather broad symbolic significance as well. The graves in the middle distance of this painting, for instance, allude to the brevity of life on earth, in contrast to the eternal life with God.

80 Interior of the Oude Kerk, Delft
Hendrick Cornelisz. van Vliet
Dutch, 1611/12–1675
Oil on canvas; 32½ x 26 in. (82.6 x 66 cm.)
Gift of Clarence Dillon, 1976 (1976.23.2)

O V E R L E A F :

JACOB VAN RUISDAEL *(Pages 106–107)*
Wheatfields

Jacob van Ruisdael was the greatest and probably the most influential of all the Dutch landscapists. With extraordinary sensitivity to the ever-shifting nuances of atmosphere and light, Ruisdael used his skills to portray the natural beauty of his native Holland, and in his landscapes he sought to express as well the majestic and incontestably supreme power of nature.

This picture shows a well-dressed gentleman approaching a fork in a road, walking toward a young woman with a child in tow, who stands just before a thick, dark patch of shadow. Distant ships sailing into the mist can be seen on the far left, and beyond the grove of trees is a shepherd with his flock. The tiny figures who populate Ruisdael's canvases—indeed, all human activities—are ultimately dwarfed by the alternating patches of shadow and sunlight, the vast canopy of sky and immense, towering clouds. This vision of nature is impressive and powerful yet never loses its wistful, melancholic beauty.

Van Ruisdael was born in 1628 or 1629, the son of a frame maker who occasionally painted. His real teacher, however, was his uncle, Salomon van Ruysdael.

81 Wheatfields
Jacob van Ruisdael
Dutch, 1628/29–1682
Oil on canvas;
39⅜ x 51¼ in. (100 x 130.2 cm.)
Bequest of Benjamin Altman,
1913 (14.40.623)

Page 105: text

MEINDERT HOBBEMA
Woodland Road

Meindert Hobbema studied with Jacob van Ruisdael in Amsterdam in the 1650s and was often Ruisdael's companion on his frequent sketching trips. Although this picture was painted after 1670, much of the composition of Hobbema's *Woodland Road* depends upon paintings by Ruisdael. The radiance of the vegetation and the lively play of light and shadow, however, are hallmarks of Hobbema's independent personality.

Hobbema's country landscapes are generally lighter than Ruisdael's in tone as well as in mood. The present picture shows a hunter with shotgun and hound walking along a muddy country road accompanied by a peasant. Another figure can be seen in the background on the road in front of a fenced-in forest. A woman looks out from a half-door in the cluster of low cottages to the right. In the enclosed meadow on the left, a man and woman walk arm in arm. As in paintings by Ruisdael, the most careful attention is given to the huge leafy trees, massive clouds, and immense, seemingly limitless sky, affirming our impression that the real subject of this picture is the almost mystical power of nature.

Hobbema's activity as a painter seems to have decreased considerably after his appointment in 1668 to the lucrative post of customs and excise officer, a position he held for the rest of his life. Nevertheless, Hobbema produced a number of outstanding works as late as 1689.

83 *Henry Frederick, Prince of Wales,
and Sir John Harington*
Robert Peake, the Elder
English, act. 1576–1626
Oil on canvas;
79½ x 58 in. (201.9 x 147.3 cm.)
Purchase, Joseph Pulitzer Bequest,
1944 (44.27)

ROBERT PEAKE, THE ELDER

Henry Frederick, Prince of Wales, and Sir John Harington

Prince Henry Frederick (1594–1612), the first-born child of King James I of England, was beloved by the court as well as by the church and the common people for his honesty and devoutly Christian outlook. Henry Frederick's virtues were particularly striking when contrasted with the extravagant life of his father the king.

Peake's double portrait is believed to commemorate the prince's visit to Burley-on-the-Hill, Rutlandshire, the residence of John, first Lord Harington, during the royal progress of King James from Scotland to London in 1603. With Henry is shown the eleven-year-old Sir John Harington, whose father had played host to the king on several occasions. This painting shows Henry triumphantly sheathing his sword after having successfully slain a stag, whose antlers are held by the young Harington. The prince's horse and hound complete the group, which is additionally decorated by the Harington coat of arms, displayed on a shield that hangs from a tree behind Sir John. Above Henry is the coat of arms of the English royal family.

Prince Henry died of typhoid fever before he reached his nineteenth birthday and was eulogized by the great English poet John Donne.

SIMON OWEN
Rosewater Ewer and Basin

When not in use, this rosewater ewer sat in the middle of the basin where a central ring was provided to hold the foot. This area was often engraved or fitted with an enameled disc showing the armorial bearings of the owner, since such items were for the use of prominent people who would hold out their hands over the basin to be ceremonially cleansed with a flow of perfumed water from the ewer.

At the center of our basin is the badge (personal emblem) of the prince of Wales, who had just been invested at the time the set was marked in London. He was Henry Frederick, son of James I of England (James VI of Scotland), during whose reign England and Scotland were joined under one sovereign. A royal goldsmith made this and a similar set, which is still used in the chapel of Eton, near Windsor.

The design of Tudor roses alternating with marine monsters was used often at this time—the monsters deriving from Flemish engravings by artists such as Hans Collaert.

A further foreign influence is seen in the chased and matted background designs, freely based on ground decoration found on contemporary Chinese porcelain, then being imported in large numbers.

84 Rosewater Ewer and Basin
Simon Owen
English, act. London 1595–1624
Silver gilt; H. of ewer 16 in. (40.6 cm.)
D. of basin 15¾ in. (40 cm.)
Gift of Irwin Untermyer, 1968 (68.141.135,136)

Monteith

The monteith came into use in England in the seventeenth century. Initially produced in silver, this rare example in English flint glass was made at the end of the century. The design of the form, essentially a large bowl with a scalloped or notched rim, allows wine glasses to be suspended by their feet from the openings in the rim while the water in the bowl cools the bowls of the glasses. This monteith is presumed to have been made to commemorate the marriage of William Gibbs and Mary Nelthorpe. Their coat of arms and the date *1700* appear on the side visible here.

The diamond-point engraved decoration around the bowl is arranged in six panels roughly determined by the positions of the wide notches in the rim and divided by columns with Corinthian capitals. The panels contain naive renderings of genre scenes and the coat of arms. A festooned garland cuts across each panel, and in each loop of the garland is a large capital letter. Together, the letters spell "William Gibbs Esq." A single trailed glass thread separates the bowl from the rim where moralistic inscriptions in different languages ornament the spaces between the notches.

Michael Rysbrack
Bust of John Barnard

Michael Rysbrack, Flemish by birth, became the leading sculptor of the Augustan Age in England. He is remembered chiefly for psychologically perceptive busts of statesmen and writers, but this bust of a rather sad-looking little boy finds him no less acute. Possibly, it is a posthumous portrait, and the child may have been a son of the bishop of Raphoe in northern Ireland. If that is so, it might be taken as a sign of the affluence of the English community in northern Ireland that a clergyman there could afford the services of the sculptor most in demand at the time.

86 Bust of John Barnard, 1744
Michael Rysbrack
Flemish, act. chiefly in England, 1694–1770
Marble; H. 17⅛ in. (43.5 cm.)
Purchase, Gift of J. Pierpont Morgan, The Moses
Lazarus Collection, Gift of the Misses Sarah and
Josephine Lazarus, Bequest of Kate Reed Blacque,
in memory of her husband, Valentine Alexander
Blacque, Bequest of Mary Clark Thompson, and
Bequest of Barbara S. Adler, by exchange, 1976
(1976.330)

85 Monteith
English, 1700
English flint glass; H. 6⅝ in. (16.8 cm.)
Bequest of Florence Ellsworth Wilson,
1943 (43.77.2)

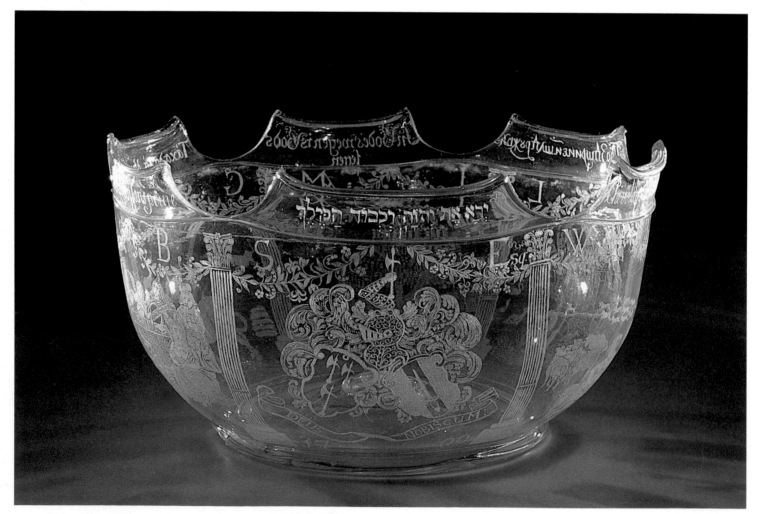

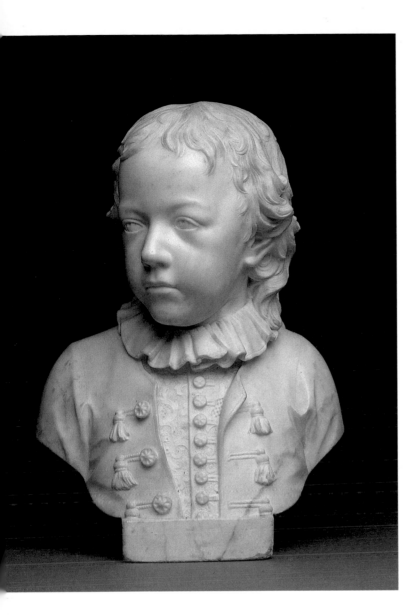

87 *Teakettle and Spirit Lamp with Tripod Table*
Simon Pantin
English, act. 1701–28
Silver; H. 40 in. (101.6 cm.)
Gift of Irwin Untermyer, 1968 (68.141.81a–f)

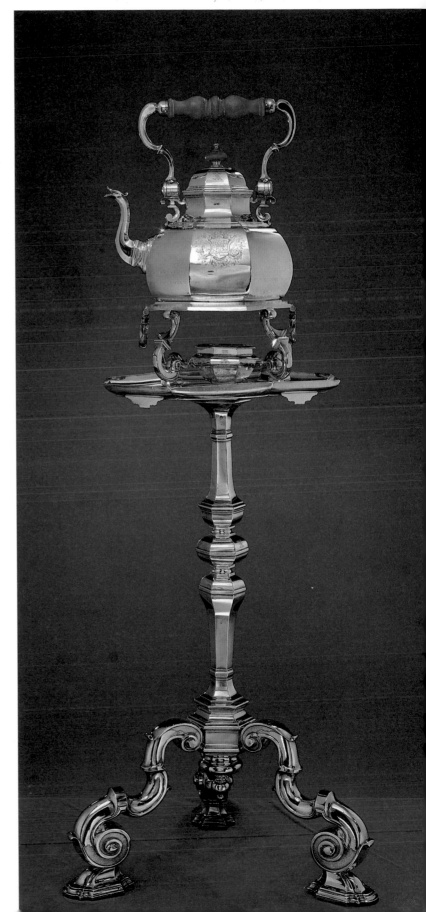

SIMON PANTIN

Teakettle and Spirit Lamp with Tripod Table

The kettle with its stand and spirit burner and its accompanying solid silver tripod table is the most important surviving work of the justly celebrated Huguenot silversmith Simon Pantin, who was active in London in the first three decades of the eighteenth century. He enjoyed the patronage of influential, fashionable clients, such as the king himself and the owners of this piece of tea equipment, George Bowes and his wife, Eleanor Verney, daughter and sole heir of an immensely wealthy father. Their coat of arms appears engraved on the kettle and the tabletop, which, somewhat unusually, can be unscrewed from the table shaft to form a salver standing on four feet. These feet, the octagonal shape of the tabletop with its upwardly curving rim, and the octagonal plan of the kettle itself derive from Chinese forms that were familiar in London at the time in both lacquers and porcelains.

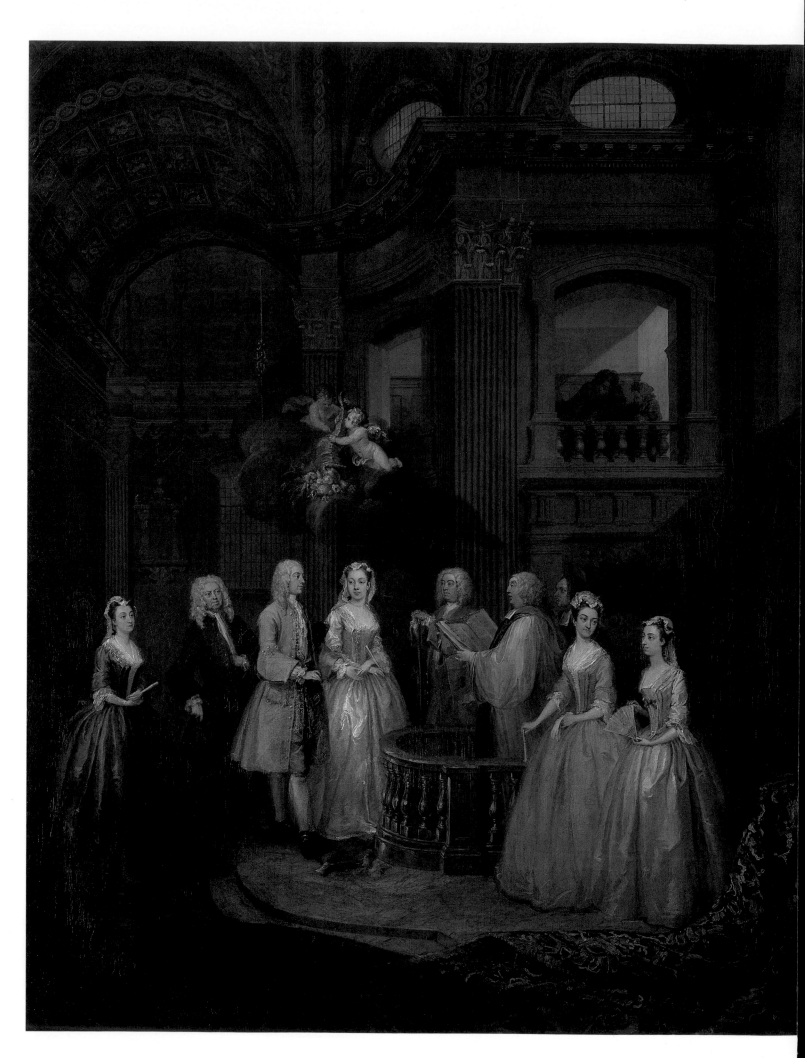

WILLIAM HOGARTH
The Wedding of Stephen Beckingham and Mary Cox

The wedding of Stephen Beckingham and Miss Mary Cox of Kidderminster took place on June 9, 1729 and was recorded in this early work by William Hogarth. The young couple stands at the altar, bathed in celestial light. Stephen, with ring in hand, looks eagerly at Reverend Thomas Cooke, who conducts the service. Stephen, like his father, was a barrister at Lincoln's Inn.

Though Hogarth later became known primarily for his satirical prints, this early work shows him to be especially gifted in his portrayal of narrative. Each figure has been given a quite specific emotional reaction to the event taking place: excitement, pride, nervousness, or envy. Though Hogarth accurately recorded the Queen Anne architecture of Saint Benet's Church at Paul's Wharf, he chose also to include the fanciful figures of the hovering putti, who discharge a cornucopia of fruit and flowers, alleviating what might otherwise have been an unnecessarily solemn painting.

AFTER WILLIAM HOGARTH
Marriage à la Mode

In his prints, William Hogarth displayed less interest in the taste of wealthy collectors than in the moral sensibility of the general public. Inexpensive and easily reproducible, Hogarth's prints were intended to appeal not to an esoteric elite, but to the common man.

In the two preceding prints of this series—engraved after paintings by Hogarth—the artist had established the couple as degenerate and indulgent. This third scene, "The Inspection," depicts the increasing profligacy of Lord Squanderfield, who, denying a seat to his diseased child-mistress, sits with a couple of pillboxes and an upraised cane, apparently returning the ineffective "medicine" that was meant to cure his illness. The scabrous and unsavory quack at the left stands next to a female criminal who wields an upraised knife. The placement of the pillbox on the chair and the beauty patches that cover the young man's cancerous sores indicate that the ailment from which he suffers is syphilis.

88 *The Wedding of Stephen Beckingham and Mary Cox,*
1729
William Hogarth
English, 1697–1764
Oil on canvas; 50½ x 40½ in. (128.3 x 102.9 cm.)
Marquand Fund, 1936 (36.111)

89 *Marriage à la Mode* (Plate 3)
[After William Hogarth], 1745
Engraved by Bernard Baron
English, 1700?–66
Engraving; 15³⁄₁₆ x 18⅜ in. (38.5 x 46.7 cm.)
Gift of Sarah Lazarus, 1891 (91.1.109)

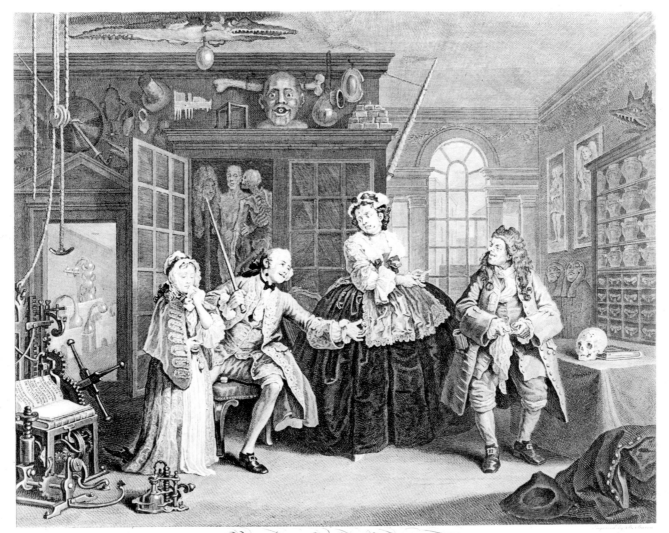

Marriage A-la-Mode. (Plate III)

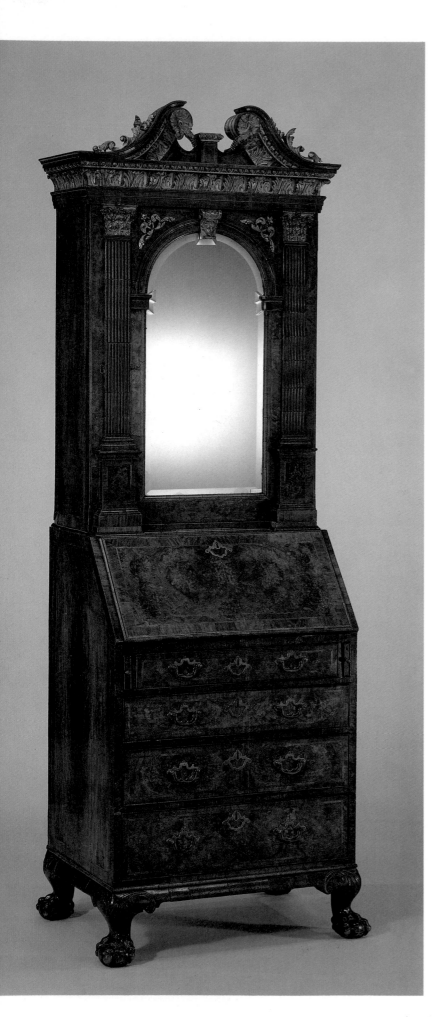

BUREAU-CABINET

Although little is known about the origin of this bureau-cabinet, its general outline reveals the maker's awareness of the latest architectural fashions. It was made about 1730–40 during the time when, in reaction to Baroque exuberance, artists, architects, and designers began returning to classicism. Though the bureau-cabinet, with its narrow proportions, does not exhibit the massiveness of some contemporary pieces, it does share their architectural idiom, seen here in the entablature supported on fluted pilasters with Corinthian capitals and the elegantly carved swan-neck pediment. The beveled mirror is treated like an arch, its keystone decorated with a female mask. This architectural character is enhanced by the gilding on the pilasters, cornice, and pediment. The interior of the writing section and cabinet, set with Corinthian and Ionic pilasters and a triangular pediment, is treated according to the same dignified plan.

90 Bureau-Cabinet
English, ca. 1730–40
Oak, walnut, gilded and carved limewood, gilt
bronze; 82½ x 29 x 21 in. (209 x 73.5 x 53.5 cm.)
Gift of Irwin Untermyer, 1964 (64.101.1110)

ROOM FROM KIRTLINGTON PARK

Kirtlington Park near Oxford was built for Sir James Dashwood between 1742 and 1746 by William Smith and John Sanderson. The three windows in this room once overlooked the garden, laid out by Capability Brown. Most of the elements here are authentic, such as the oak floor and the mahogany doors and shutters, as well as the richly carved marble chimney piece and the overmantel painting signed by John Wootton and dated 1748. But most important of all are the beautiful plaster decorations, partly in high relief, thought to have been executed by Thomas Roberts of Oxford. Although some of Sanderson's designs for this room show fully developed Rococo ornament, the actual decoration of walls and ceiling was executed in a less vigorous style. For a dining room (as this used to be), plasterwork was much preferred to tapestries and wall hangings, which would retain the smell of food. The four central ceiling panels, emblematic of the seasons, as well as the delicately carved Bacchantes on the overmantel, are not inappropriate for a room where the fruits of nature were to be enjoyed.

91 Room from Kirtlington Park
English, 1742–48
Wood, plaster, and marble;
H. 20 ft. (6.09 m.)
Fletcher Fund, 1932 (32.53.1)

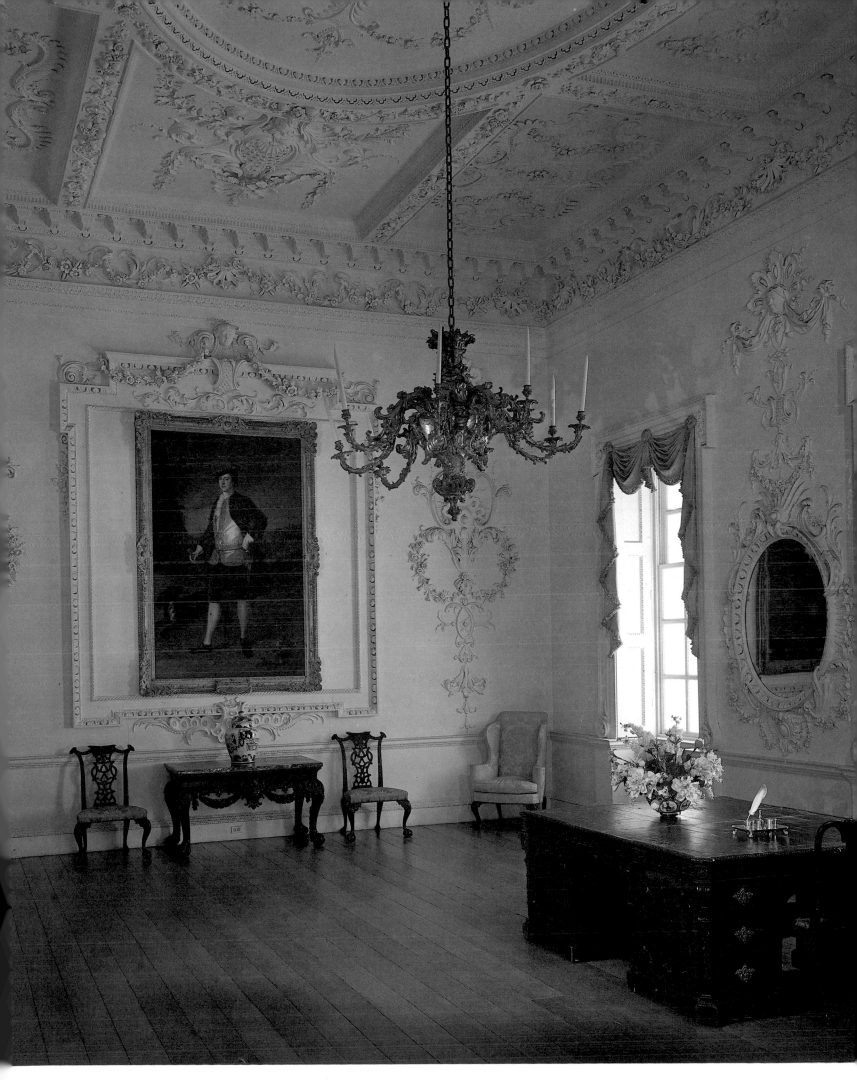

92 *The Assumption of the Virgin*, 1632
Adam Lenckhart
Austrian, 1610–61
Ivory; H. 10⅞ in. (27.6 cm.)
Bequest of Mary Clark Thompson,
1923 (24.80.88)

JOACHIM FRIESS
Automaton: Diana and the Stag

Renaissance Augsburg was, after Nuremberg, the greatest of the German manufacturing and commercial cities, and a ready supply of silver enabled its guild of goldsmiths to fashion prodigious numbers of richly ornamented vessels for export. Although Augsburg's trade declined somewhat in the course of the sixteenth century, its goldsmiths remained prosperous.

This whimsical representation of the goddess Diana, armed with bow and arrows, riding a richly caparisoned stag, and attended by hounds and a tiny cupid perched beside her on the stag's rump, was made about 1619 by Joachim Friess.

Diana, designed in a svelte, Late Mannerist style, is seated on a hollow-bodied stag with a removable head that functions as a drinking vessel. A spring and fusee mechanism in the base can be wound up and the automaton propelled around a table top on wheels concealed in the base. When used for drinking games, the stag was filled with liquid, the spring released, and the automaton allowed to run freely until it came to a halt before one of the participants, who then had to drain the stag of its contents.

Diana's bow and arrows and the jewels set in the trappings of the stag are modern replacements.

93 *Automaton: Diana and the Stag*, ca. 1620
Joachim Friess
German (Augsburg), ca. 1579–1620
Case of silver, partly gilded and enameled, and
set with jewels, with movement of iron and wood;
H. 14¾ in. (37.5 cm.)
Gift of J. Pierpont Morgan, 1917 (17.190.746)

ADAM LENCKHART
The Assumption of the Virgin

The composition is divided into two zones, with the swooning Virgin above borne to heaven on a cloud of buoyant angels, while astonished Apostles congregate below; this reflects the longevity of the formula first devised by Titian for his altarpiece in the church of the Frari in Venice, painted in 1518. However, the strongly individualized reactions and air of consternation that characterize the Apostles in Lenckhart's relief set it quite apart from the majestically orchestrated composition of its Italian forebear. So, too, does the fully Baroque conception of the Virgin herself.

Lenckhart was one of the early virtuosos of ivory carving, combining a refined and elegant technique with a powerful command of human form and a distinctly German emotional fervor. This intense composition is one of a pair of signed reliefs whose distinctive style would mark them as his work even without his signature.

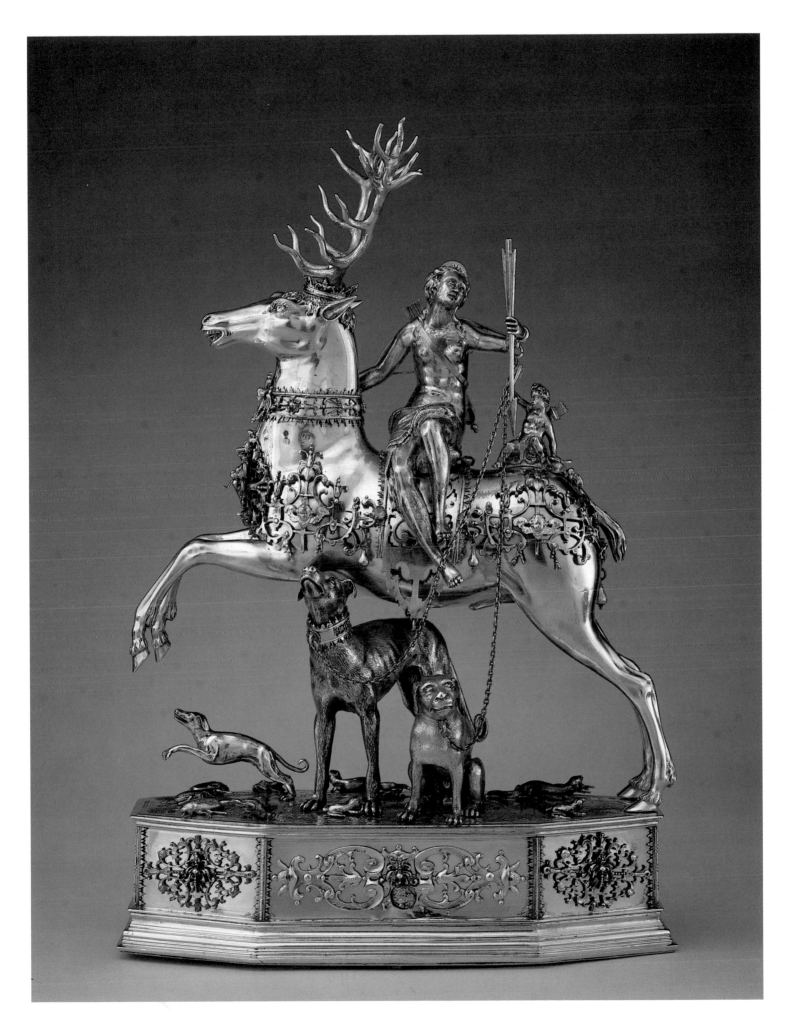

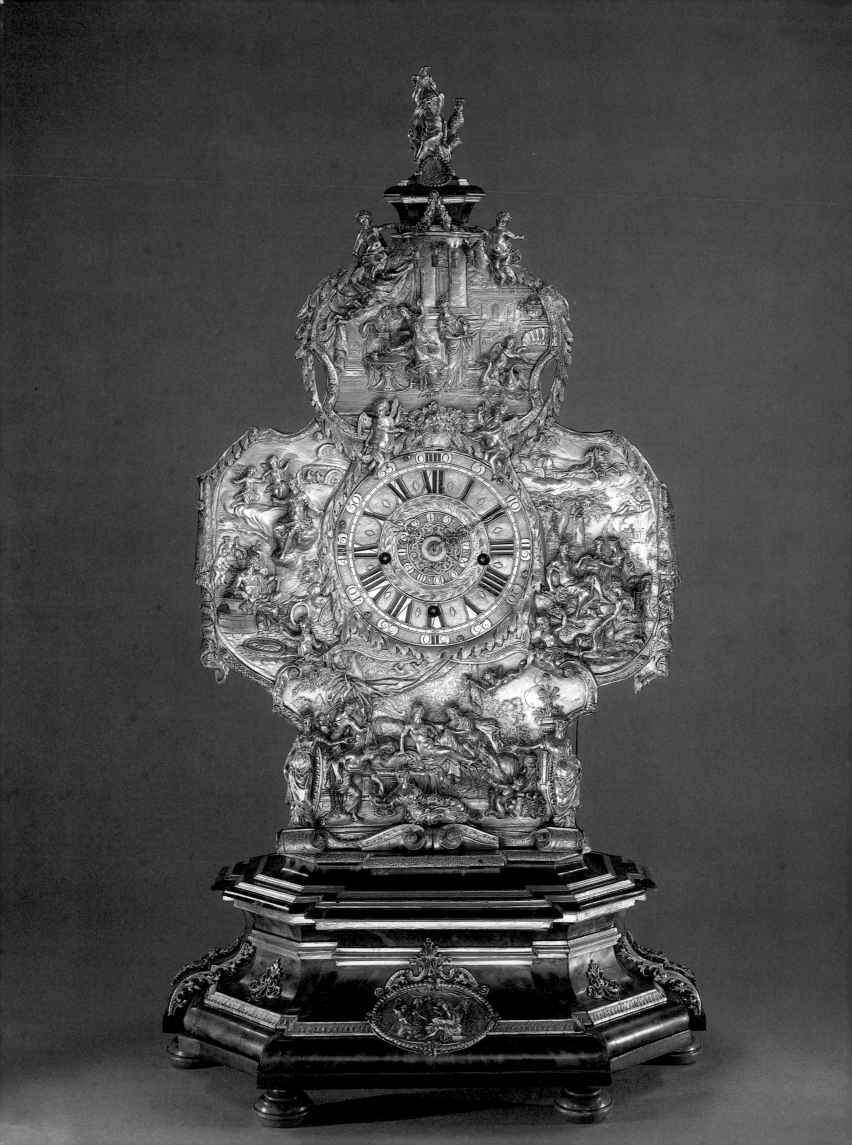

JOHANN ANDREAS THELOT
Mantel Clock

In the last quarter of the seventeenth century, Augsburg goldsmiths specialized in mounting painted enamels and semiprecious stones on objects of gilded silver to create lavish Baroque designs. There also continued an older tradition of working silver in high relief to create decorative designs or narrative scenes. Probably the most famous of the traditional goldsmiths was Johann Andreas Thelot, whose pieces were often adapted from works by such well-known artists as Poussin and Le Brun.

The source of the charming vignettes on this clock has never been identified, but they depict Venus. She is shown at her toilette, with Cupid preparing her swan chariot (top); receiving the goddess Diana, who kneels beside her and lays a brace of game birds at her feet (right); alighting from her chariot at the forge of Vulcan (left); and reclining on a couch with Mars, her lover, attended by cupids and serving maidens (bottom).

The tortoiseshell and silver base is typical of Augsburg clocks of the late seventeenth or early eighteenth century, but the quarter striking movement with alarm mechanism was probably made about fifty years later by an Augsburg clockmaker, Franz Xaveri Gegenreiner, who signed the back plate.

DU PAQUIER PERIOD TRAY

When Claude Innocent du Paquier opened his factory in 1718, it was only the second hard-paste manufactory in Europe. This tray illustrates well the robust and inventive character of Vienna porcelain of the Du Paquier period. The form, with its undulating rim edged in gold, derives from silver-gilt examples produced in Augsburg during the first third of the eighteenth century. The ebb and flow of the ornamental brackets and cartouches further emphasize the rich contours of the form.

The decoration conforms to a vocabulary of ornament established at the court of Louis XIV by Jean Berain and popularized through engravings of his designs and those of the designers he influenced. Conceived in two dimensions, this type of ornament invited variation and experimentation. It was employed equally in two and three dimensions for the design and ornament of architecture, interiors, and gardens, and for the decorative arts, particularly metalwork. Only the Vienna factory adapted this type of ornament for painted decoration on porcelain. It is executed in the refined palette of violet, rose, iron-red, blue, and gold characteristic of Vienna, and the effect is one of complete assurance and restraint.

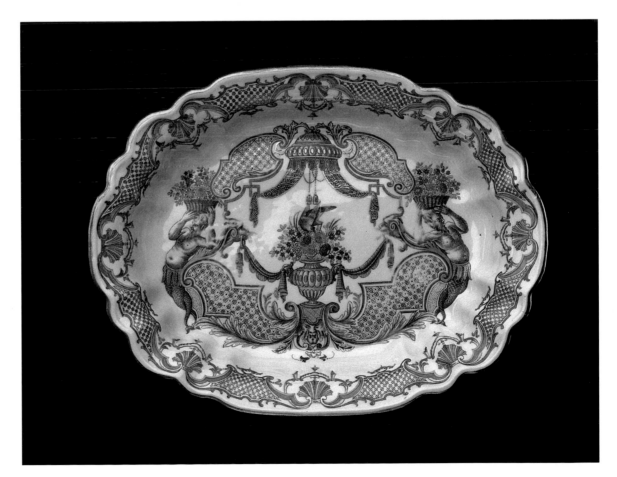

94 *Mantel Clock*, ca. 1710
Johann Andreas Thelot
German (Augsburg), 1655–1734
Case of silver, partly gilded, and tortoiseshell veneer,
with movement of brass and steel; H. 31¾ in. (80.6 cm.)
Rogers Fund, 1946 (46.162)

95 *Tray*, ca. 1730–40
Austrian (Vienna), Du Paquier period (1719–44)
Hard-paste porcelain; 9⅛ x 7 x 1⅞ in.
(23.2 x 17.8 x 4.7 cm.)
Gift of R. Thornton Wilson, in memory of Florence
Ellsworth Wilson, 1950 (50.211.9)

Under Augustus the Strong, the energy and resources of the Electorate of Saxony were directed in large part to the establishment of a court of such splendor as would rival the leading courts of Europe. In 1710, the founding of the first European hard-paste porcelain manufactory at Meissen placed the Dresden court in a position of leadership for an achievement that had long been the ambition of princes and private entrepreneurs alike. Meissen set the standards for quality and originality in European porcelain that so strongly inspired and influenced its imitators.

The technical capabilities and requirements of the porcelain medium were thoroughly tested during the first decades of production, when Augustus's grand Baroque vision inspired the modelers Johann Gottlieb Kirchner and Johann Joachim Kändler to execute these two sculptures, one monumental in conception, the other monumental in scale.

Johann Gottlieb Kirchner worked with Balthasar Permoser on the sculptural decoration for the Zwinger, the enclosed courtyard with pavilions designed by Matthäus Pöppelmann, before becoming a modeler at Meissen in 1727. This rosewater fountain draws its iconography and the vitality of its modeling from Permoser's stone figures. Essentially a literal interpretation of a grand Baroque fountain for the tabletop, it mirrors the architectural setting from which it derives and where court festivities were often held. The composition being frontal with a strong vertical thrust, it was necessary to cast and fire the model in three separate sections. Tense, contorted figures of satyrs are pressed together on a rocky

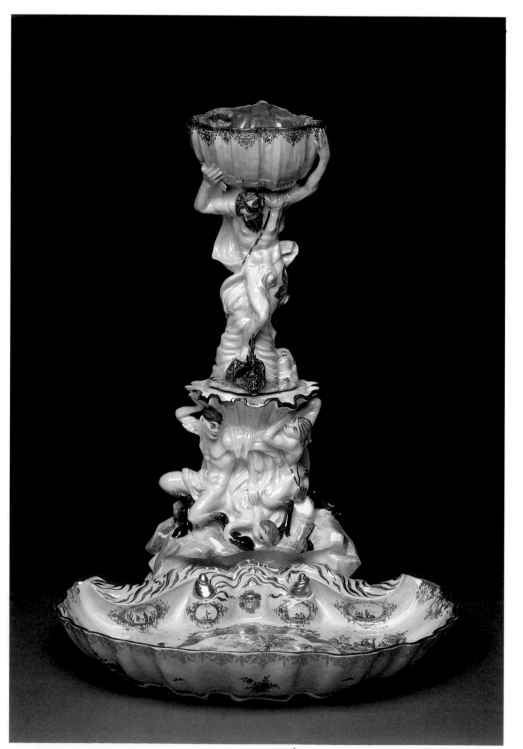

96 Meissen Table Fountain, ca. 1727–28
Modeled by Johann Gottlieb Kirchner
German, b. ca. 1706
Hard-paste porcelain; 25$\frac{1}{16}$ x 18$\frac{5}{16}$ in.
(63.7 x 46.5 cm.)
Gift of R. Thornton Wilson, in memory
of Florence Ellsworth Wilson, 1954
(54.147.65a–c)

base, forming a pyramid as they strain to support the shell, which contains their heavy load. Hercules, his foot on the head of a dolphin, undertakes his eleventh labor by temporarily assuming the burden of Atlas, in this case a half-shell, the reservoir for the rosewater that issues from a spigot in the dolphin's mouth. Used for rinsing the hands during banquets, the water collects in the colossal shell basin where the undulating rhythms established by the modeler were probably echoed in the stirred surface of the water. It is surprising to find that fanciful chinoiseries decorate the interior of the basin, an addition that may have relieved the formality of Kirchner's creation when glimpsed by the users of the fountain.

The group of an angora goat with suckling kid was mod-eled by Johann Joachim Kändler, a modeler at Meissen since 1731. It belongs to a series of large animals and birds originally begun by Kirchner for the Elector, who intended to display these almost-lifesize figures in the porcelain rooms of the so-called Japanese Palace. This sensitive rendering, in particular, is testimony to the creative capabilities of the young Kändler, who became model master at Meissen after Kirchner's departure in 1733. Conceived in the round, this primary view shows the she-goat reclining with her young kid sprawled across her back and feeding eagerly as she grooms it. In the interaction of mother and kid, a progression of forms is established, which flows in a figure-eight pattern articulated and controlled by the rhythm of curves and graceful profiles.

97 *Meissen Group: Goat and Suckling Kid*, ca. 1732
Modeled by Johann Joachim Kändler
German, 1706–75
Hard-paste porcelain; 19½ x 26 in. (49.4 x 66 cm.)
Gift of Mrs. Jean Mauzé, 1962 (62.245)

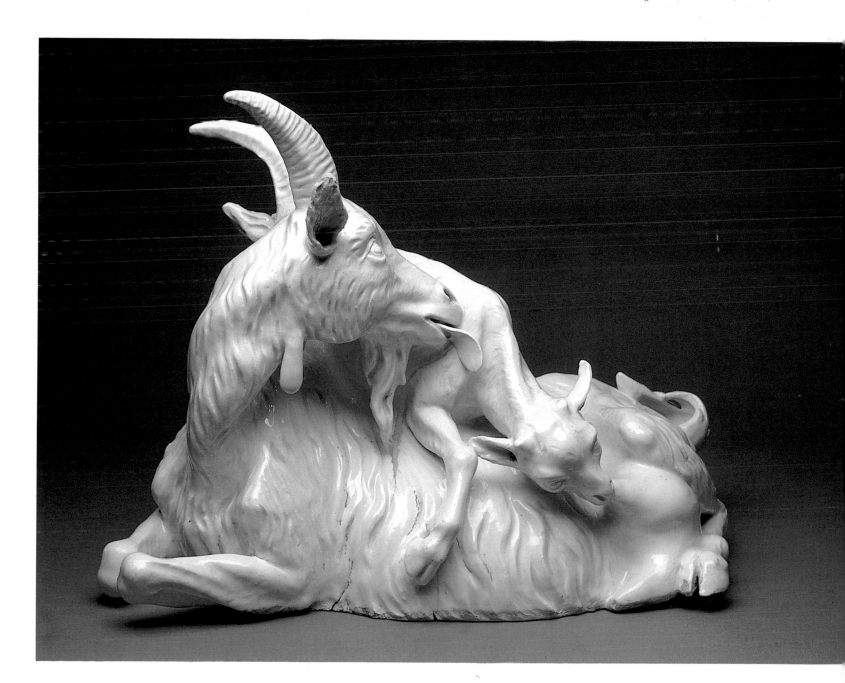

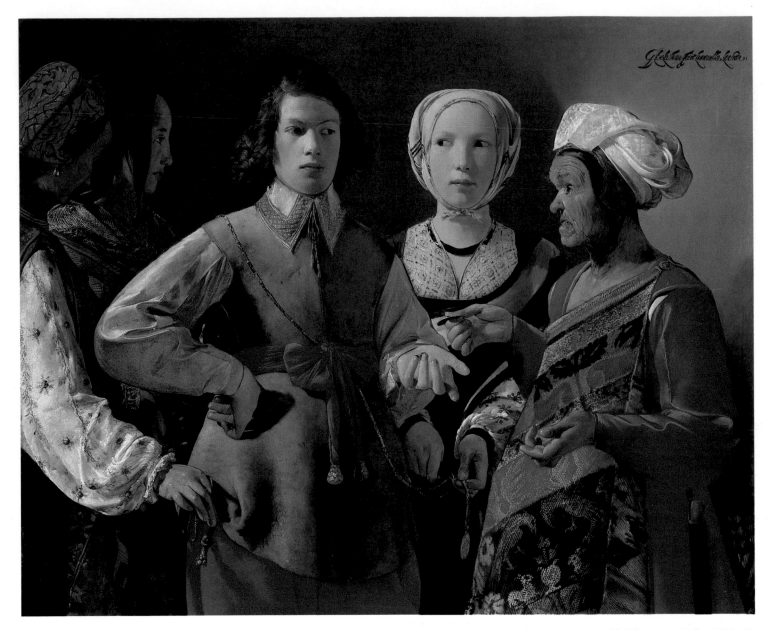

98 *The Fortune Teller*, 1632–35
Georges de La Tour
French, 1593–1652
Oil on canvas; 40⅛ x 48⅝ in.
(101.9 x 123.5 cm.)
Rogers Fund, 1960 (60.30)

Opposite: detail

GEORGES DE LA TOUR
The Fortune Teller

Georges de La Tour was born in 1593 in the independent duchy of Lorraine. His works reveal his knowledge of contempory Caravaggesque painting. Some scholars postulate that La Tour went to Italy during the 1610s, while others propose that he made a study trip to the Netherlands. By 1616 he had established himself as a master at Lunéville in Lorraine; he remained there for most of the rest of his life. Though his work was virtually forgotten for almost three centuries, La Tour was rediscovered in the twentieth century and is now recognized as an artist of great brilliance and originality.

This painting shows a fashionably dressed young cavalier being ensnared by deceitful gypsies. Though he regards them with suspicion, he is unaware that the two young ladies to his right are lifting the purse out of his pocket and that the gold chain of his pocket watch is being severed. *The Fortune Teller* serves as a lesson in prudence, warning the unsuspecting of the deceitful ways of the world. The subject of trickery and the use of exotic and imaginary costumes were both common in seventeenth-century paintings and were popularized by Caravaggio and many of his followers.

The profusion of details, the delicate handling of paint, the unusually large number of figures, the size of the canvas, and the rich variety of hand gestures signify that this was a very important work for the young artist, and it is usually dated between 1632 and 1635.

GEORGES DE LA TOUR
The Penitent Magdalen

This picture, probably painted between 1638 and 1643, is one of four representations that La Tour did of the penitent Magdalen. It is unique in depicting her at the dramatic moment of her conversion. The elaborate silver mirror symbolizes luxury, the rejection of which is stated by the pearls that now lie on the night table before her and the jewels that have been cast down to the floor. The self-consuming candle reflected in the mirror suggests the frailty of human life. The Magdalen clasps her hands in prayer on top of a skull, which may stand for the peaceful acceptance of death. La Tour's extraordinary control of light—from near total darkness to the bright flame—contributes to the profoundly moving effect of this painting.

The still atmosphere and meticulous rendering of ornament were aspects of the prevailing Caravaggesque style that La Tour cheerfully incorporated into his own work. Though paintings from the earlier part of his career were lit with bright and diffuse daylight, La Tour was increasingly drawn to candle-lit scenes, which, austere and startlingly eloquent, are now among his best-known works.

99 Penitent Magdalen, 1638–43
Georges de La Tour
French, 1593–1652
Oil on canvas; 52½ x 40¼ in. (133.4 x 102.2 cm.)
Gift of Mr. and Mrs. Charles Wrightsman, 1978
(1978.517)

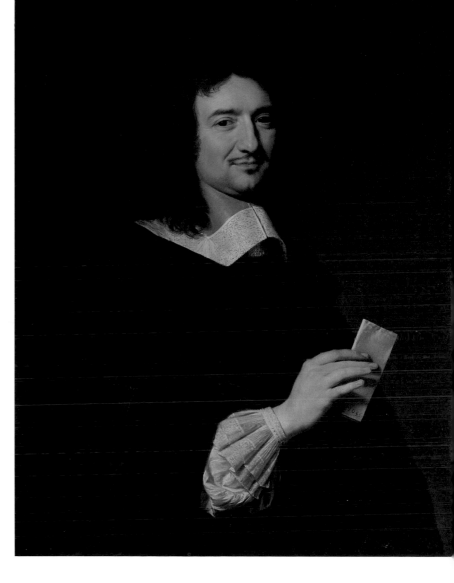

100 Jean Baptiste Colbert
Philippe de Champaigne
French, 1602–74
Oil on canvas; 36¼ x 28½ in. (92.1 x 72.4 cm.)
Gift of The Wildenstein Foundation, Inc.,
1951 (51.34)

PHILIPPE DE CHAMPAIGNE
Jean Baptiste Colbert

Philippe de Champaigne was one of the very few French artists of the seventeenth century who did not incorporate elements of Italian painting into his work. Born in Brussels in 1602, Champaigne chose instead to look to the art of his native Flanders. After seven years of struggle in Paris, Champaigne was chosen to paint an official portrait of King Louis XIII in 1628. In 1640, Champaigne came into contact with the doctrines of Jansenism, a severe form of Catholicism. The Jansenists' rejection of materialism led to a shift in the way Champaigne chose to construct his portraits: They became much simpler, the sitter usually looking out directly at the viewer.

Jean Baptiste Colbert was among the most important political figures of his day. In 1655, Colbert became the administrator of the private fortune of Cardinal Mazarin, a powerful political leader and the most enlightened collector of art in France. Colbert was appointed King Louis XIV's principal adviser on all economic, political, and religious matters. In 1664, he became superintendent of Louis XIV's buildings. Colbert believed that the arts should be controlled by the state, and he played a major role in the establishment of the official French Royal Academy as well as the planning of the Louvre and Versailles. Colbert also enlarged France's merchant fleet, labored to regulate industry, and was notoriously successful in ruthlessly crushing any opposition to the state.

NICOLAS POUSSIN
The Companions of Rinaldo

This vividly colorful painting represents an episode from *Jerusalem Delivered* (1580) by the Italian poet Torquato Tasso. Two Christian knights are about to slay the dragon that guards the palace of the pagan sorceress Armida. Their aim is to reach Rinaldo, their companion who is being held prisoner under Armida's spell, and to exhort him to rejoin the First Crusade. A female figure of Fortune, who has guided the knights to the island, looks on.

The Companions of Rinaldo probably dates from the early 1630s, relatively early in Poussin's career. The vivacity and bright colorism of Venetian Renaissance painting, which were in vogue in Rome during the 1620s and 1630s, are still evident in this work.

101 The Companions of Rinaldo
Nicolas Poussin
French, 1594–1665
Oil on canvas; 46½ x 40¼ in. (118.1 x 102.2 cm.)
Gift of Mr. and Mrs. Charles Wrightsman, 1977
(1977.1.2)

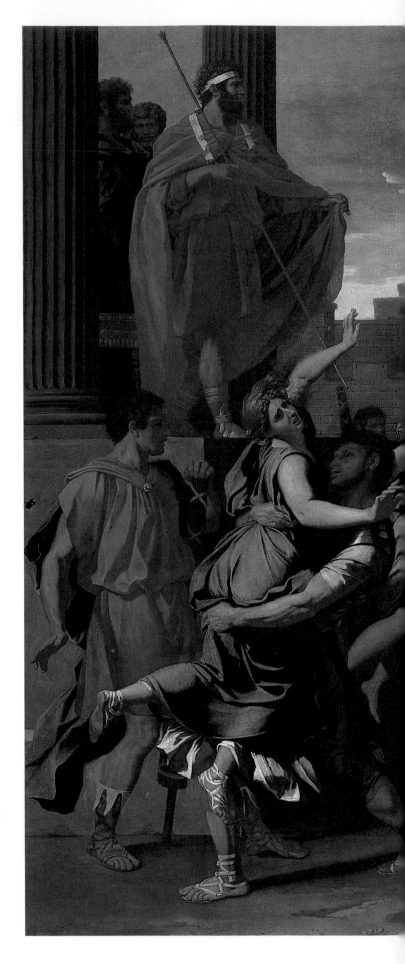

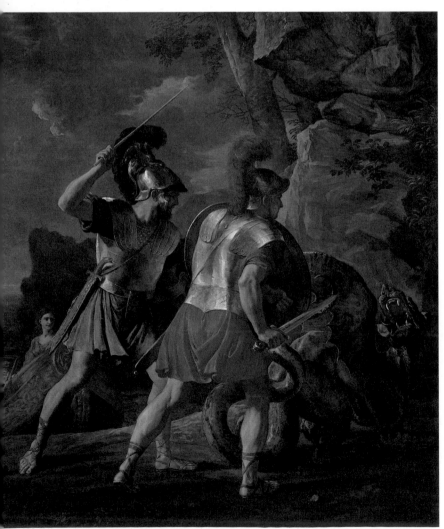

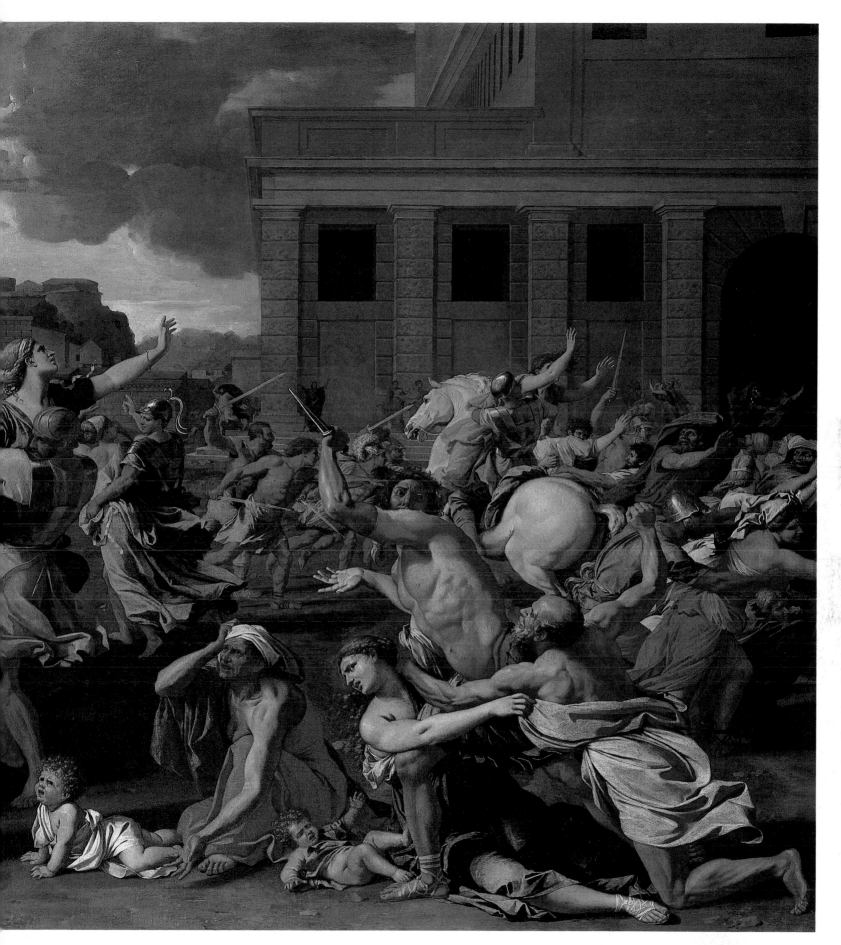

102 *The Rape of the Sabine Women*
Nicolas Poussin
French, 1594–1665
Oil on canvas; 60⅞ x 82⅝ in. (154.5 x 209.8 cm.)
Harris Brisbane Dick Fund, 1946 (46.160)

Page 132: text

131

NICOLAS POUSSIN *(Pages 130–131)*
The Rape of the Sabine Women

One of the formative experiences for Poussin was his participation in a vast project engineered by the collector Cassiano dal Pozzo to create a drawn catalogue of monuments and fragments of ancient Roman art. These studies became the source for his figures and the details of the weapons, armor, and architecture of his paintings. Just as he based his treatment of the human form on existing ancient artifacts, Poussin depended upon his knowledge of Roman history and Greek mythology to provide him with endless themes for his austere and deliberated exercises in Classical style.

This painting is based upon a well-known myth from antiquity, the Rape of the Sabine Women, a story treated by Livy, Plutarch, and Virgil, among others. Romulus, ruler of the newly founded city of Rome, is shown raising a fold in his garment—the prearranged signal for his soldiers to carry off all unmarried women of the Sabine tribe. The unarmed Sabine men, who had been duped into attending what they thought would be a religious celebration, are being put to flight as their women are seized. Married women and children were to be spared, but in the midst of the confusion a slaughter ensued.

NICOLAS POUSSIN
Blind Orion Searching for the Rising Sun

This painting is one of Poussin's many illustrations taken from Classical mythology. Oenopian, the king of Chios, blinded the giant hunter Orion, who had attempted to ravish his daughter, Merope. Told by an oracle that only the rays of the rising sun would restore his sight, Orion walked eastward. Here Cedalion, Orion's guide, is shown standing on Orion's shoulder, while at his feet Hephaestus, the god of fire, points out where the sun will rise. Diana, goddess of the hunt, looks down from the clouds.

This treatment of the story of Orion is characteristic of the work Poussin did later in life, when he fused mythological scenes with idyllic landscapes. The delight taken in precisely rendered natural phenomena and the mystical forces found in nature emphasize the heroic subject matter of the picture. Painted in 1658 for an erudite collector who may have suggested the subject, this powerful and haunting vision of the story of Orion is one of Poussin's great achievements.

103 Blind Orion Searching for the Rising Sun, 1658
Nicolas Poussin
French, 1594–1665
Oil on canvas; 46⅞ x 72 in. (119.1 x 182.9 cm.)
Fletcher Fund, 1924 (24.45.1)

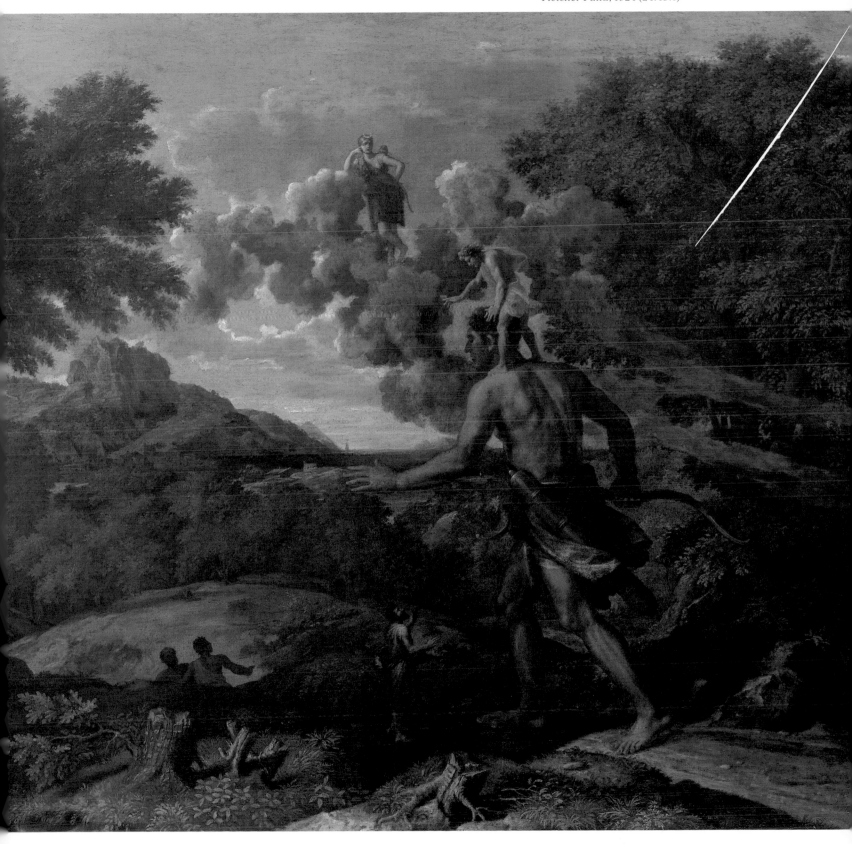

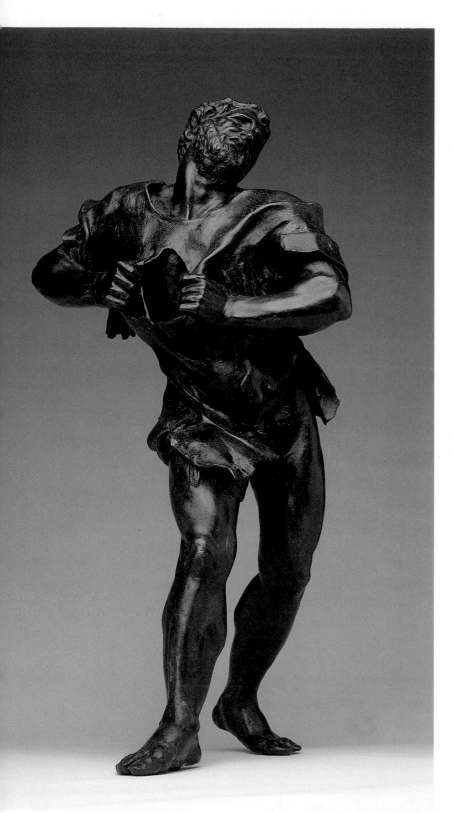

PIERRE PUGET

Hercules in the Coat of Nessus

This rarely depicted subject portrays the hero Hercules in a desperate but futile attempt to wrench a poisoned coat from his body. The centaur Nessus, slain by Hercules's poisoned arrow while attempting to abduct the hero's wife, Deianira, had tricked her into preserving the tunic soaked with his envenomed blood, convincing her that it would serve as a potent love charm. When Hercules became enamored of another, Deianira sent him the centaur's coat, the true nature of which she was unaware. The heretofore impervious hero is shown as his body arches in the titanic throes of his final agony. As Ovid recounts the tale, Nessus's poisoned garment became so fused with the hero's body that in attempting to divest himself of its fiery grip he ripped away chunks of his own flesh. Puget evokes this horrific image, endowing the leathery shirt with an organic quality that makes it seem a physical extension of the writhing strongman himself.

Like many French artists of his time, Puget had studied and worked for years in Italy. Still, as this bronze reveals, he showed little inclination to absorb the lessons of Classical antiquity that underlay the coolly rhetorical and decorous manner favored at the court of Louis XIV. Those ancient sculptures he chose to emulate were such supreme expressions of contorted anguish as the *Laocoön*, and it was to the style of the Italian Baroque and the spirit of the long-dead Michelangelo that he was most attracted. This is particularly evident in the *Hercules*, whose subject, the hero as victim of his own strength, elaborates the Michelangelesque theme of the spirit trapped in mortal flesh. Puget's bronze transcends the narrative terms of its subject and becomes a metaphor for man's earthly nature, whose strangulating and inescapable hold is loosened only by death.

104 Hercules in the Coat of Nessus, ca. 1676–81
Pierre Puget
French, 1620–94
Bronze; H. 24 in. (61 cm.)
The Jules Bache Collection, 1949 (49.7.61)

105 *View of La Crescenza*, ca. 1648–50
Claude Gellée (called Claude Lorrain)
French, 1600–82
Oil on canvas; 15¼ x 22⅞ in. (38.7 x 58.1 cm.)
Purchase, The Annenberg Fund, Inc. Gift, 1978
(1978.205)

CLAUDE LORRAIN
View of La Crescenza

French painting of the seventeenth century reached its apogee in the work of Poussin and Claude. Neither artist spent a great deal of time in France, however, both preferring to work in Rome, the source of their Classical inspiration. Claude established a permanent home in Rome in 1623, and he remained there until his death in 1682.

The overall composition of this small landscape is based upon schema that Claude had often used in his religious and mythological pictures. What we see here, however, is not a view of an idealized world, but an actual site: the family house of La Crescenza, a property near Ponte Molle, not far from Rome. This canvas, which was painted about 1648–50, is apparently the first of a series of views of La Crescenza made over a number of years.

Typical of Claude's style are the warm and gentle evening atmosphere, the subtle tonal gradations, and the exceptionally fluid handling of space. This exquisite and very well-preserved work was painted for Carlo Camillo Massimi, secret chamberlain to Pope Innocent X. A very learned man, Massimi was a great supporter of the arts and commissioned at least four other paintings from Claude, whose works he especially admired.

Claude Lorrain
The Trojan Women Setting Fire to Their Fleet

Claude based a number of his paintings on the poems of Virgil, who tells the story of the Trojan women in the Fifth Book of the *Aeneid*. Defeated by the Greeks in the Trojan War, a band of Trojans, led by Aeneas, set out to found a new city in Latium. These legendary ancestors of the Roman people met with many adventures. In Sicily, the women, exhausted by seven years of seemingly aimless wandering, were incited by goddesses Juno and Iris to take matters into their own hands, as their pleadings to the men of their band had hitherto fallen on deaf ears. While their husbands were holding competitive games, the Trojan women set to burning their "beautifully painted" ships, hoping that this would force the exiles to stop following "a fleeing Italy" and settle where they had landed. Upon discovering the attempted destruction of their fleet, however, Aeneas and his son, Ascanius, prayed to Jupiter to intervene, and he promptly extinguished the raging fires with a rainstorm.

Claude chose to depict three dramatic moments of Virgil's narrative: the attempted arson, Aeneas's discovery of the fires, and the pacifying rainstorm. Claude succeeded in this highly unusual approach, for though he sacrificed any semblance of temporal unity, he achieved remarkable narrative clarity. Claude often used idealized landscapes in his work; here the enhanced effects of sunlight and atmosphere transform Italian scenery into a halcyon vision of the antique world.

CHARLES LE BRUN
Allegory in Honor of Cardinal Richelieu

Charles Le Brun was the most important and powerful artist in seventeenth-century France. As First Painter to Louis XIV and head of the Royal Academy, he reigned supreme as virtual dictator over all artistic matters. In addition to creating a vast program of painted decoration for Versailles, he supervised royal commissions of every sort, from architecture and sculpture to tapestries and furniture.

This large black-chalk drawing, an exceptionally fine example of Le Brun's early draftsmanship, was engraved in reverse as the lower part of a thesis dedicated to Cardinal Richelieu in 1642. The naval attributes refer to Richelieu's role as Grand Admiral of France, while the figures of Mars and Apollo allude to the cardinal's eminence in the arts of war and peace.

FRANÇOIS GIRARDON
Allegorical Figure

The poppy held by this melancholic tomb figure is the symbol of Sleep, a metaphor for Death, which, in its freedom from conventional religious associations, appealed to the secular spirit of the French Enlightenment. The presence of this poppy, however, dates only to the first decade of the nineteenth century, when significant alterations to the shape and content of the relief took place. Originally, the figure, part of a tomb in the church of Saint-André-des-Arts in Paris, was accompanied by the attributes of the three Cardinal Virtues: Faith (the foundation block on which the figure's right foot rests), Hope (an anchor, no longer present, formerly held by the figure's right hand along the lower right side of the relief), and Charity (a flaming heart once held in her left hand, which was later recarved as a poppy).

The prominent position accorded Charity in the original composition was meant to reflect its salient role in the life of Anne-Marie de Martinozzi, princesse de Conti, whose two sons, popular figures at the court of Louis XIV, commissioned the monument from the King's First Sculptor. The tomb's inscription noted that the princess, niece of Cardinal Mazarin, sold her jewels and gave up her personal fortune to feed the starving poor during the famine of 1662.

The allegory is one of many works of art rescued from destruction during the French Revolution. After the removal of its religious associations, it was rehabilitated as a secular allegory of death and mourning. It was then conveyed to the Empress Josephine's "English Garden" at Malmaison, where it lent the requisite note of melancholy to the romantic landscape.

107 *Allegory in Honor of Cardinal Richelieu*
Charles Le Brun
French, 1619–90
Black chalk, black and gray wash;
14⅝ x 29⅛ in. (37.3 x 74.9 cm.)
Harry G. Sperling Fund, 1974 (1974.106)

108 *Allegorical Figure*, ca. 1672–75
François Girardon
French, 1628–1715
Marble;
56¾ x 25¼ in. (144.2 x 64.1 cm.)
Fletcher Fund, 1939 (39.62)

Savonnerie Carpet

After the ascension of Louis XIV, the Savonnerie manufactory was moved from its original location to an abandoned soap factory—hence its name—near Paris. Its commissions consisted almost exclusively of royal orders, the most ambitious of which was for ninety-three carpets (only ninety-two were actually woven) to cover the nearly 500-yard-long floor of the Long Gallery of the Louvre. Woven between 1668 and 1680, the carpets are all about 30 feet long and vary between 10 to 16 feet in width.

The elaborate and impressive scheme of these carpets is undoubtedly that of Charles Le Brun. They were designed to harmonize with and echo the architecture of the gallery.

The field of each carpet is divided into three sections: a large central compartment and a smaller medallion or cartouche at each end, which framed either a landscape, as in this example, or imitation bas reliefs. Stately acanthus scrolls, naturalistic flowers gathered in garlands or bouquets, and decorative motifs drawn from antiquity fill the interstitial spaces. Appropriately for a decorative program intended to glorify the monarch, emblems of royalty or royal attributes are prominent on every carpet. In this example, the three fleurs-de-lis of France are shown surmounted by a royal crown; in the center are arms and trophies testifying to the military power of the king.

109 Carpet
Number 73 of a series of 92 carpets woven for
the Long Gallery of the Louvre
French (Paris, Savonnerie Manufactory), 1680
Knotted and cut wool pile; ca. 90 knots per sq. in.,
29 ft. 9¾ in. x 10 ft. 4 in. (9.08 x 3.15 m.) Gift of
Mr. and Mrs. Charles Wrightsman, 1976 (1976.155.114)

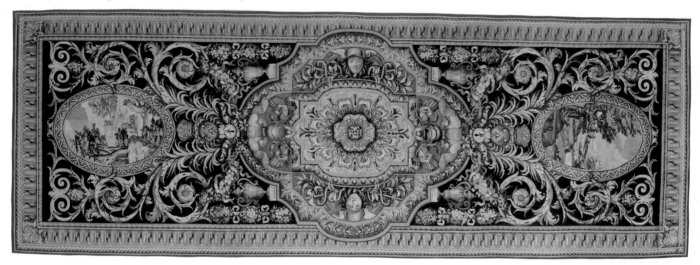

110 Andromeda and the Sea Monster, ca. 1700–04
Pierre Etienne Monnot
French, 1657–1733
Marble; H. 64 in. (162 cm.)
Purchase, Josephine Bay Paul and C. Michael Paul
Foundation, Inc. Gift, and Charles Ulrick and
Josephine Bay Foundation, Inc. Gift, 1967 (67.34)

Pierre Etienne Monnot

Andromeda and the Sea Monster

Andromeda, the Ethiopian princess, was offered up as a sacrifice to appease the sea monster sent by Poseidon to terrorize her countrymen. She was rescued from the rock to which she had been chained by the fortuitous arrival of Perseus, who slew the monster and took her for his bride. In this sculpture, only Andromeda and the monster are to be seen; the advent of Perseus is, however, suggested by the welcome apparent in Andromeda's gesture and gaze.

One of the French artists sent to Italy to absorb the lessons of Classical antiquity, Monnot never returned to work in France. He was in fact at work on the tomb of Innocent XI when Lord Exeter ordered from him a tomb for himself and his wife as well as five other sculptures, all to be sent

back to England and installed at Burghley House in Northamptonshire.

Exeter was a member of the staunchly Catholic Cecil family, more interested in contemporary ecclesiastical sculpture than the typical Englishman doing the Grand Tour. The Andromeda myth, while superficially a Classical subject, undoubtedly held a deeper, encoded meaning for him. A popular metaphor signifying the rescue of a beleaguered state from oppression, it was used by Protestants to represent England rescued from the clutches of the Papacy by William of Orange. For Cecil, clearly, the meaning would have been reversed, standing for the hopes of English Catholics for the restoration of the Stuart monarchy.

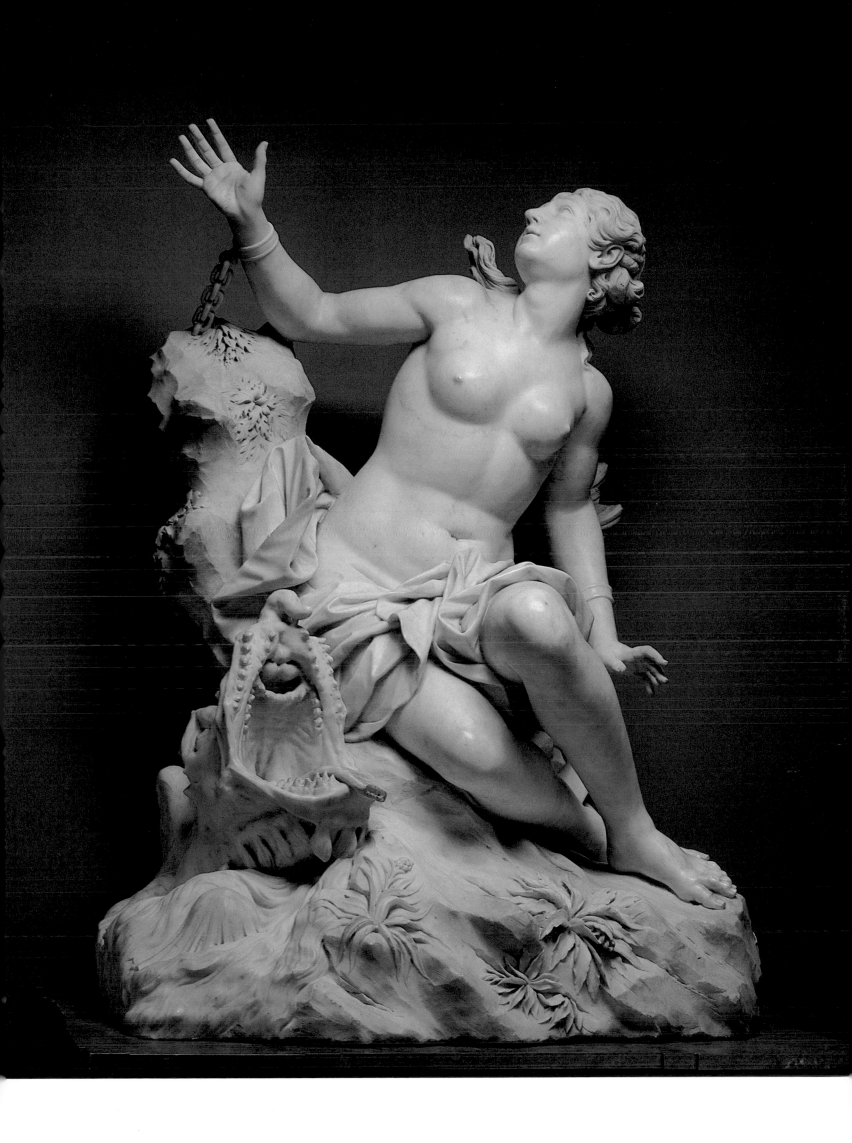

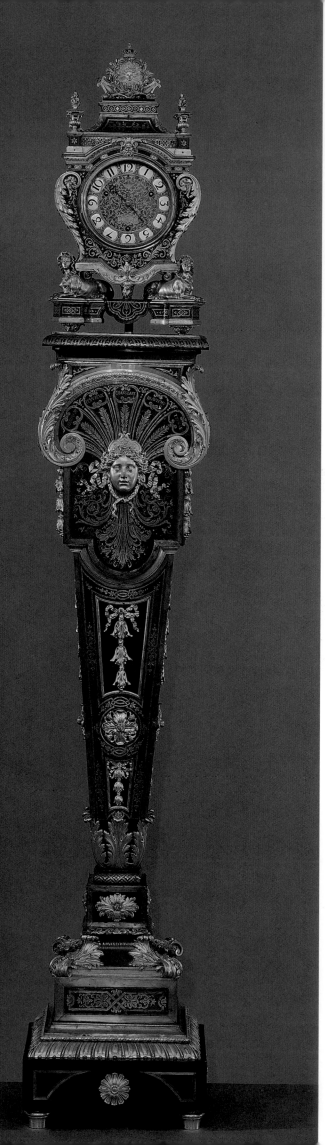

CLOCK WITH PEDESTAL

Based on the splendor of its design, the high quality of the marquetry, and the skillfully sculptured mounts, the case and pedestal of this clock are ascribed to André Charles Boulle. Boulle, who is known to have produced a number of clock cases as well as several tapering pedestals, received the title of Royal Cabinetmaker in 1672. His workshops and lodgings in the Louvre were not far away from those of the clockmaker Jacques Thuret, who was responsible for the clock's movement. Both worked for the king and nobility. Although Boulle was not the first to employ marquetry of brass, pewter, and tortoiseshell (originally an Italian technique), his name is generally applied to this kind of marquetry since he brought it to perfection. Sheets of tortoiseshell and metal were glued together before being cut in the required design. When cut, the layers could be used as two sets, one with a tortoiseshell ground inlaid with metal, known as "first part," and the other in the reverse. The shell inlay in metal ground is called the "counterpart" and was less highly valued than the first part, of which this clock is an example. The decorative mounts in the form of a female mask, the husks, the flaming urns, and the sphinx supporters echo the ornamental designs of Jean Berain. This clock, in all its grandeur, embodies the taste for magnificent and sumptuous furniture that characterized the reign of Louis XIV.

111 Clock with Pedestal
French, ca. 1700
Movement signed by Jacques Thuret (act. 1694–1738)
Case and pedestal attrib. to André Charles Boulle (1642–1732)
Oak, ebony, tortoiseshell, brass, engraved pewter, and gilded
bronze; H. 7 ft. 3¼ in. (2.22 m.) Rogers Fund, 1958 (58.53a-c)

GUILLAUME COUSTOU, THE ELDER
Bust of Samuel Bernard

Samuel Bernard became Chevalier of the Order of Saint-Michel in 1702 (he wears the insignia here), secretary to Louis XIV in 1706, and comte de Coubert in 1725, but he lives in history as the royal banker extraordinaire. He was the son of a painter and printmaker, and the powers of discrimination that we might associate with such a background were amply demonstrated when he chose Coustou as his portraitist. The face is framed asymmetrically in a tumultuous flurry of wig and lace, but not for one second do they distract us from the banker's shrewd gaze. Coustou, like so many French sculptors, was trained at the French Academy in Rome, but his busts, few in number, belong to purely Gallic traditions of incisive portraiture.

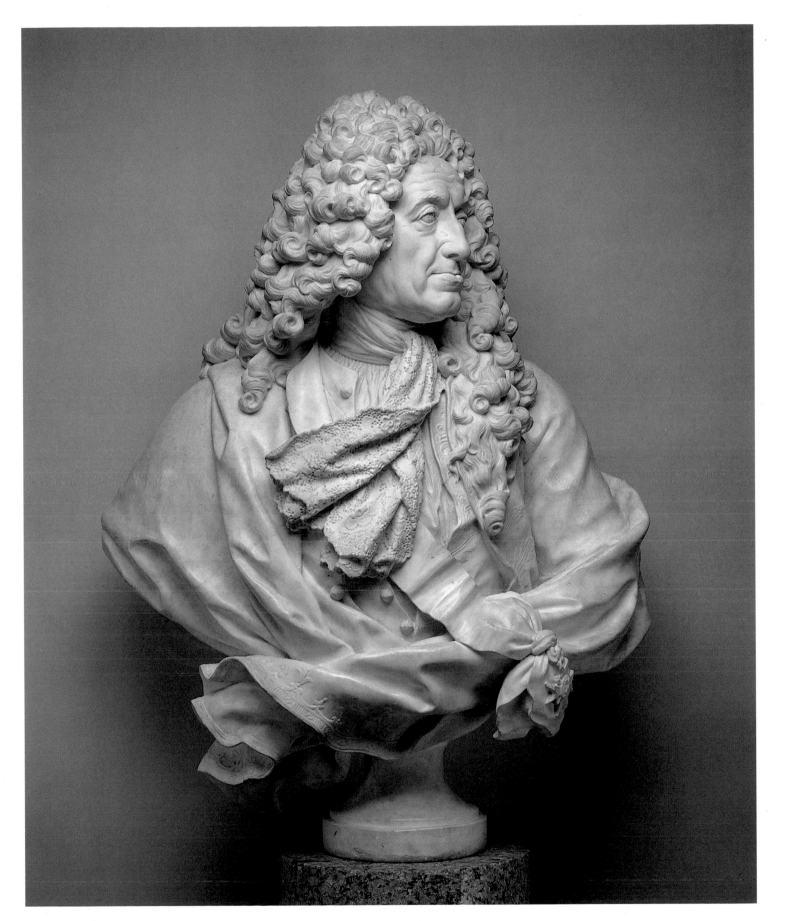

112 Bust of Samuel Bernard, ca. 1720
Guillaume Coustou, the Elder
French, 1677–1746
Marble; H. (incl. socle) 37½ in. (95 cm.)
Purchase, Josephine Bay Paul and C. Michael Paul
Foundation, Inc. Gift and Charles Ulrick and
Josephine Bay Foundation, Inc. Gift, 1966 (66.210)

THE CAMEL

The Camel is from a set of tapestries called the Berain Grotesques. In actuality, the designs were executed by the French flower painter Jean Baptiste Monnoyer. He was influenced by Jean Berain, who may have provided the preliminary sketches. Berain was designer to the king, and he evolved a particular style of grotesque decorations echoing that of Raphael and Classical antiquity but introducing a new liveliness and light-heartedness that heralds the oncoming age of the Rococo. His fantastic architectural settings, filled with figures, birds, and beasts, underlie the designs of the tapestries, but they have been further embellished by Monnoyer.

The Grotesques were first woven in the 1680s and proved very popular: Over one hundred fifty individual examples exist today. A set usually consisted of three large horizontal tapestries and three smaller vertical panels. The tapestry illustrated here belongs to a set completed by four hangings

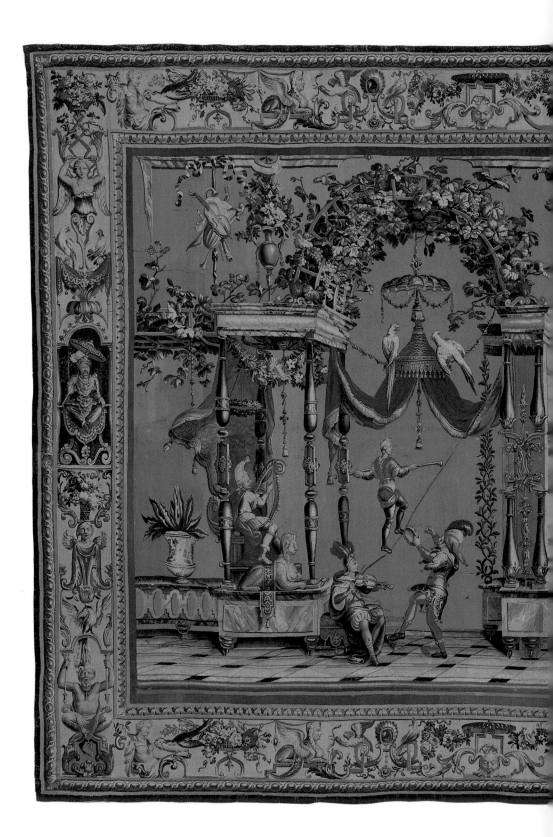

113 *The Camel*
French (Beauvais), late 17th–early 18th c.
Wool and silk tapestry;
9 ft. 10 in. x 17 ft. 4½ in. (3 x 5.30 m.)
Gift of John M. Schiff, 1977 (1977.437.1)

in The Metropolitan Museum of Art: *The Elephant, Musicians and Dancers* (horizontal), *Violin and Lute Players*, and *The Offering to Bacchus*; the sixth piece is probably *The Offering to Pan* in the Musée des Arts Décoratifs, Paris. Each piece has a dull yellow ground, a color referred to as *tabac d'Espagne*, translated as "Spanish tobacco" or Havana yellow, which was also popular as a ground color for Savonnerie carpets and screen panels after the mid-1680s. The borders were possibly designed by Guy Vernansal and combine grotesque decorations with chinoiserie figures against a white or pale gray ground.

The name "BEHAGLE," which appears in the lower right corner of the *Musicians and Dancers*, indicates that the set was woven while Philippe Behagle was director of the Beauvais manufactory or during the directorship of his widow and son.

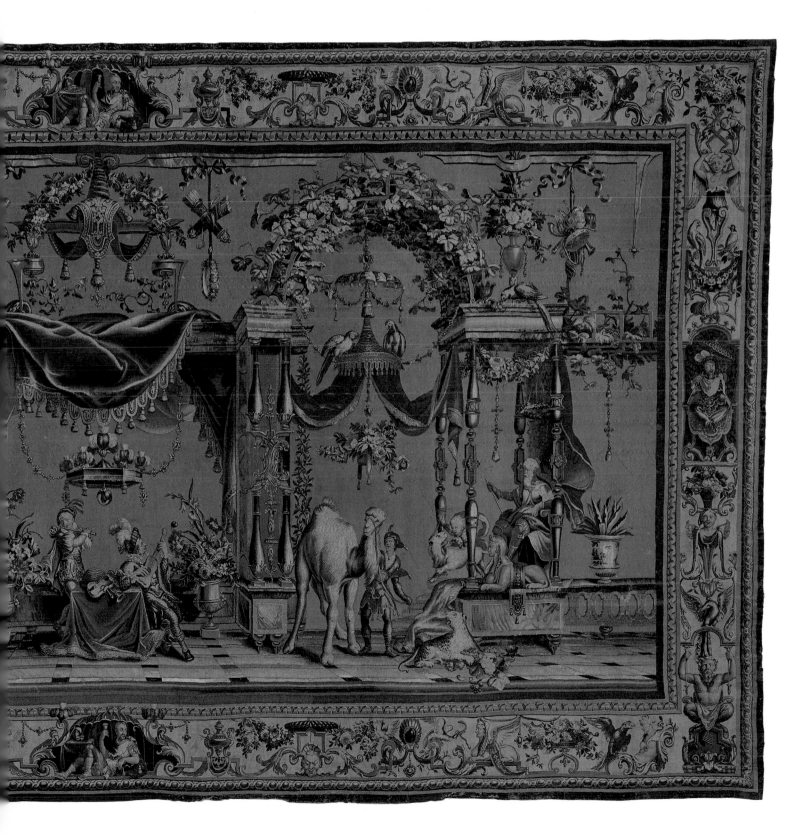

ANTOINE WATTEAU
Seated Woman Holding a Fan and *Head of a Man*

In his study of a seated woman (Plate 114), Watteau has added white highlights to the red- and black-chalk figure in what is known as the *trois crayons* technique. This elegant eighteenth-century lady appears in his painting *La Perspective*, in the Museum of Fine Arts, Boston.

The sensitively modeled head in Plate 115 is a preparatory study for the seated figure of Mezzetin as he appears in the painting by Watteau reproduced on the right. The Museum acquired this fine sheet just three years after the painting had entered the collection. The drawing is a typical example of the draftsmanship of Watteau, who often used a combination of red and black chalk in his figure studies.

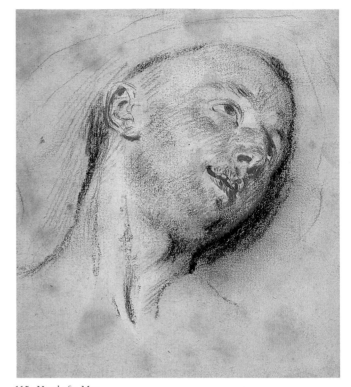

115 Head of a Man
Antoine Watteau
French, 1684–1721
Red and black chalk;
5⅞ x 5⅛ in. (14.9 x 13.1 cm.)
Rogers Fund, 1937 (37.165.107)

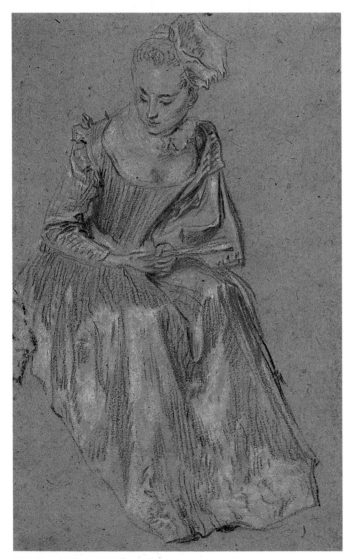

114 Seated Woman Holding a Fan
Antoine Watteau
French, 1684–1721
Red and black chalk, heightened with white,
on beige paper; 8⅜ x 5⅛ in. (21.4 x 13.1 cm.)
Gift of Ann Payne Blumenthal, 1943 (43.163.23)

ANTOINE WATTEAU
Mezzetin

Mezzetin, a stock character of the commedia dell'arte, is shown singing before a verdant garden in which a classically posed young woman stands with her back turned. The spatial and psychological distance between the two borders on the tragic, and though the character of Mezzetin was occasionally the romancer in serio-comic sketches, by the eighteenth century his name had become virtually synonymous with unrequited love. The monochromatic female figure is usually understood to be a statue, but if this tableau is understood as representing a stage set, then the woman is actually but a part of a painted backdrop, and what we are looking at is a painting of a painting of a sculpture of a woman. This kind of complex layering of multiple realities was one of Watteau's major preoccupations. He delighted in the depiction of scenes imbued with the ambiguous relationship that existed between stage life and real life—the world of art and the actual world.

Watteau was undoubtedly the greatest painter of the French Rococo period. His poignancy and intellectual perspicuity made him unique among his peers. This painting was made between 1718 and 1720, near the end of the artist's short life.

116 Mezzetin, 1718–20
Antoine Watteau
French, 1684–1721
Oil on canvas; 21¾ x 17 in.
(55.2 x 43.2 cm.)
Munsey Fund, 1934 (34.138)

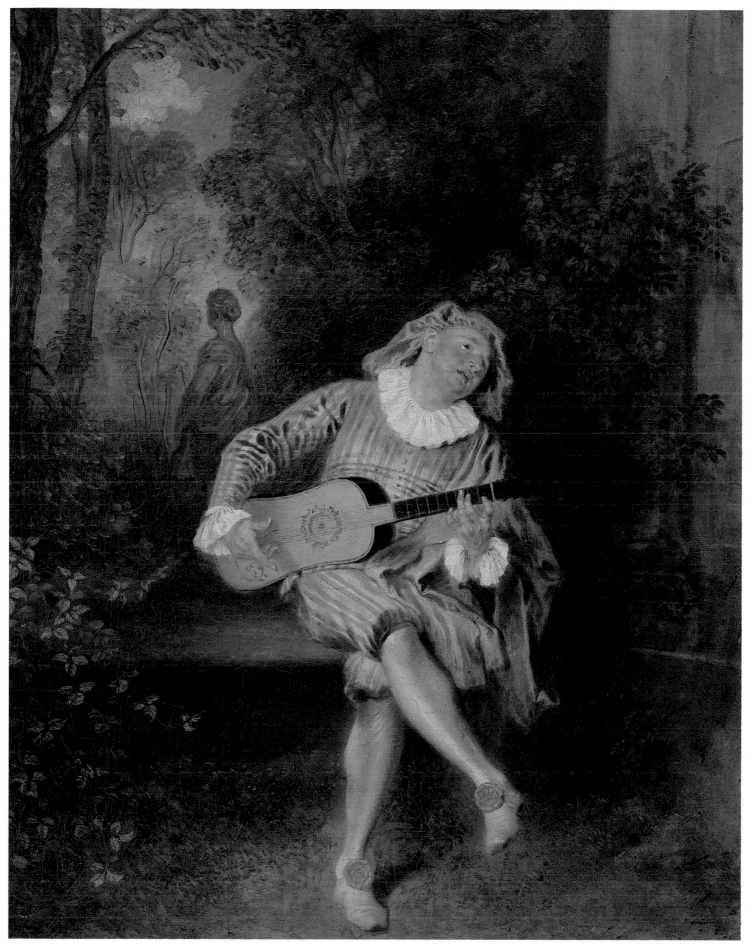

117 *The Fair at Bezons*, ca. 1733
Jean Baptiste Joseph Pater
French, 1695–1736
Oil on canvas; 42 x 56 in. (106.7 x 142.2 cm.)
The Jules Bache Collection, 1949 (49.7.52)

JEAN BAPTISTE JOSEPH PATER
The Fair at Bezons

The art of Jean Baptiste Pater was decisively influenced by that of his teacher, Antoine Watteau. The popular autumnal festival held in the rural area outside the town of Bezons, near Versailles, seems to have been the inspiration for many paintings by Watteau and was certainly the source for this 1733 painting, perhaps Pater's greatest work.

More than two hundred figures have been successfully integrated into this picturesque landscape. The composition unfolds about a gallant young couple who dance a minuet. They are surrounded by scores of animated figures in brilliant costumes: actors, musicians, clowns, dancers, acrobats, pairs of lovers, and even a magician who appears on stage with a well-dressed monkey. Like those of Watteau, Pater's figures are not ordinary people, but the exotic persons of the world of the theater, the world of make-believe. The ruined château in the background center and the dilapidated farmhouse at left add an element of gentle wistfulness to what is otherwise a dreamworld of wealth, gaiety, youth, and comfort.

The ebullient spirit of the picture is at variance with what is known about the painter himself. Pater was notorious for his parsimony and generally sour disposition. His hypochondria and obsessive fear of poverty ultimately led him to a premature death. Pater was a prolific, though somewhat repetitive artist, and while his talent was modest, he achieved an enormous popularity in his day. Frederick the Great of Prussia was especially fond of Pater's work, at one time owning over forty of his canvases.

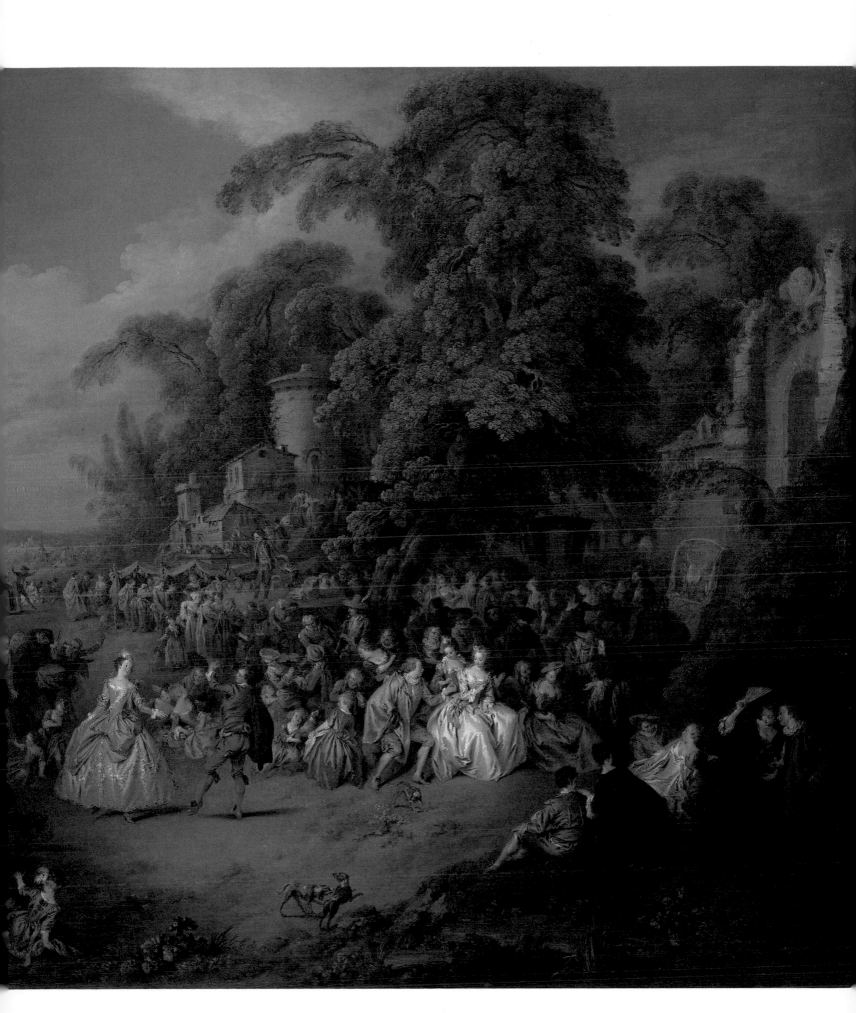

149

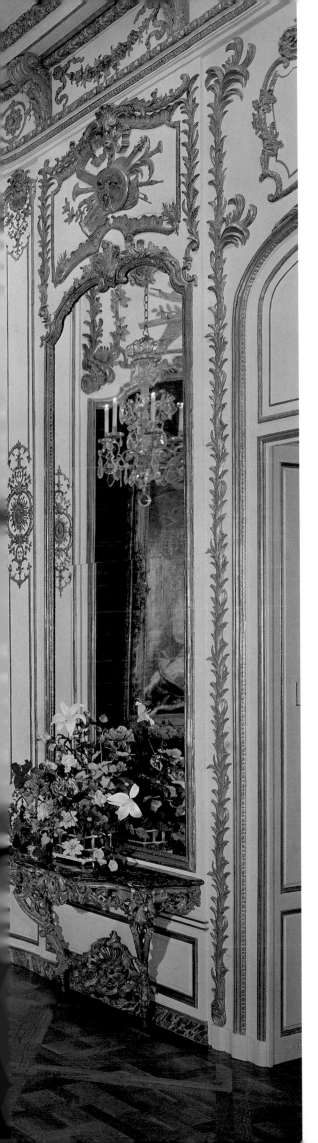

LOUIS XV ALCOVE

The *boiserie*, or decorated wood paneling, of this alcove was originally part of a larger room; the present dado and cornice are later additions. Enriched with highly decorative trophies and other gilded carvings, this woodwork is in the early Louis XV style and dates from about 1730–35. In Greek and Roman times, decorative trophies—an array of captured arms and armor either piled up on the ground or hung from a tree—commemorated military victories. In later periods, they became a major ornamental device no longer consisting solely of war gear.

The trophies on the rounded corner panels, symbolizing the four seasons, incorporate gardening tools and a basket of flowers (spring), a sheaf of wheat and a straw hat (summer), a pannier of grapes and hunting attributes (autumn), and a jester's bauble and a violin (winter). The wall panels are surmounted by smaller trophies of music and the hunt, which, like the larger four, are suspended from ribbons. Due to analogies with drawings by François Antoine Vassé, a designer and woodcarver who worked at Versailles, the design of this alcove has been attributed to him.

118 Alcove, ca. 1730–35
Design attrib. to François Antoine Vassé
French, 1716–72
Painted and gilded oak; H. 19 ft. (5.79 m.)
Gift of J. Pierpont Morgan, 1906 (07.225.147)

HYACINTHE RIGAUD
Louis XV as a Child

Rigaud, a provincially trained artist, began his career in Paris at the age of twenty-two. He originally supported himself by painting portraits of fellow artists and of middle-class patrons. In 1688, he was asked to paint a portrait of Monsieur, King Louis XIV's brother. His flattering and graceful compositions soon made him a favorite of the French court. His numerous portraits included virtually everyone of any distinction who visited the king.

Working within the confines of the existing formulae for royal portraiture, what Rigaud extols here is not the character of the young Louis XV—looking far more adult than his five years would allow—but the monarchy itself. The elegant stance and haughty expression of the sitter lend credence to the belief that Rigaud based many of his compositions on prototypes popularized by van Dyck.

This painting is one of several replicas that Rigaud made of his original painting, which is now at Versailles. There is an inscription in the medallion at the base of the painting's frame stating that this version was given by the king to Monsieur Dombreval in 1724.

119 Louis XV as a Child
Hyacinthe Rigaud
French, 1659–1743
Oil on canvas; 77 x 55½ in. (195.6 x 141 cm.)
Purchase, Mary Wetmore Shively Bequest in memory
of her husband, Henry L. Shively, M.D., 1960 (60.6)

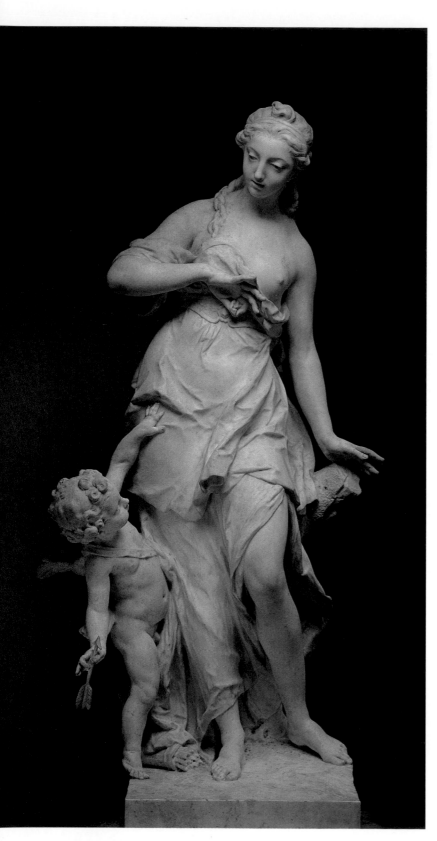

JEAN LOUIS LEMOYNE
The Fear of Cupid's Darts

Erotic yet somehow ambivalent in its meaning, as is typical of amorous imagery of the Rococo, the subject of this sculpture is a nymph recoiling at the advances of Cupid. At the same time, her features show a hypnotic attraction, and the fingers at her breast seem to describe playfully the very area Cupid wishes to strike.

The composition and carving technique fully live up to this vision of young love, which seems distilled for all time even as it shows all the stylistic hallmarks of the age. The nymph's bowing movement, exceedingly fetching when viewed from the corners, is a fine piece of Rococo invention. The group was given by Louis XV to the marquis de Marigny (brother of Madame de Pompadour), who placed it outdoors at his château, Ménars. Despite a certain amount of abrasion, the surface retains the character of being swiftly broken up in churning facets, like flickering strokes of sunlight.

JEAN MARC NATTIER
Madame Marsollier and Her Daughter

This charming double portrait dates from 1749, when the French portraitist Jean Marc Nattier was at the peak of his fame. The subjects of this painting, Madame Marsollier and her daughter, a young lady who later became the contesse de Neuberger, are presented as the epitome of stylishness. Madame Marsollier is elegantly poised before her lace-covered dressing table, which is adorned with a powder box, a ewer, and an elaborately framed mirror. She appears in a magnificent *déshabille* of white satin, which is draped with a beautiful wrap of blue taffeta. The low décolletage of Madame Marsollier's dress was highly popular at the time. She is about to dress the hair of her beautiful young daughter, who wears a low-necked gown and holds open a jeweled vanity box.

Madame Marsollier was the daughter of an attorney for the king. She was also the wife of a prosperous textile merchant who specialized in the sale of imported silks and velvets. Madame Marsollier was anxious to conceal what she felt was an unacceptably middle-class background and demanded that her husband purchase a title of peerage. They were successful in this venture and became known as the count and countess of St. Pierre. When news of Madame Marsollier's rather overt social climbing became known, however, members of the court dubbed her with the sarcastic and unflattering sobriquet, "the Duchess of Velvet."

120 The Fear of Cupid's Darts, 1739–40
Jean Louis Lemoyne
French, 1665–1755
Marble; H. 72 in. (182.9 cm.)
Purchase, Josephine Bay Paul and C. Michael Paul
Foundation, Inc. Gift, and Charles Ulrick and
Josephine Bay Foundation, Inc. Gift, 1967 (67.197)

121 Madame Marsollier and Her Daughter, 1749
Jean Marc Nattier
French, 1685–1766
Oil on canvas; 57½ x 45 in. (146.1 x 114.3 cm.)
Bequest of Florence S. Schuette, 1945 (45.172)

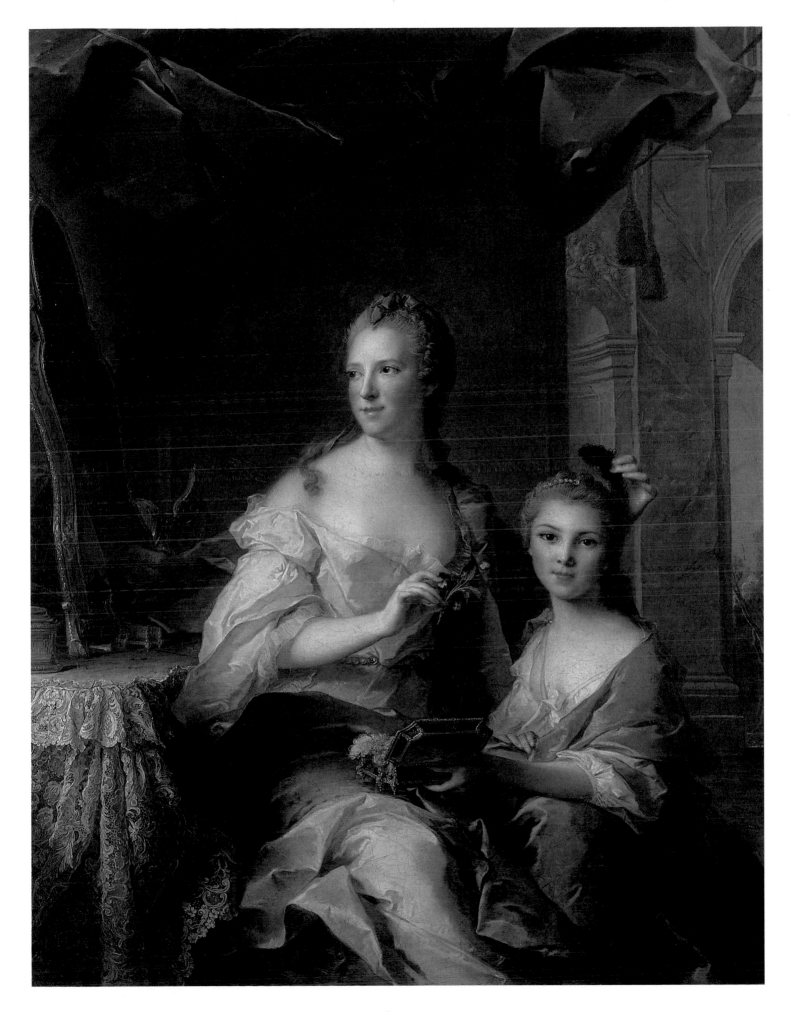

153

BERNARD VAN RISENBURGH II
Commode

Bernard van Risenburgh, working in the fully developed Louis XV style, belonged to a family of cabinetmakers of Dutch extraction. His initials, BVBR, are stamped once at each corner under the marble top of this commode.

About 1730, it became fashionable for cabinetmakers to mount furniture with lacquer panels, as illustrated in this example, dating from around 1745. The curving front and sides are skillfully veneered with decorative panels from an incised Coromandel lacquer screen. The name of this type f lacquer, produced only in China, derives from its route of export to Europe via the Coromandel coast, which stretches north and south of Madras in southeast India. The front, showing oriental figures, and the sides, depicting fantastic animals, are set with Rococo mounts of exquisite quality and individual design. The applied narrow moldings of gilt bronze, running down to the feet, highlight the commode's serpentine outline and elegant design.

122 Commode, ca. 1745
Bernard van Risenburgh II
French, act. ca. 1730–65
Coromandel lacquer, ebony, oak, gilt bronze,
marble top; 34 x 33 x 25¾ in. (86.4 x 83.8 x 64.1 cm.)
The Lesley and Emma Sheafer Collection, Bequest
of Emma A. Sheafer, 1973 (1974.356.189)

JEAN BAPTISTE PIGALLE
Bust of Madame de Pompadour

Louis XV's *maitresse en titre*, Madame de Pompadour, and her brother, the marquis de Marigny, the king's *Directeur des Bâtiments*, offered many commissions to Jean Baptiste Pigalle, a favorite of intellectuals as well as the court. His style, combining Rococo embellishment with an often painfully honest naturalism, embodies the ambivalence of the era. In this bust, he has provided posterity with an accurate, if not particularly flattering, portrait of his great patron. The Classical purity of the subject's head, of her famously elegant neck and shoulders, and even her bosom, belie the graceful fancy of the Rococo framework: the floral nosegay atop her precise coiffure and the lace-edged shawl, which coquettishly preserves her from total nudity. These appurtenances of fashion do little to disguise the humorous intelligence and strength of will revealed in her gaze, which reminds the viewer that Voltaire and Montesquieu were guests at her *salon* before she was ever ensconced at court.

123 Bust of Madame de Pompadour, 1748–51
Jean Baptiste Pigalle
French, 1714–85
Marble; H. 29½ in. (75 cm.)
The Jules Bache Collection, 1949 (49.7.70)

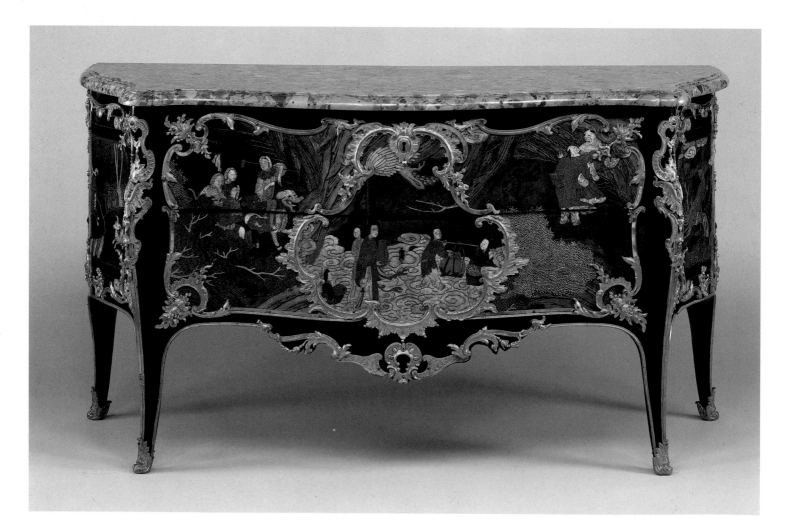

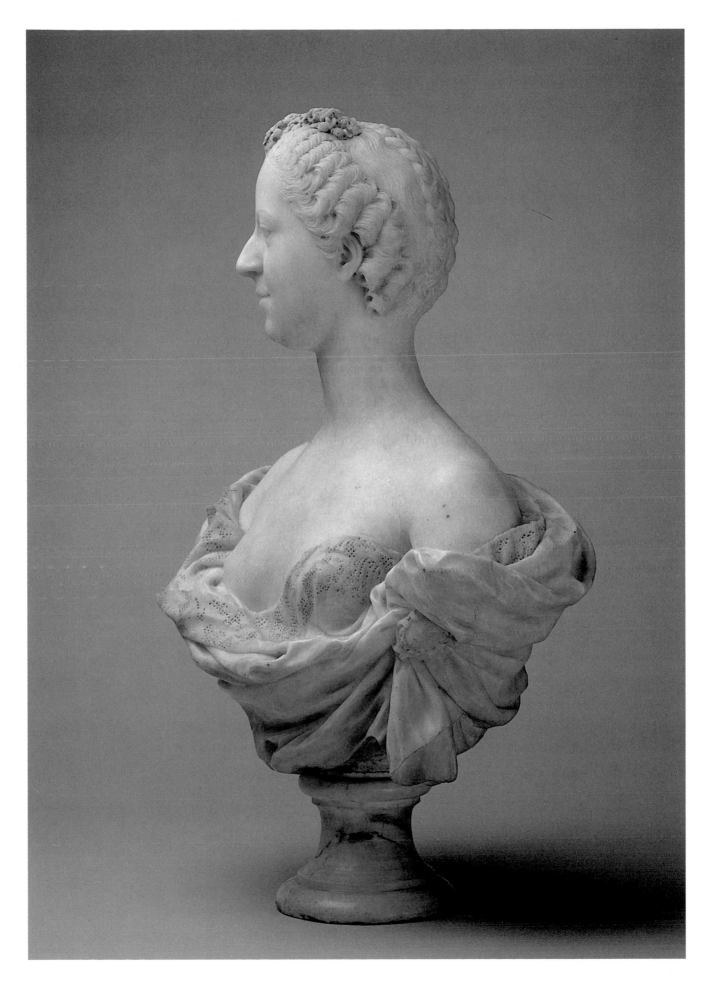

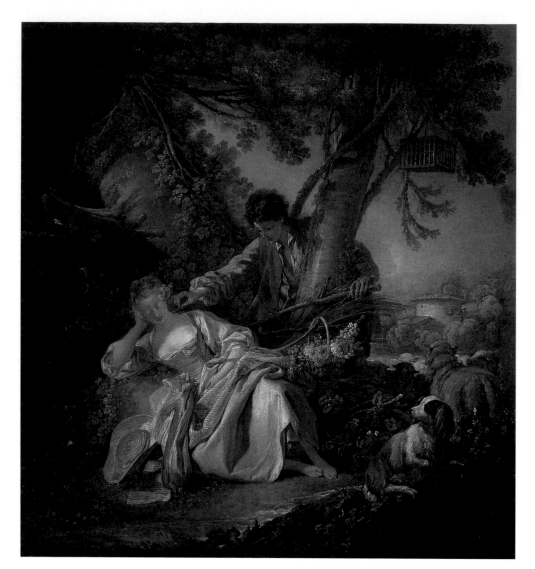

124 The Interrupted Sleep, 1750
François Boucher
French, 1703–70
Oil on canvas; 29½ x 25½ in. (75 x 64.8 cm.)
The Jules Bache Collection, 1949 (49.7.46)

125 The Toilet of Venus, 1751
François Boucher
French, 1703–70
Oil on canvas; 42⅝ x 33½ in.
(108.3 x 85.1 cm.)
Bequest of William K. Vanderbilt,
1920 (20.155.9)

FRANÇOIS BOUCHER
The Interrupted Sleep

No painter of the eighteenth century was more inextricably linked to court patronage than François Boucher. This painting was made in 1750 for one of the châteaux of Madame de Pompadour. It shows one of Boucher's most popular themes, pastoral love.

A dainty and fashionably dressed shepherdess with flowers in her hair dozes before a well-tonsured tree, from which a bird cage is suspended. The young lady's straw hat and a basket of freshly picked flowers lie on the ground. Her exquisitely formed, delicate pink feet are bare. A clear-eyed, rosy-cheeked boy has evidently just crept forward so as not to wake her. He holds a straw and is just about to tickle her. Sheep graze indifferently in the distance, and the frisky lap dog to the right intently watches the amorous play.

Although the couple appears more like a pair of figurines than human beings, and the stylized and artificial view of nature in no way reflects the reality of peasant life, Boucher can hardly be faulted. As one of the foremost painters of the privileged class, he was expected to produce elegant, voluptuous, and intellectually innocuous pictures. Boucher's world was one of presentation and display, a world that shunned social problems and religious questions.

FRANÇOIS BOUCHER
The Toilet of Venus

This picture, signed and dated 1751, was commissioned as part of the decoration for Madame de Pompadour's *salle de bain* at the Château de Bellevue, one of the private retreats built for her by King Louis XV. The indolent and dreamy figure of Venus sits on rose-colored velvets, which drape over an ornately carved love seat. She holds a dove on her thigh and is attended to by three pudgy little putti; one dresses her hair, another pulls on the dove's ribbons, and a third reaches for her string of pearls. The winged putti and the pair of doves are attributes of Venus in her guise as goddess of Love; the flowers allude to her role as patroness of gardeners, and the pearls to her mysterious birth from the sea. The elaborate and highly theatrical setting includes such ornamentation as the enormous incense burner to the far right, sculpted putti on the love seat, and dramatically painted drapery and architecture. Boucher suspended any hint of story line in order to insist more emphatically on the voluptuous forms and translucent colors of this rich display.

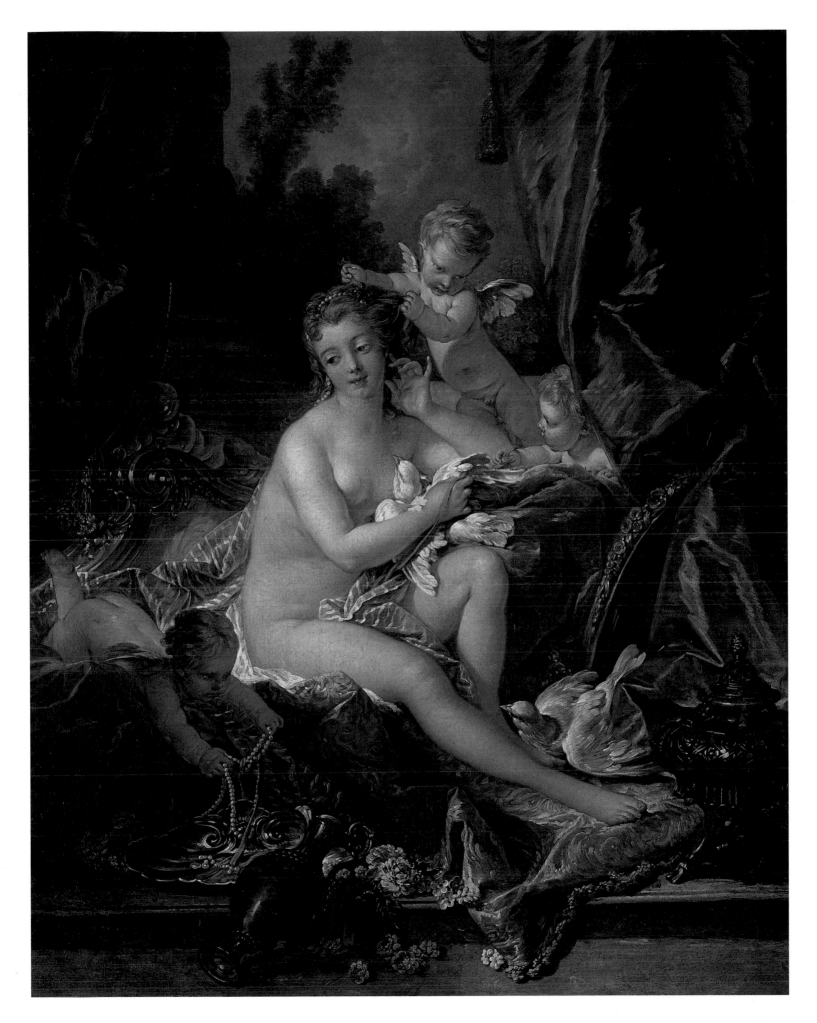

JEAN BAPTISTE SIMEON CHARDIN
The Silver Tureen

Chardin had the extraordinary gift of infusing the most ordinary objects of everyday life with an aura of dignity and value. He transformed the tureen (a pot used specifically to serve *oille*, a Spanish peasant soup), two pears, two chestnuts, a bright red apple, and an orange into objects worthy of sustained contemplation. To this meditative and static composition Chardin then added the cat, who stalks the bounty before him, as if ready to pounce. The cat not only enlivens the composition but also creates a sense of conflict between the living and dead animals, underscoring a theme especially common in Chardin's genre scenes: the evanescence of life.

Chardin was a contemporary of Boucher, and though they occasionally had some of the same patrons, no two artists could have been more different. Dark in tone, contemplative in nature, Chardin's deceptively simple compositions nearly always contain a moral and a contemptuous disregard for mere "prettiness." This masterful still life dates from about 1728, shortly before Chardin was received into the French Academy.

126 The Silver Tureen
Jean Baptiste Siméon Chardin
French, 1699–1779
Oil on canvas;
30 x 42½ in. (76.2 x 107.9 cm.)
Fletcher Fund, 1959 (59.9)

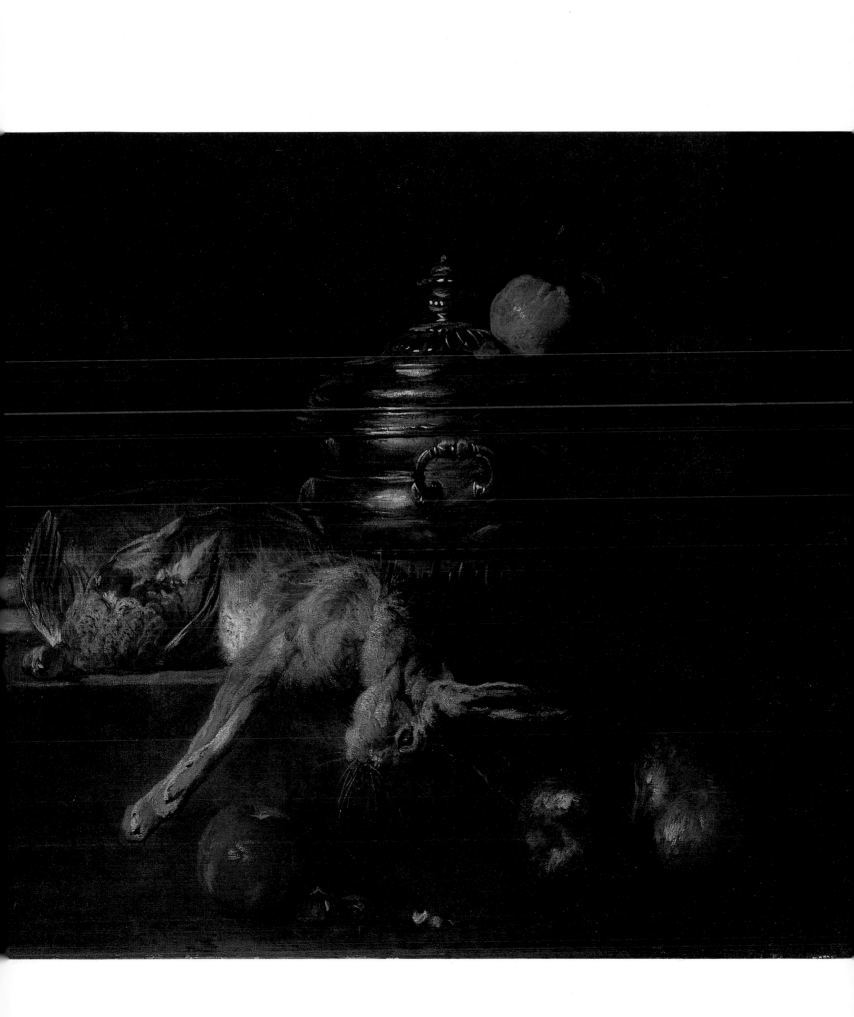

INDEX

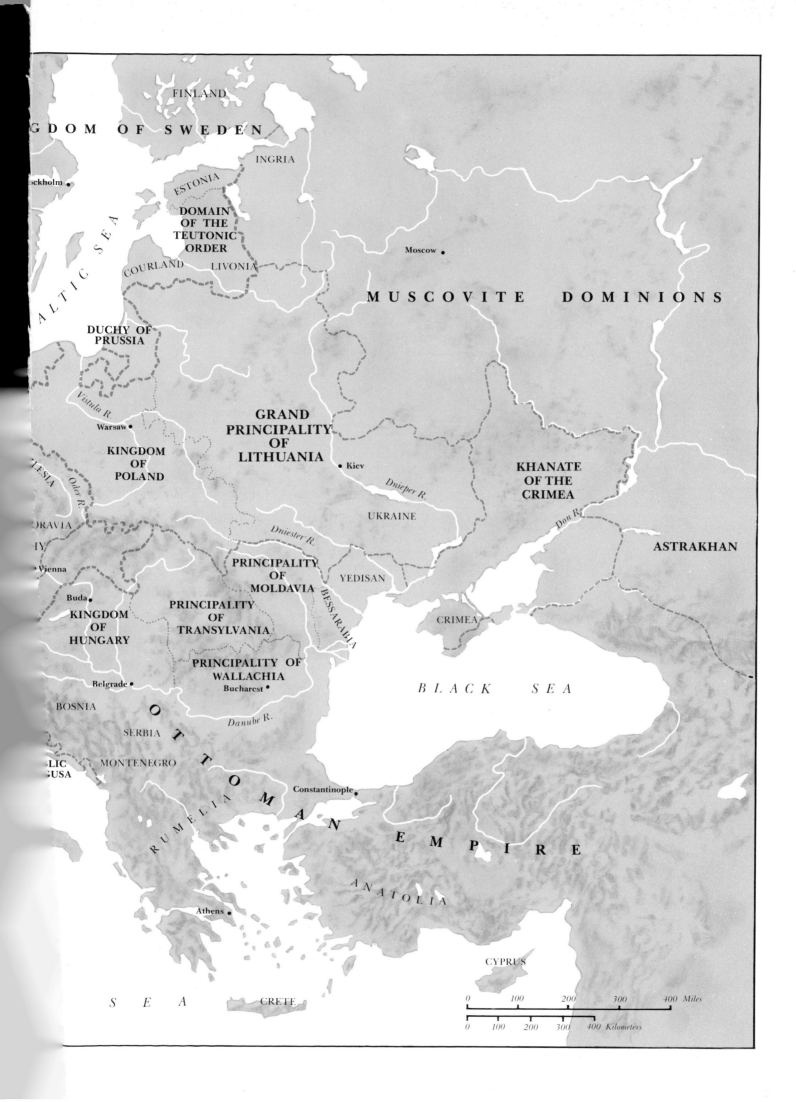

FINLAND

GDOM OF SWEDEN

INGRIA

ESTONIA

ockholm •

DOMAIN
OF THE
TEUTONIC
ORDER

Moscow •

COURLAND LIVONIA

BALTIC SEA

MUSCOVITE DOMINIONS

DUCHY OF
PRUSSIA

Vistula R.

GRAND
PRINCIPALITY
OF
LITHUANIA

Warsaw •

KINGDOM
OF
POLAND

Oder R.

ILESIA

• Kiev

Dnieper R.

KHANATE
OF THE
CRIMEA

ORAVIA

UKRAINE

Dniester R.

Don R.

HY

• Vienna

PRINCIPALITY
OF
MOLDAVIA

YEDISAN

ASTRAKHAN

Buda •

KINGDOM
OF
HUNGARY

PRINCIPALITY
OF
TRANSYLVANIA

BESSARABIA

CRIMEA

Belgrade •

PRINCIPALITY OF
WALLACHIA

Bucharest •

BLACK SEA

BOSNIA

Danube R.

SERBIA

MONTENEGRO

Constantinople •

LIC
GUSA

O
T
T
O
M
A
N

RUMELIA

E
M
P
I
R
E

ANATOLIA

Athens •

CYPRUS

SEA CRETE

0 100 200 300 400 *Miles*

0 100 200 300 400 *Kilometers*

EUROPE

1600	Shakespeare's *Hamlet*
1600	Population (in millions): France 16; Germany 14; Spain 8; England and Ireland 5; Holland 3
1603	Elizabeth I of England succeeded by James I
1605	Boris Godunov, czar of Russia, succeeded by Feodor I
1605	Guy Fawkes's "Gunpowder Plot"
1605	Cervantes's *Don Quixote*, Part I
1607	Monteverdi's *Orfeo*
1609	Kepler's first two "laws"
1609	Lope de Vega's *El arte nuovo de comedias*
1610	Henry IV of France succeeded by Louis XIII
1610	Jonson's *The Alchemist*
1611	Authorized Version of the Bible
1612	Chapman's translation of the *Iliad*
1612	Rudolph II, Holy Roman Emperor, succeeded by Matthias
1613	Michael elected first Romanov czar
c1614	Webster's *Duchess of Malfi*
1616	Richelieu named a secretary of state in France
1616	Domenichino's *Landscape with Moses and the Burning Bush*
1618	Netherlands' Thirty Years War with Spain begins
1619	Inigo Jones begins Banqueting House, Whitehall, London
1619	Matthias, Holy Roman Emperor, succeeded by Ferdinand II
1621	Philip III of Spain succeeded by Philip IV
1622	Ignatius of Loyola canonized

DOMENICHINO
Landscape with Moses and the Burning Bush
(see Plate 5)

1625	James I of England succeeded by Charles I
1627	Ford's *'Tis Pity She's a Whore*
1628	Harvey's *On the Movement of the H[eart] and Blood*
1629	Zurbarán's *Funeral of St. Bonavent[ure]*
1632	Gustavus Adolphus of Sweden succeeded by Christina
1633	John Donne's *Poems* (posthumous)
1633	Galileo tried by Inquisition, abjur[es] beliefs
1635	Richelieu grants Académie Franç[aise] royal patent
1637	Descartes's *Discours sur la méthode*
1637	Corneille's *Le Cid*
1637	Ferdinand II, Holy Roman Empe[ror] succeeded by Ferdinand III
c1639	Rubens's *The Artist, His Wife, and S[on]*
c1638–43	La Tour's *Penitent Magdalen*
c1640	Calderon de la Barca's *El Alcalde [de] Zalemea*
1642	Richelieu dies, succeeded by Maza[rin]
1643	Louis XIII of France succeeded b[y] Louis XIV
1648	Thirty Years War ends, Dutch wi[n] independence
1649	Charles I executed, England dec[lared] Commonwealth

ASIA, AFRICA, THE AMERICAS

1600	Ieyasu Tokugawa defeats *daimyos* at Battle of Sekigahara
1600	English East India Company founded
1601	Ricci, Jesuit missionary, admitted to Peking
1602	Dutch East India Company founded
1603	Muhammad III, sultan of Turkey, succeeded by Ahmed I
1603	Ieyasu founds Tokugawa shogunate in Japan, with Edo (Tokyo) as capital
1605	Akbar, Mughal emperor of India, succeeded by Jahangir
1605	Ieyasu, shogun of Japan, succeeded by Hidetada
1607	First English settlement in America at Jamestown (Virginia)
1608	French colony in Québec founded by Champlain
1617	Ahmed I, sultan of Turkey, succeeded by Mustafa I
1619	First African slaves arrive in North America
1619	Dutch establish trading post at Batavia, Java
1620	*Mayflower* sails from England
1623	Mustafa I, sultan of Turkey, succeeded by Murad IV
1623	Hidetada, shogun of Japan, succeeded by Iemitsu
1624	Dutch establish New Amsterdam (New York)

a "THE CONCOURSE OF THE BIRDS"
(Iranian, ca. 1600)

1627	First English settlement on Barb[ados]
1628	Jahangir, Mughal emperor of I[ndia] succeeded by Shah Jahan
1628	Shah Abbas I, the Great, of Per[sia] succeeded by Safi I
1630	Building of Taj Mahal begins
1636	Harvard College founded
1638	Murad IV of Turkey recovers [Baghdad] from Persia
1639	Iemitsu expells Portugese and [closes] Japan to most foreign trade
1640	English build Fort St. George a[t Madras]
1640	Murad IV, sultan of Turkey, s[ucceeded] by Ibrahim
1642	Montréal, Canada, founded
1642	Safi I, shah of Persia, succeed[ed by] Abbas II
1642–93	Ihara Saikaku, Japanese nove[list]
1644	Manchus conquer China, Fu[lin (Shun-] chih) becomes emperor, fou[nds Ch'ing] dynasty
1648	Ibrahim, sultan of Turkey, s[ucceeded] by Muhammad IV

1650 Velázquez's *Juan de Pareja*
1651 Hobbes's *Leviathan*
1653 Fronde rebellion crushed by Louis XIV
1653 Oliver Cromwell named Lord
 Protector of England
1655 Bernini begins Piazza of St. Peter's,
 Rome
1657 Ferdinand III, Holy Roman Emperor,
 succeeded by Leopold I
1658 Poussin's *Blind Orion Searching for the Sun*
1660 English monarchy restored under
 Charles II
1663 Preti's *Pilate Washing His Hands*
1664 Molière's *Tartuffe*

1665 Philip IV of Spain succeeded by
 Charles II
1665 Colbert named controller general of
 finances by Louis XIV
1666 Stradavari labels his first violin
1666 Great Fire of London
1667 Racine's *Andromaque*
1667 Milton's *Paradise Lost*
1669 Last entry in Pepys's *Diary*
1670 Pascal's *Pensées* (posthumous)
1673 Test Act excludes Catholics from office
 in England
1675 Wren begins rebuilding of St. Paul's
 Cathedral

GEORGES DE LA TOUR
Penitent Magdalen
(see Plate 99)

NICOLAS POUSSIN
Blind Orion Searching for the Rising Sun
(see Plate 103)

*c*1650 Kano Sansetsu's *Aged Plum*
1651 Iemitsu, shogun of Japan, succeeded
 by Ietsuna
1652 Dutch ("Boers") settle in southern
 Africa
1654 Portugese drive Dutch from Brazil
1655 Li Tsai's *Serried Peaks amid Clouds and
 Mist*
1658 Shah Jahan, Mughal emperor of India,
 succeeded by Aurangzeb

1661 Fu-lin, emperor of China, succeeded
 by Hsüan-yeh (K'ang-hsi)
1661 English establish trading post at
 Bombay
1664 French East India Company founded
1666 Abbas II, sultan of Turkey, succeeded
 by Suleyman
1667 Tao-chi's *The Sixteen Lohans*
1669 Marquette founds mission on
 Mackinac (Michigan)

b KANO SANSETSU
Aged Plum
(Japanese, ca. 1650)

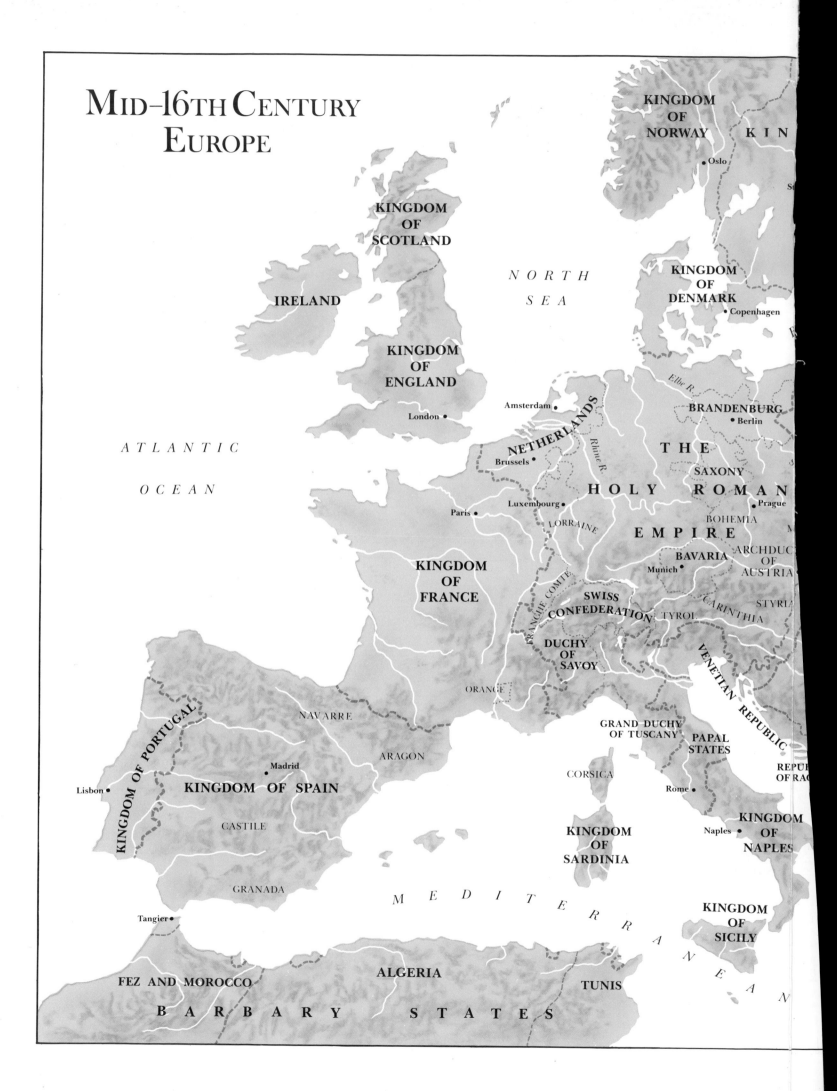

MID-16TH CENTURY EUROPE

KINGDOM OF NORWAY

KIN

• Oslo

KINGDOM OF SCOTLAND

NORTH SEA

KINGDOM OF DENMARK

• Copenhagen

IRELAND

KINGDOM OF ENGLAND

Amsterdam •

BRANDENBURG

• Berlin

Elbe R.

London •

NETHERLANDS

Brussels •

T H E

SAXONY

ATLANTIC

Rhine R.

H O L Y R O M A N

OCEAN

Paris •

Luxembourg •

• Prague

BOHEMIA

LORRAINE

E M P I R E

ARCHDUC OF AUSTRIA

KINGDOM OF FRANCE

BAVARIA

Munich •

STYRIA

CARINTHIA

FRANCHE-COMTÉ

SWISS CONFEDERATION

TYROL

DUCHY OF SAVOY

VENETIAN REPUBLIC

ORANGE

NAVARRE

GRAND DUCHY OF TUSCANY

PAPAL STATES

REPU OF RAG

KINGDOM OF PORTUGAL

ARAGON

CORSICA

Rome •

Madrid •

KINGDOM OF SPAIN

KINGDOM OF NAPLES

Naples •

Lisbon •

CASTILE

KINGDOM OF SARDINIA

GRANADA

MEDITER

KINGDOM OF SICILY

Tangier •

R

FEZ AND MOROCCO

ALGERIA

TUNIS

A

N

B A R B A R Y S T A T E S

EUROPE

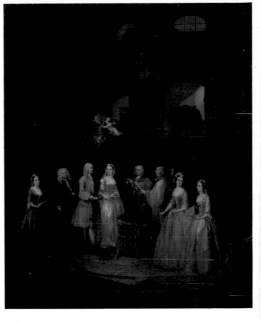

1725	Peter the Great of Russia succeeded by Catherine
1726	Couperin's *Le Parnasse, ou l'Apothéose de Corelli*
1726	Swift's *Gulliver's Travels*
1727	George I of England succeeded by George II
1728	Gay's *Beggar's Opera*
1729	Bach's *St. Matthew Passion*
1740	Frederick William I of Prussia succeeded by Frederick II, the Great
1742	Handel's *Messiah*
1742–50	Gray's "Elegy Written in a Country Churchyard"
1745	Hogarth's *Marriage à la Mode*
1746	Philip V of Spain succeeded by Ferdinand V
1747–48	Richardson's *Clarissa*
1748	Hume's *An Enquiry Concerning Human Understanding*
1749	Fielding's *Tom Jones*

WILLIAM HOGARTH
The Wedding of Stephen Beckingham and Mary Cox
(see Plate 88)

ASIA, AFRICA, THE AMERICAS

Ietsugu, shogun of Japan, succeeded by Yoshimune
Hsüan-yeh forbids propagation of Christianity in China
China conquers Tibet
Shah Sultan Hoseyn of Persia succeeded by Tahmasp II
Hsüan-yeh, emperor of China, succeeded by Yin-chen (Yung-cheng)

1725	Muhammad Shah, Mughal emperor of India, succeeded by Ahmad Shah
1728	Bering Strait crossed
1730	Ahmed III defeated by Nader Shah
1730	Ahmed III, sultan of Turkey, succeeded by Mahmud I
1732	Nader Shah deposes Tahmasp, installs Abbas III as shah of Persia
1733	Oglethorpe founds Savannah, Georgia
1736	Nader Shah assumes throne of Persia, makes Sunni state religion
1735	Yin-chen, emperor of China, succeeded by Hung-li (Ch'ien-lung)
1739	Persians under Nader Shah sack Delhi, carry off Peacock Throne
1745	Yoshimune, shogun of Japan, succeeded by Ieshige
1748	Muhammad Shah, Mughal emperor of India, succeeded by Ahmad Shah
1748	Shah Rukh succeeds Nader Shah in Persia

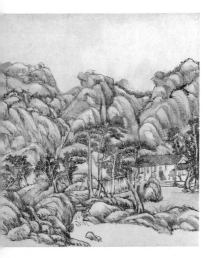

a (detail)

e　JAPANNED HIGH CHEST
(Boston, Massachusetts, 1730–60)

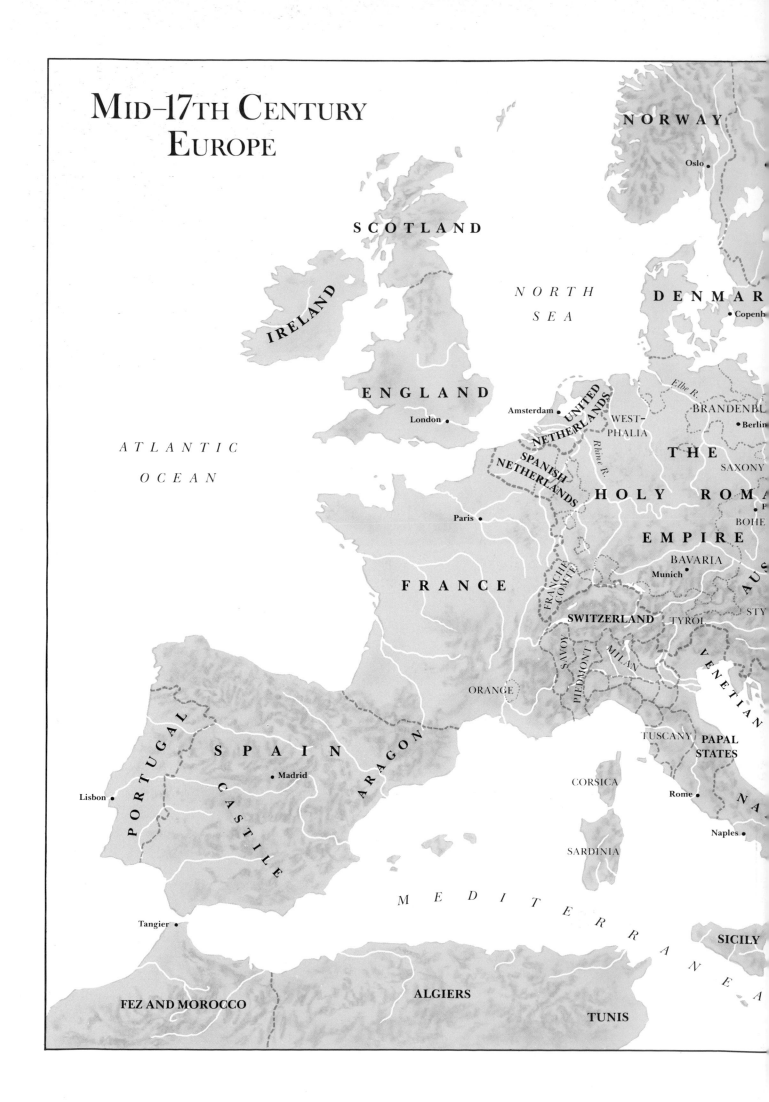

Mid-17th Century Europe

NORWAY

Oslo

SCOTLAND

NORTH SEA

DENMARK

Copenh

IRELAND

ENGLAND

London

Amsterdam

UNITED NETHERLANDS

WEST-PHALIA

Elbe R.

BRANDENBL

Berlin

SPANISH NETHERLANDS

Rhine R.

THE

SAXONY

ATLANTIC OCEAN

Paris

HOLY ROMA

BOHE

EMPIRE

BAVARIA

Munich

AUS

FRANCHE COMTÉ

FRANCE

SWITZERLAND

TYROL

STY

SAVOY

MILAN

VENETIAN

PIEDMONT

ORANGE

PORTUGAL

SPAIN

ARAGON

TUSCANY

PAPAL STATES

CORSICA

Rome

NA

CASTILE

Madrid

Lisbon

Naples

SARDINIA

Tangier

MEDITERRANE

SICILY

FEZ AND MOROCCO

ALGIERS

TUNIS

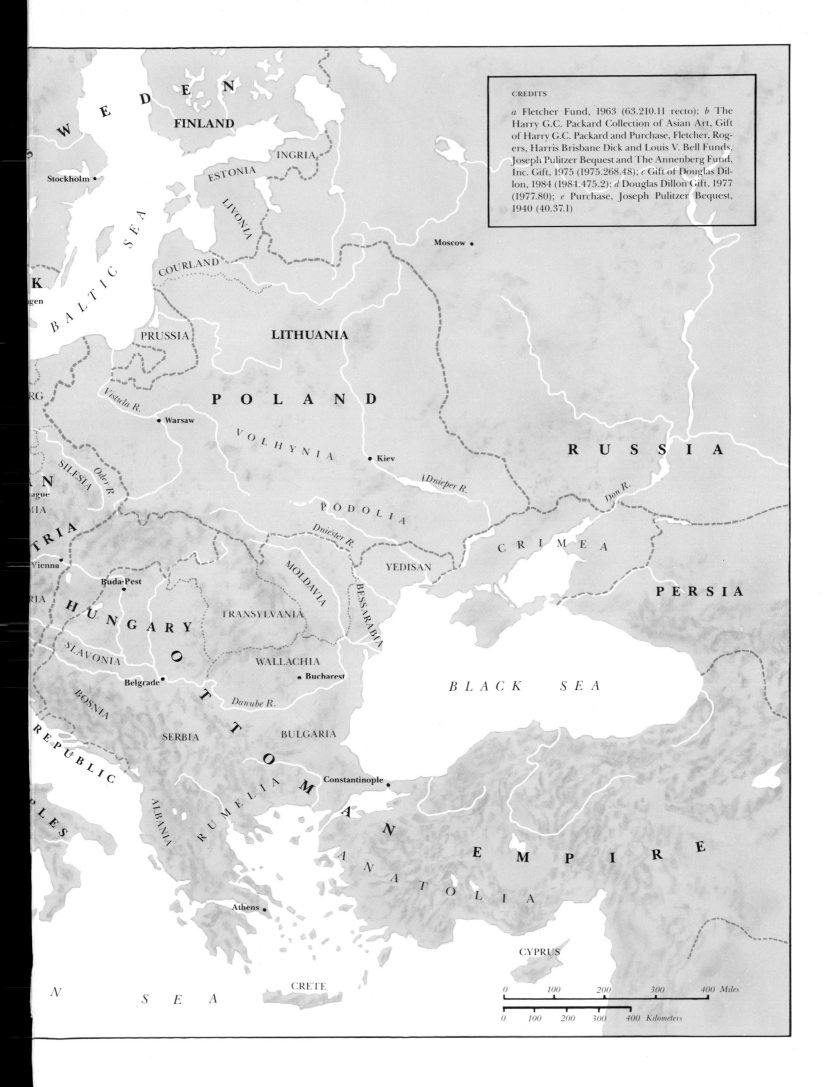

CREDITS

a Fletcher Fund, 1963 (63.210.11 recto); *b* The Harry G.C. Packard Collection of Asian Art, Gift of Harry G.C. Packard and Purchase, Fletcher, Rogers, Harris Brisbane Dick and Louis V. Bell Funds, Joseph Pulitzer Bequest and The Annenberg Fund, Inc. Gift, 1975 (1975.268.48); *c* Gift of Douglas Dillon, 1984 (1984.475.2); *d* Douglas Dillon Gift, 1977 (1977.80); *e* Purchase, Joseph Pulitzer Bequest, 1940 (40.37.1)

S W E D E N

FINLAND

INGRIA

ESTONIA

Stockholm •

LIVONIA

Moscow •

K

agen

BALTIC SEA

COURLAND

PRUSSIA

LITHUANIA

RG

Vistula R.

POLAND

• Warsaw

RUSSIA

SILESIA

Oder R.

VOLHYNIA

• Kiev

rague

MIA

PODOLIA

ADnieper R.

Don R.

TRIA

Dniester R.

CRIMEA

• Vienna

MOLDAVIA

YEDISAN

PERSIA

Buda-Pest •

H U N G A R Y

TRANSYLVANIA

BESSARABIA

RIA

O

SLAVONIA

WALLACHIA

Belgrade •

• Bucharest

BOSNIA

Danube R.

BLACK SEA

REPUBLIC

SERBIA

BULGARIA

LES

T

ALBANIA

RUMELIA

M

Constantinople •

A

N

A N A T O L I A

E M P I R E

Athens •

CYPRUS

N S E A

CRETE

| 0 | 100 | 200 | 300 | 400 Miles |

| 0 | 100 | 200 | 300 | 400 Kilometers |

SEBASTIANO RICCI
Baptism of Christ
(see Plate 25)

PIERRE ETIENNE MONNOT
Andromeda and the Sea Monster
(see Plate 110)

c TAO-CHI
Bamboo in Wind and Rain
(Chinese, before 1697)

d WANG YUAN-CHI
The Wang Ch'uan Vi
(Chinese, 1711)